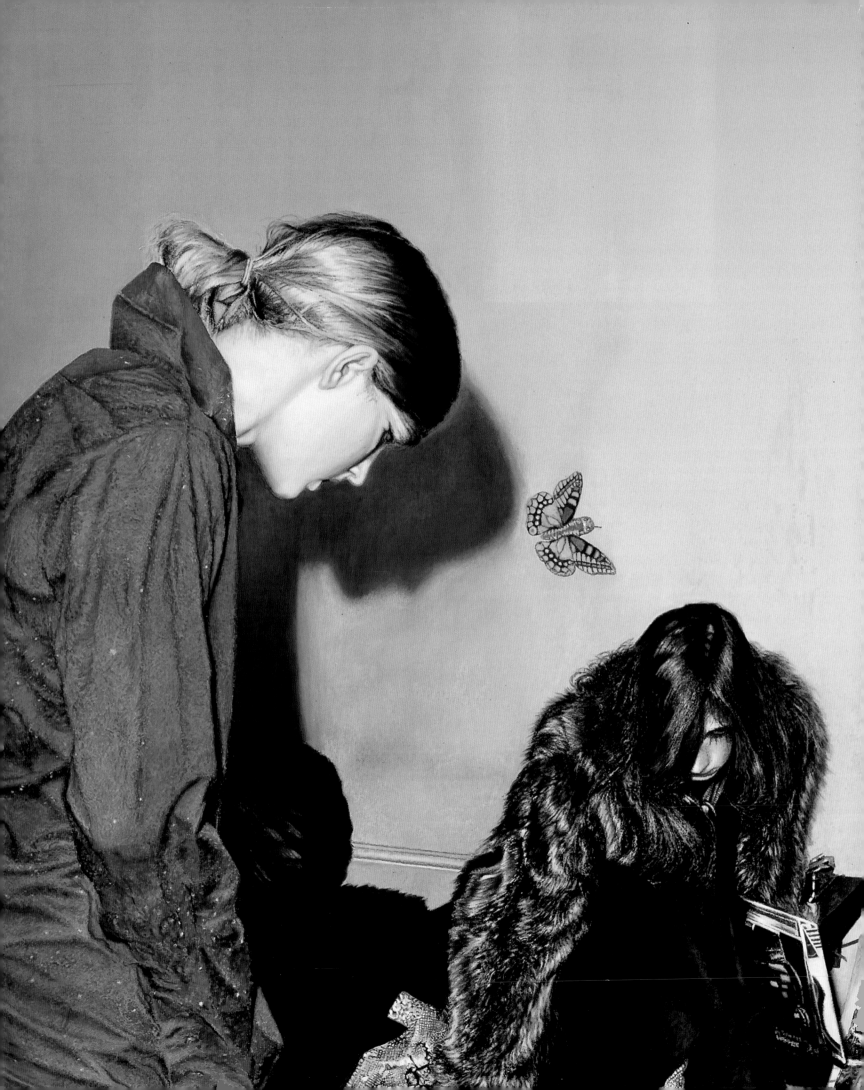

THE PAINTING
OF MODERN LIFE

1960s TO NOW

ARTS COUNCIL ENGLAND

SOUTHBANK CENTRE
HAYWARD PUBLISHING

Published on the occasion of the exhibition *The Painting of Modern Life*, The Hayward, London, UK, 4 October – 30 December 2007, and Castello di Rivoli, Museum of Contemporary Art, Turin, Italy, 6 February – 4 May 2008

Exhibition curated by Ralph Rugoff
Exhibition organised by Caroline Hancock
assisted by Siobhan McCracken

Castello di Rivoli, Museum of Contemporary Art
Director: Ida Gianelli
Chief Curator: Carolyn Christov-Bakargiev
Head of Exhibitions: Chiara Oliveri Bertola
Assistant Curator: Marianna Vecellio

Art Publisher: Caroline Wetherilt
Publishing Co-ordinator: Charlotte Troy
Sales Manager: Deborah Power
Additional editorial assistance by Helen Luckett
Catalogue designed by Allon Kaye
Printed in Italy by Graphicom

Front cover: Johannes Kahrs, *La Révolution Permanente*, 2000 (cat. 47, detail);
Gerhard Richter, *Woman with Umbrella*, 1964 (cat. 86, detail)

Pages 2–3: Franz Gertsch, *At Luciano's House*, 1973 (cat. 32, detail)
Page 5: Judith Eisler, *Smoker (Cruel Story of Youth)*, 2003 (cat. 28, detail)
Page 9: Eberhard Havekost, *National Geographic*, 2003 (cat. 40, detail)
Pages 50–51: Peter Doig, *Concrete Cabin II*, 1992 (cat. 13, detail)
Pages 178–179: Vija Celmins, *Freeway*, 1966 (cat. 11, detail)

Published by Hayward Publishing, Southbank Centre, Belvedere Road, London, SE1 8XX, UK
www.southbankcentre.co.uk

ISBN 978-1-85332-263-1

Distributed in North America, Central America and South America through D.A.P./Distributed Art Publishers, 155 Sixth Avenue, 2nd Floor, New York, N.Y. 10013
T +212 627 1999 F +212 627 9484
www.artbook.com

Distributed outside North America, Central America and South America by Cornerhouse Publications, 70 Oxford Street, Manchester M1 5NH
T +44 (0)161 200 1503 F +44 (0)161 200 1504
www.cornerhouse.org/books

Contents

Preface

In his celebrated essay of 1863 'The Painter of Modern Life', French poet and critic Charles Baudelaire challenged the painters of his day to forego the traditional subjects of academic painting. Instead, he urged them to pay close attention to the fast-changing world around them and produce pictures that captured the 'transient, the fleeting, the contingent' – that captured, in other words, the emerging character of modern life. A little less than 100 years later, a handful of artists working in different countries chose to break away from abstraction, which by then had become a new form of academic painting, to create canvases that depicted the social landscape of the times by translating, and in a sense reinventing, photographic imagery. As it has evolved over the past 50 years, this approach to making pictures has become one of the most influential developments in the history of contemporary painting.

The Painting of Modern Life explores this critical tendency beginning with photo-inspired works from the early 1960s by artists such as Andy Warhol, Gerhard Richter, Vija Celmins and Richard Artschwager. Spanning five decades, it surveys the different ways that artists have made use of snapshots, news images, family portraits and archival photos as source material for paintings that address the epic as well as the everyday. On one level, their work provides a compelling artistic chronicle of the past half-century, scanning vivid scenes of modern leisure, politics, fashion, war, domesticity and urban life.

At the same time, *The Painting of Modern Life* examines how these artists transformed representational painting into a conceptually-driven practice. Initially growing out of an impulse to find a 'third way' between modernist avant-gardism and traditional forms of figurative painting, the work in this exhibition eschews an emphasis on the subjectivity of the artist and instead stresses our activity of reading images, highlighting processes of translation and interpretation that are shared by painter and viewer alike. In addition, this work provokes us to reconsider the degree to which our pictures of reality are shaped by the visual conventions and codes of particular media. And inasmuch as photography is commonly taken to be an accurate means of picturing the world, these artists confronted photographic images as a way of questioning the means by which we represent reality. Dealing with painting's myriad possibilities as well as its limits, this approach has anticipated a number of key aesthetic strategies and issues central to the development of contemporary art over the pasty 40 years. These range from the appropriation of popular imagery and a concern with examining the mechanisms of mass media to an engagement with questions about the nature of authorship and artistic originality.

But although this work has made a crucial contribution to the recent history of art, its impact and broader significance have been inadequately assessed and at times almost entirely neglected. Indeed, my motivation for organising this exhibition was inspired, in part, by a comment made by the artist Jeff Wall to the effect that the painters of our era had failed to take on the task of depicting the world in which we live. I hope that the images and essays in this book, along with the writings and remarks by the participating artists, offer evidence to the contrary, and can illuminate the importance of this complex and still-evolving dialogue about how we picture the reality and history of our times.

For their immediate and enduring support of this project, I would personally like to thank Michael Lynch and Jude Kelly as well as Southbank Centre's Board of Trustees. From the very beginning they have understood the value of this project and its invitation to our audiences to re-examine scenes of our recent history through the eyes of artists.

The artists' families, studios, estates and galleries have been an essential point of liaison during our preparations, and we thank them all profusely for their constant efforts and rigour: Acquavella Galleries, Inc., New York; Galerie Paul Andriesse, Amsterdam; Gallery Paule Anglim, San Francisco; Gavin Brown Enterprise, New York; Daniel Buchholz Galerie, Cologne; Galerie Gisela Capitain, Cologne; Cittadellarte – Fondazione Pistoletto, Biella; Cohan and Leslie Gallery, New York; Sadie Coles HQ, London; Marlene Dumas Studio, Amsterdam; Foksal Gallery, Warsaw; Frith Street Gallery, London; Gagosian Gallery, London and New York, with special thanks to Bob Monk and Mark Francis; GAM – Galleria Civica d'Arte Moderna e Contemporanea, Turin; museum franz gertsch, Burgdorf; Barbara Gladstone Gallery, New York; Marian Goodman, New York; Hauser and Wirth, London and Zürich; David Hockney Studios, London and Los Angeles; Annely Juda Fine Art, London; Anton Kern Gallery, New York; Christine König Galerie, Vienna; Galerie Gebr. Lehmann, Dresden; Jean Marc Decrop and Galerie Loft, Paris; Peter Gould and LA Louver Gallery, Los Angeles; Luhring Augustine, New York; McKee Gallery, New York; Victoria Miro Gallery, London; Malcolm Morley Studio, New York; neugerriemschneider, Berlin; Friedrich Petzel Gallery, New York; Raster Gallery, Warsaw; Regen Projects, Los Angeles; Gerhard Richter Archive, Dresden; Atelier Gerhard Richter, Cologne; Sonnabend Gallery, New York; Sperone Westwater, New York; Richard Telles Fine Art, Los Angeles; The Andy Warhol Foundation for the Visual Arts, New York; The Andy Warhol Museum, Pittsburgh; Michael Werner Gallery, New York; White Cube, London; Galerie Krobath Wimmer, Vienna; Zeno X Gallery, Antwerp with special thanks to Frank Demaegd and Rose Van Doninck; and David Zwirner, New York.

In addition, indispensable advice and assistance was provided by Janet Bishop, Ivor Braka, Christies London, Camilla Davidson, Dietmar Elger, Regina Fiorito, Vincent Fremont, Aphrodite Gonou, Sotheby's London and Milan, Karsten Schubert and Walter Soppelsa.

This exhibition would not have been possible without the extraordinary generosity of all those who have loaned us important and extremely valuable paintings from their collections. We extend to them our deepest gratitude and appreciation for making these artworks available to the public. (All lending public and private collections and galleries, except for those who wish to remain anonymous, are listed on page 8.)

We are also deeply grateful to the following organisations for their crucial support of this project: Austrian Cultural Forum London; Embassy of Switzerland, London; Goethe-Institut London; Institut für Auslandsbeziehungen e.V., Germany; Polish Cultural Institute, London; and The Red Mansion Foundation, London.

It has been a pleasure to collaborate with Castello di Rivoli, Museum of Contemporary Art, near Turin, Italy, where this exhibition will open in 2008. Castello di Rivoli houses one of the most highly regarded contemporary art collections in Italy and has a programme of international exhibitions to which The Hayward is honoured to contribute on this occasion. I would like to thank its Director Ida Gianelli and Chief Curator Carolyn Christov-Bakargiev for their immediate embrace of this project and their continuing engagement. Our gratitude extends to all their colleagues including Marcella Beccaria, Luisa Mensi, Chiara Oliveri Bertola, Franca Terlevic and Marianna Vecellio.

Many people involved in the production of this catalogue also deserve mention. Firstly, my thanks go to eminent art historian T.J. Clark for allowing us to borrow part of the title of his landmark book, *The Painting of Modern Life: Paris in the Art of Manet and His Followers*. I also wish to extend our gratitude to the contributing authors – Carolyn Christov-Bakargiev, Martin Herbert, Barry Schwabsky and Kaja Silverman – for their insightful essays that shed new light on how 'the painting of modern life' was reinvented by contemporary artists. We are once again indebted to the artists and their estates for permitting us to publish excerpts of previously printed texts and interviews and/or for contributing new interviews to this book. Caroline Wetherilt in Hayward Publishing and her colleagues Charlotte Troy and Deborah Power expertly oversaw the editing, picture research and production of this publication. Allon Kaye's design concept won over our imagination from the start as he patiently developed the design of this book with a sense of adventure and creativity. We also wish to acknowledge the help of Francesco Baragiola Mordini and his team at Skira on the production of an Italian edition of this book.

Theatre designer Michael Vale delighted us all with his inventive and inspired approach to designing the exhibition, which Sam Forster Ltd skilfully realised in the galleries. Our thanks also go to Konrad Watson for lighting the exhibition, to Philip Miles for the exhibition graphics, and to Andrea Gall for diligently surveying the condition of the loans throughout the tour as the Exhibition Conservator. Immense credit is also due to numerous individuals and teams across Southbank Centre for their help. Ed Smith, Ruth Pelopida, Mark King and The Hayward technicians made sure that priceless artworks were expertly handled and installed, while Imogen Winter, Sam Cox and Alison Maun flawlessly organised transport and insurance matters. Helen Luckett developed interpretative materials for the exhibition with an astute combination of scholarship and style. Thanks also go to: Pamela Griffin in The Hayward library and archive for help with research; Honor Fletcher-Wilson and Helen Faulkner and the Marketing and Design Departments; Alison Cole, Sarah Davies, Gillian Fox and the Communications Department; Karen Napier and the Development team; Catherine Mallyon, Tony Wooley, Terry Vickery and Facilities staff; and Melford Deane for legal advice.

In addition, Hayward Deputy Director Laura Stevenson, assisted by Susie Lennette, provided crucial and expert help in countless areas. Rafal Niemojewski organised an ambitious talks programme, and Shân Maclennan's Learning and Participation team developed an exciting series of public programmes to accompany the exhibition. A special thank you goes to poet Jamie McKendrick, composer Tony Hymas, and mezzo-soprano Monica Brett-Crowther for creating (and performing) a unique song cycle inspired by paintings in the exhibition. Their brilliant work was supported by a generous gift from The Eranda Trust Foundation, to whom we are also extremely grateful.

A small handful of people have been dedicated more or less exclusively to this project over the past 14 months. Valuable contributions have been made by interns Melissa Falkenham, Caroline Gaussens, Michelle Greaves and Gabriella Kessler. The exhibition could never have been realised without the skilful work and constant diligence of Assistant Exhibition Organiser Siobhan McCracken. Her predecessors Isabel Finch and Constance Gounod made significant contributions to the early development of the project. Caroline Hancock, who has worked on this exhibition from the very beginning, has won my deep appreciation and respect for her substantial contributions in many different areas, as well as for her thoughtfulness, considered advice and unwavering enthusiasm.

Finally, all of us at The Hayward reserve our most profound gratitude for each of the 22 artists in this exhibition. They have enriched us all by creating inspiring paintings that reinvent our images of the world.

Ralph Rugoff
Director, The Hayward

Lenders to the Exhibition

Public collections

Aargauer Kunsthaus Aarau

Arbeitkammer Wien (Chamber of Labour, Vienna)

The Art Institute of Chicago

British Council Collection

Castello di Rivoli Museo d'Arte Contemporanea, Rivoli-Turin

The Detroit Institute of Arts

GAM – Galleria Civica d'Arte Moderna e Contemporanea, Turin

Kunstmuseen Krefeld

The Metropolitan Museum of Art

Musée d'Art moderne et contemporain de Strasbourg

The Museum of Modern Art, New York

Centre Pompidou, Paris, Musée National d'art moderne/Centre de création industrielle

National Gallery of Art, Washington

S.M.A.K. (Stedelijk Museum voor Actuele Kunst), Ghent

Tate, London

Ulmer Museum, Ulm

Whitney Museum of American Art, New York

Private collections and galleries

Thomas Borgmann, Cologne

The Stephanie and Peter Brant Foundation, Greenwich, CT

Collection Jean-Christophe Castelli

Chadha Art Collection, The Netherlands

Cohan and Leslie, New York

Harold Cook, PhD.

The Cranford Collection, London

Daros Collection, Switzerland

Collection Jean-Marc Decrop, Courtesy Galerie Loft

Devonshire Collection, Chatsworth

Marlene Dumas

Stefan T. Edlis Collection

Sammlung Essl Klosterneuburg/Vienna

Froehlich Collection, Stuttgart

Heide Giesing-Grübl, Hamburg

Galerie Bärbel Grässlin, Frankfurt a.M.

Hauser & Wirth Collection, Switzerland

Hort Family Collection

Estate Martin Kippenberger, Galerie Gisela Capitain, Cologne

Christine König Galerie, Vienna

Kunstmuseum Bern, on permanent loan from private collection, Switzerland

Locksley Shea Gallery

Heinz G. Lück, Hamburg

Collection Ninah and Michael Lynne

Collection Meisel Family

Malcolm Morley

Friedrich Petzel, New York

François Pinault Collection

Collection Pistoletto Foundation

Private collection. Courtesy Ivor Braka Ltd.

Private collection. Courtesy Sadie Coles HQ, London

Private collection. Courtesy Victoria Miro Gallery

Private collection. Courtesy neugerriemschneider, Berlin

Private collection. Courtesy White Cube, London

Private collection on long term loan to L.A.C. Lieu d'Art Contemporain, Sigean

Mima and César Reyes Collection, San Juan, Puerto Rico

Sammlung Rheingold

David Roberts Collection

Sir Evelyn and Lynn Forester de Rothschild

Rubell Family Collection, Miami

The Saatchi Gallery, London

Kathy & Keith Sachs

Sander Collection

Wilhelm Sasnal

Collection Glenn Scott Wright

Sender Collection

Collection of Stanley & Nancy Singer

Collection Stolitzka, Graz

Collection David Teiger

Collection of Guy & Myriam Ullens Foundation, Switzerland

Helen van der Mey-Tcheng

Zeno X Gallery

Together with those who wish to remain anonymous.

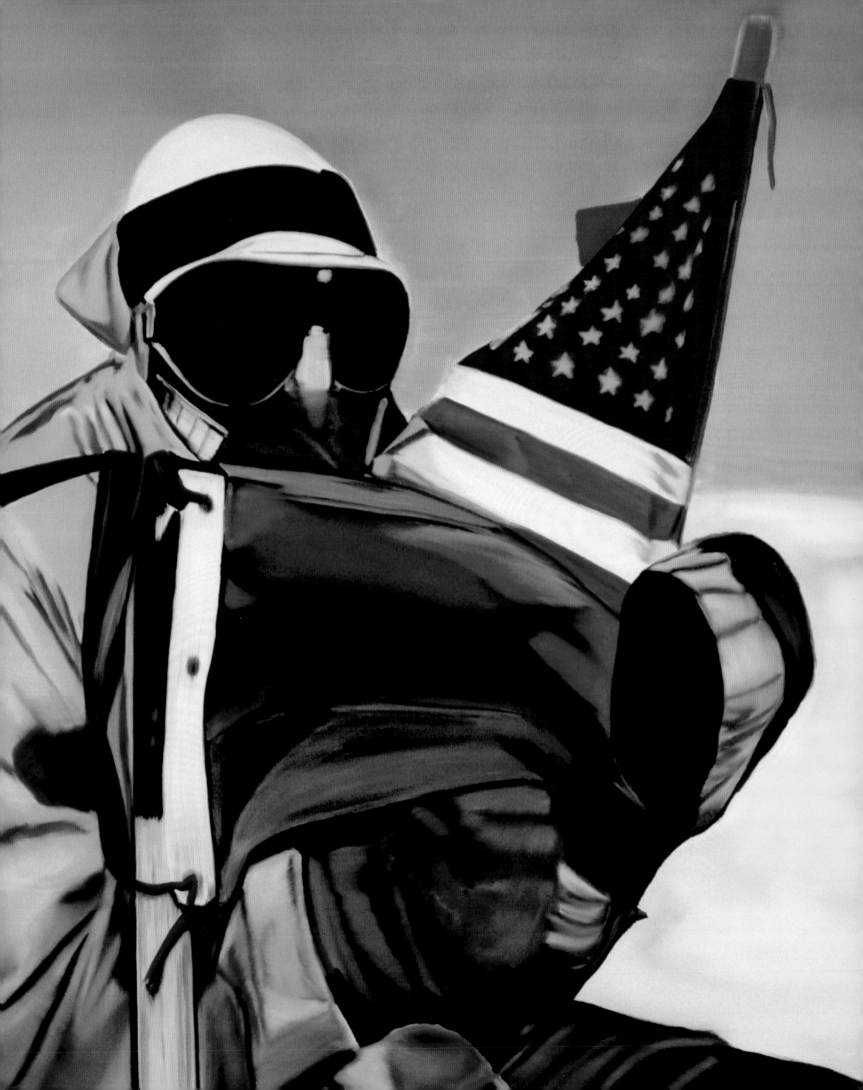

Painting Modern Life

Ralph Rugoff

In the early 1960s, at a time when abstraction still largely dominated serious contemporary art, a small group of artists quietly introduced a major turn in the history of painting. Working independently of one another, Gerhard Richter in Cologne, and Andy Warhol and Richard Artschwager in New York, began making paintings that translated photographic images taken from newspapers, advertisements, historical archives and snapshots. Whereas artists since Eugène Delacroix in the nineteenth century had routinely used photographs as an *aide-mémoire* in preparing compositions, the approach of these artists went beyond using photography as the equivalent of a preparatory sketch or as a resource for pictorial ideas. Instead, their work explicitly addressed the nature of its source material in ways that profoundly explored not only the relationship of painting and photography, but also the nature of how we forge our pictures of 'reality'.

Along with canvases from the early 1960s by Michelangelo Pistoletto in Turin, Los Angeles-based Vija Celmins and New York-based Malcolm Morley, many of these seminal works were executed in grisaille, echoing the black-and-white photography that dominated the mass media of the day. And while these artists employed a variety of techniques, ranging from Warhol's incorporation of silkscreens to Artschwager's use of a textured Celotex ground to the discreetly modulated tonal painting of Richter, Celmins and Morley, all of their pictures maintained a self-evident resemblance to the mechanical reproductions on which they were based. Rather than merely being a servant to painting, in other words, photography – and the culture of images it spawned – became in these works an integral part of the painter's subject.

On a literal level photography provided these artists with the raw data to depict the world around them. 'Photography had to be more relevant to me than art history; it was an image of my, our, present-day reality,' Richter observed in a 1972 interview. 'And I did

not take it as a substitute for reality but as a crutch to help me to get to reality.'[1] Drawing on the vast archive of existing photography, artists were able to re-introduce a broad range of socially-inflected subject matter into the field of painting. Warhol explored the dark side of industrial society with canvases that recycled news images of car crashes and the electric chair, and along with Richter produced portraits of a grief-stricken Jacqueline Kennedy based on photographs taken after the assassination of President Kennedy. Richter's pictures repeatedly referenced the history of the Second World War and its aftermath, including the rise of grim modernist cityscapes and oppressively anonymous housing developments – a subject covered across the Atlantic at roughly the same time by Artschwager. Vija Celmins' *Time Magazine Cover* (1965, p. 70) presented a grisaille image of the news periodical featuring a story on the Watts riots, a major civic conflict in Los Angeles that epitomised the tense state of race relations in the United States. A few years later, Richard Hamilton used a *Daily Mail* photo of his gallerist Robert Fraser handcuffed to Mick Jagger following a drug arrest as the basis for *Swingeing London 67 (f)* (1968–69), a pointed commentary on media sensationalism as well as a wry deflation of the popular image of 1960s London. And in the early 1970s, both Malcolm Morley and Franz Gertsch dedicated monumental canvases to images of the war in Vietnam. Paintings such as these reframed contemporary history in ways that confronted the viewer's attitude towards major events of the day.

Beyond headline news, painters also drew on publicity materials and personal snapshots as the basis for pictures that explored emerging cultural milieus of the 1960s. One of Richter's earliest canvases, the schematic and thinly painted *Folding Dryer* (1962, p. 60), ironically translated an advertising image of a merry housewife with her new portable drying rack. Malcolm Morley's *On Deck* (1966, p. 80) transformed a glossy reproduction from a cruise line brochure into a large, luridly-coloured canvas that satirised bourgeois aspirations for

the 'good life,' as well as the fantasies promoted by mass marketing. Robert Bechtle's paintings, based on snapshots of his own family and environs in the San Francisco area, portrayed scenes of white middle-class American life that seemed quietly haunted by an atmosphere of isolation and sterility. Meanwhile, David Hockney in London and Los Angeles, and, slightly later, Franz Gertsch in Lucerne, Switzerland, drew on their own photographs to create epic portraits of acquaintances in the growing bohemian and gay subcultures of the 1960s and early 1970s. In these paintings, details of clothing, hair styles, physical attitudes and living spaces delineated the rise of an alternative and hedonistic cultural milieu.

This renewed concern with depicting the social landscape was not a matter of seeking to imitate journalistic reportage, however. For all its seemingly styleless style, the work of these artists embodied a sophisticated play with pictorial conventions. It brought to bear on photographic imagery the accumulated memory of painterly traditions, framing the immediacy of contemporary experience within the history of an ancient medium, so that the subject of even the most casual snapshot took on an unexpected gravity when translated to the canvas. In this respect, the approach of these artists comprised a progressive leap backwards, sailing past critic Clement Greenberg's proscriptive formulations that modern painting should be divorced from worldly concerns and imagery to ideas raised by

French poet (and critic) Charles Baudelaire in his 1863 essay 'The Painter of Modern Life'. Baudelaire had described 'the painter of modern life' as dedicated to depicting the fast-changing landscape of modern life – capturing images of the 'transient, the fleeting, the contingent' and 'extract(ing) from fashion that poetry that resides in its historical envelope.'[2] At a moment when art was still largely engaged with treating time-honoured themes (mythology, ceremonial history, religious scenes) in terms that drew on established aesthetic decorum, Baudelaire's call for painters to focus on the world around them was relatively novel. Most importantly, he championed a mode of painting that, rather than compete with photography, would instead fuse reportage with the 'high philosophical imagination' of fine art.

Almost 100 years after the publication of Baudelaire's essay, the work of Warhol, Richter, Artschwager et al, seemed to offer a significantly updated version of the poet's schema for a contemporary history painting. Inasmuch as 'the painter of modern life' explores and confronts his times, rather than merely reflects them, it was no mere irony that their pictures were translations of photographic images. Indeed, what was truly timely about their approach was its dual focus: their paintings not only addressed the world in which they lived but also the phenomenon of how it was represented. Beyond forging a telling chronicle of the times, these artists proposed that painting

Photo source for Richard Hamilton, *Swingeing London 67 (f)*, 1968–69 (cat. 33, reproduced right)
Detail from Richard Hamilton's photo collage, *Swingeing London 67*, 1967–68

David Hockney
The Room, Manchester Street
Acrylic on canvas
304.8×213.4 cm

could constitute a means of thinking about the making and reading of images as a paramount activity of modern life. Thus the evolution of their work is also the story of how representational painting was transformed into both a conceptual practice and a platform for probing the social and cultural histories of our mass media age.

Anticipating many key aesthetic concerns of the next four decades, this approach to painting initially grew out of an impulse to find a 'third way' between traditional modes of pictorial representation and modernist avant-gardism. In the art world of 1960, the latter was still largely unchallenged. The idea that advanced painting had to be abstract and divorced from worldly imagery dominated critical thinking – a position articulated most forcefully by Greenberg. 'A modernist work of art must try, in principle, to avoid communication with any order of experience not inherent in the most literally and essentially construed nature of the medium,' Greenberg had declared. 'Among other things this means renouncing illusion and explicit subject matter.'[3]

In part, this aversion to representation grew out of the long history of painting's relationship to photography, and to the notion – voiced shortly after the latter's invention – that serious painting must inevitably concede the task of straightforward depiction to the camera.[4] But for artists in the early-to-mid 1960s, painting from photographic sources offered an escape route from what had become a limiting formalist end game. Figuration – considered regressive if not reactionary since the critical triumph of abstract painting in

the 1940s – was seized upon by these artists as a means of resistance to modernism's linear 'progress'. Indeed, by choosing to translate photographic imagery into paintings, artists sought to free themselves from modernism's relentless emphasis on formal invention. Whereas 'painterly' issues of composition, colour relationships and handling had previously been seen as central concerns of their medium, and the basic materials of forging a heroic artistic signature, these artists cultivated a neutral, self-effacing style that was conspicuously low-key and distinguished their work not only from the dramatic gestures of Abstract Expressionism but also from the snazzy graphic punch of Pop art. Devoid of affectation, their work emphasised its information content, foregrounding the importance of the image and placing the artist's subjectivity in the background. If Abstract Expressionism had valorised the artist's inner life as a wellspring of creativity, these painters – along with their Pop peers – followed the lead of Jasper Johns, whose target and flag paintings of the late 1950s had utilised 'objective' or pre-existing images that, in historical terms at least, had nothing to do with the rhetoric of existential identity.

Pop art, developing at roughly the same moment, followed a similar tactic of presenting images of mass-produced images. But in contrast to the slick commercial vocabulary appropriated by most Pop artists, Richter, Artschwager, Celmins, Morley and Warhol (at least in his 'Death and Disaster' series) based their far more sober pictures on images of everyday life that were redolent with allusions to the contemporary social environment as well as recent history. And compared to Pop's ironic celebration of commercial culture, their choice of imagery as well as their style of depiction struck a decidedly unheroic note. Pictures ranging from Celmins' 1966 windshield vista of a Los Angeles freeway (*Freeway*, p. 74) to Artschwager's contemporaneous depictions of nondescript offices and factories (e.g. *Office Scene*, 1966, p. 66, and *Fabrikhalle*, 1969, p. 64) are infused with a dismally comic banality. Yet these artists regarded the banal as being far from trivial: just as the ordinary may often be a cover for something else, in their eyes banality was a potentially rich and revealing vein of anthropological data. In addition, a number of works by these artists expressed a sympathetic attitude toward what Artschwager called 'the pathos of photography'.[5] Considered in all its lowly incarnations – cheap newspaper reproductions, tourist postcards, publicity materials – the photograph had become

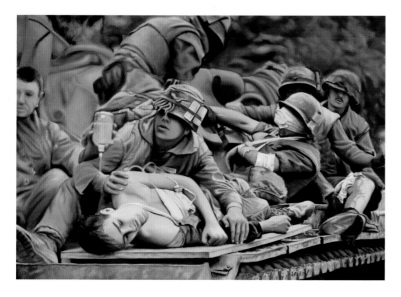

Franz Gertsch
Vietnam, 1970
Dispersion on unprimed half-linen
205×290 cm

the pictorial equivalent of a weed, a devalued and routinely over-looked cultural artefact. 'Perhaps … I'm sorry for the photograph,' Richter once remarked in explaining his work. 'I would like to make it valid, make it visible.'[6] Thus their project of recuperating the banal included not just the subject matter found in photographs, but aspects of photographic reproduction itself that were left unscrutinised by Pop art's iconic treatment of common objects.

New art evolves not only in reaction to the achievements of a preceding generation, but also in response to the cultural landscape of the times. By the early 1960s, photographic media had become a conspicuously pervasive, even overwhelming, aspect of contemporary life. Artists found themselves working amidst an explosion of reproductions and images in comparison with which first-hand experience seemed to diminish in importance. 'Cinema, television, magazines, newspapers immersed the artist in a total environment and this new visual ambience was photographic,' Richard Hamilton observed at the time. 'Somehow it didn't seem necessary to hold on to that older tradition of direct contact with the world. Magazines, or any visual intermediary, could as well provide a stimulus [for making pictures].'[7] By using photographic sources, artists tacitly acknowledged that it no longer made sense to isolate the making of pictures from the dizzying plenitude of mechanically reproduced images, and to varying degrees their work explored how this ubiquitous medium was altering our ways of seeing.

Over the years, many critics have argued that this approach to painting was primarily concerned with interrogating the documentary status of photographic media as well as the mediated nature of contemporary experience. In fact, only a relative handful of paintings produced by these artists explicitly engaged in this kind of critique.[8] One such work, Richter's *Volker Bradke* (1966, p. 63) persuasively portrays what appears to be a newspaper image of a

young leftist leader surrounded by followers and posters, conjuring the type of protest movements then spreading across Europe and the United States. The painting was, in fact, based on a photograph Richter took of a friend at an arts festival, and so, as an exercise in duplicity, equates our faith in the credibility of photographic realism with a naïve willingness to follow ideological icons.[9]

For the most part, however, this kind of painting was principally engaged with deconstructing a traditional understanding of 'realism'. Towards this end, the most fertile emphasis of this work was on the activity, and consequences, of translating imagery from one medium to another. Rather than simply drawing on photography as a source of subject matter, these artists were interested in examining how the meaning and information content of a photographic image inevitably changes when it is reinvented as the subject of a canvas. By mixing painterly and photographic codes to create complex and contradictory sets of pictorial signs, their work unsettled preconceptions about both media while probing the role played by codes and conventions in forging our perception and understanding of the world.

In other words, these artists were motivated by a desire to blur the line between existing categories of depiction, along with the values attendant to each of them. Hamilton summed up this position in a 1968 article on painting and photography by remarking, 'I felt that I would like to see how close to photography I could stay yet still be a painter in intent.'[10] On the most literal level this blurring of categories took the form of conflating signs of the handmade and the mechanical,

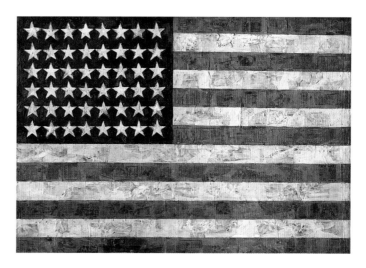

Jasper Johns
Flag, 1954–55
Encaustic oil and collage on fabric
mounted on plywood (3 panels)
107.3×153.8 cm

13

a tactic pioneered by Warhol's silk-screening of photographic imagery directly onto canvas. Taking up Warhol's example, Richter developed his technique of feathering a wet brush over the surface of a painting to smear or 'blur' the underlying image in order to mimic the variable focus of a photograph. Other artists such as Franz Gertsch meticulously reproduced photographic effects such as the artificial light created by flash bulbs and the flattening of pictorial space while conjuring mechanical enlargements with the heroic scale of their paintings. Through all of these approaches, artists conflated the appearance of the infinite reproducibility of photography with the finite, unique status of the art object, creating a hybrid form that simultaneously evoked public and private, the plural and the singular. As psychologist (and LSD pioneer) Timothy Leary remarked of Gertsch's paintings, these works wed 'the subjective personal aura of the handmade artefact to the clarity of the photograph.'[11] In that unsettling mix – in which the conventions of both media were equally estranged– one could perhaps discern an allusion to an ongoing crisis of definition that then beset traditional ideas of individuality and identity; for example, the ambiguous 'reality' of Gertsch's paintings seemed to mirror that of Lucerne's gender-crossing youth culture, the subject of some of his key works from the early 1970s.

The temporality of these pictures was also provocatively ambiguous. Photography, which records an impression made from the light reflected off physical objects, is conventionally seen as having a direct, or indexical, relationship to reality. The scene it depicts is tied to a specific and irretrievable moment in time. Representational painting, on the other hand, makes no claim on reality beyond that of creating a likeness of its subject. Its subject exists not in a frozen moment of past time, but in an unfolding present. Thus a painting of a photograph would seem to automatically short-circuit the indexical status of its source. But in the paintings made by these artists, the contradictory temporal values of these two media were disarmingly merged. They mixed the present-tense corporeality of the canvas with the removed and disembodied character of the photograph, engaging us in an elusively shifting experience of time and physical presence – an encounter that echoed the confusions between first and second-hand experience engendered in a media-saturated culture. They conjured, in other words, a kind of post-modern temporality inflected by currents of reference and repetition, and in which images of the present were inevitably permeated with a sense of *déjà-vu*.

In purely visual terms, the most disorienting aspect of this approach to painting was the way it conflated flatness and illusionism. One of the consequences of working from photographs, which offer a unified consistency of detail, was that artists gave equal attention to every part of the canvas' surface. Echoing the 'all-over' composition of Jackson Pollock's Abstract Expressionism and Jasper Johns' targets and flags, their works effectively lacked a centre of attention. This levelling or equalising of the painting's surface resulted in a pictorial flattening that obscured the separation between figure and background so that the objects no longer either dramatically jumped out from the picture plane or receded into an illusionary depth. In works by a number of artists, including Richter, Celmins, Hockney, Hamilton and Morley, the image was also occasionally framed by a white border (sometimes an allusion to the border of a snapshot), which further heightened the tension between the canvas' surface and the recessive space of the image. But rather than seeking, in the tradition of Paul Cézanne, to ultimately affirm the flatness of the image's support, this approach to painting produced a pulsating stereoscopic space, vertiginously alternating between depth and surface, that kept the viewer's perception in a constant state of flux. Celmins, commenting on her own practice in terms that also apply to that of her peers, explained that she was interested 'in that constant tension and shifting between the feeling of depth and a strict adherence to the reality of the two-dimensional plane ... when these two are in a certain balance I perceive a projection of another kind of space. It is this which I find exciting.'[12]

With their non-hierarchical composition, in which objects were treated without any distinction between their importance so that a background detail might be accorded the same amount of attention as a face, these paintings suggested a pictorial equivalent of the *nouveau roman* pioneered by Alain Robbe-Grillet (an author in whom Celmins was particularly interested). In comparing Morley's work to the *nouveau roman*, art historian Arnold Hauser (who was briefly a

colleague of Morley's at Ohio State University) pointed out how the artist's method of using a grid system, where each subdivided area of the canvas was painted independently, created a paradoxical effect that destabilised the apparent unity of the image. 'The progressive addition of one particle after another intercepts a figurative perception of the painting and de-individualises its parts' – an effect that highlighted the abstraction of the actual photographic source.[13] The perceptual schizophrenia engineered by these works was further augmented, particularly in the large-scale, Ektachrome-like paintings of Morley and Gertsch, by their meticulous magnification of small photographic reproductions, so that the intimacy of the source material was uncannily preserved at the scale of history painting.

Though often subtle enough to pass under the radar of conscious perception, these various optical strategies produced a net effect of infecting seemingly straightforward images with a disarming disequilibrium. The key to achieving this result was the manner in which artists, in translating photographic imagery into paintings, managed to preserve a near-perfect tension between the visual rhetoric of parallel pictorial systems. 'These works do not rest on a secure, one-directional reference, but fluctuate between source and transformation, between one sign system and another,' as Lawrence Alloway observed of Morley's paintings. 'In place of wonder we are given uncertainty, but both states of feeling have to do with a mobile rather than a fixed subject matter.'[14]

Morley himself described this effect in terms that reflected the counter-culture ethos of the late 1960s. 'If what the viewer is experiencing far away is totally different to what is going on up close, then something is happening in them, not in the picture. They're actually having hallucinations. Painting that doesn't hallucinate is not painting.'[15] Morley's reference to hallucination, as well as the uncertainty described by Alloway, directly link the effect of this work to the notion of the uncanny, leading us to the surprising revelation that, in its second coming, the painting of modern life sought to portray contemporary history with one of the primary tools of Surrealist art.

Uncanniness can be understood as the effect produced by a familiar object that has been rendered suspect or inexplicably strange, and so provokes an anxious confusion about its status. Rather than pioneering

new formal languages, the Surrealists had characteristically made use of conventional representations of reality – including photography and realist painting – that they then defamiliarised by various means. But while Salvador Dalí and René Magritte played on the contradiction of depicting dream-like scenes in a realistic manner, the artists mentioned above undermined the conventions of realism in a far less obvious fashion. Painters like Celmins, Morley, Bechtle and Gertsch managed to imbue a sense of enigma and ambiguity in everyday images of unblinking precision and clarity. Rather than conjuring another kind of reality, their work seemed to denature our most fundamental means of picturing the objective world: photographic realism.

This uncanny depiction of the photographic could be seen as challenging our very ability to grasp the real. Remarking on this phenomenon, Richter noted that photography is 'what everyone believes in nowadays: it's "normal". And if that then becomes "other", the effect is far stronger than any distortion of the sort you find in Dalí's figures or Bacon's. Such a picture can really scare you.'[16] What is 'scary' about such pictures is the way they undo the formal categories and definitions with which we make up our image of the world around us. They imply not only that realism, whether in photography or painting, is merely a style, an artificial and arbitrary rhetorical convention, but also that the 'reality' it claims to depict is merely a discursive category, rather than something that we have direct access to. A fundamental alienation thus characterises our

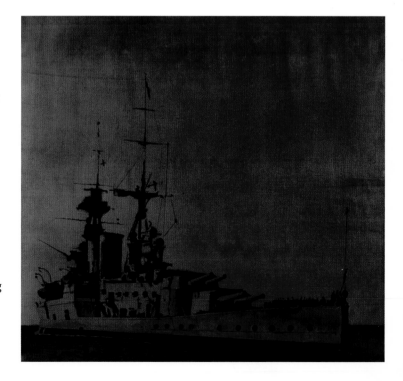

Malcolm Morley
HMS Hood (Friend), 1965
Liquitex and ink on canvas
106×106 cm

relationship to our pictures of the world, which we produce by translating and interpreting interlocking systems of signs, each of which frames 'objective' reality in different terms.

The great discovery of these artists was to find a means of delineating this intellectually complex puzzle by mixing up the codes of two types of realism. Rather than focusing on imagery *per se*, their work called attention to the fact that the meaning of pictures, and indeed of all that we perceive, is largely framed by contingent conventions, rather than timeless formal laws. Again, Richter eloquently sums up the situation: 'Life communicates itself to us through convention and through parlour games and laws of social life. Photographs are ephemeral images of this communication – as are the pictures that I paint from photographs. Being painted they no longer tell of a specific situation, and the representation becomes absurd.'[17] The photographic representation becomes 'absurd,' or uncanny, precisely because it has been translated into a medium where its indexical status and corollary 'truthfulness' is commingled with the conventions of a competing sign system. The result denatures our reading of both media, and underscores the artificiality of how we look at both realist painting and photography as faithful representations of the world.

In the hands of these artists, then, resemblance became a means of unsettling the familiar and the recognisable, rather than reaffirming the known. But their strategic intent went beyond a critical deconstruction that denied the universality of any particular sign system or medium. It also involved an attempt to open up the field of representation to encompass contradictory and multiple readings. As Hamilton noted of his own approach, 'It's an old obsession of mine to like to see conventions mix ... [they] multiply the levels of meaning and ways of reading.'[18] Instead of cancelling each other out, the competing conventions in these pictures create a productive uncertainty that invites us to continually renegotiate how we look at and think about them.

In presenting pictures that have already been 'read' – interpreted and modified from their original state – these artists also connected their own work to our activity as viewers. Their art joins us in a linked enterprise of interpretation whilst insisting that a work's meaning emerges from a process of reading as much as from making.

Underlying this approach is the idea, derived from Marcel Duchamp's 'ready-mades', that artistic creation can be a matter of altering existing material rather than creating from scratch (an attitude that, in part at least, reflects an engaged response to the teeming abundance of objects and images produced within consumer societies). At the same time, the process of transforming an image's significance through a modest modification highlights the contingency of how we assign meaning to pictures, and also calls into question our understanding of art's conceptual underpinnings. 'I remember being inspired to imagine what is art if you remove all of these [traditional elements],' Celmins commented of her pared-down approach to painting from photographs. 'What was left was a kind of poetic reminder of how little a work of art really is art, and how elusive it is to chase that part that excites you and turns one thing into something else.'[19] Bereft of grandiose distractions, this kind of painting invites us to chase the play of those elusive mechanisms in our own thinking as well.

Ultimately, rather than receiving a death sentence from the camera's invention, painting encompassed photography to redefine and extend its conceptual reach. The great irony of this development is that, in an era of instant media, painting's resilience has been intricately linked to its slowness as a medium. Not so much in the sense that it takes time to make a painting (as opposed to the fraction of a second needed to take a photograph), but in the sense that its more nuanced and variegated surface invites the eye to linger, to scrutinise the hundreds of contacts between brush and canvas. Compared to a photograph's slick and uniform flatness, the layering of information in a painting – with its under-drawing, its washes and built-up levels of paint, its complexly mixed colours – requires far more time to process. Drawing on these traditional elements of craft to critically decelerate our reading of the familiar, this approach to painting managed to instil a crucial delay in our response to overexposed photographic imagery. It thus opened up a space for re-evaluating the meaning of our mass-produced pictures of modern life, and for reinvesting feeling into images whose affect has been drained through repetition. Only by exploiting its slowness, then, were these artists able to reinvent a radical role for painting. Their legacy, developed by succeeding generations, reveals how painting, far from being an irrelevant cultural antique or mere commodity in the marketplace, continues to be an indispensable medium for confronting and understanding images of the times in which we live.

Richard Hamilton
Whitely Bay, 1965
Oil on photograph laid on panel
81×122 cm

Notes

1 Gerhard Richter, 'Interview with Peter Sager', in *The Daily Practice of Painting: Writings 1962–1993*, Hans-Ulrich Obrist (ed.), Thames & Hudson, London, 1995, p. 66.

2 Charles Baudelaire, 'The Painter of Modern Life', in *The Painter of Modern Life and Other Essays*, Jonathan Mayne (ed. and trans.), Phaidon Press, London, 1964.

3 Clement Greenberg, 'Sculpture in our time', 1958, in '*The Collected Essays and Criticism, vol. 4*, John O'Brian (ed.), The University of Chicago Press, Chicago, 1993, p. 56.

4 Indeed in 1839, in response to the invention of the daguerreotype, academic painter Paul Delaroche became the first of many to prematurely announce the death of painting.

5 Richard Artschwager and Frédéric Paul, 'Conversation, 14 April, June–July 2003', in *Richard Artschwager*, Domaine de Kerguéhennec, France, 2003.

6 Gerhard Richter, *The Daily Practice of Painting*, op. cit., p. 33.

7 Richard Hamilton, 'Photography and Painting', in *Studio International*, March 1969, p. 120.

8 See, for example, Jerry Saltz, 'The Richter Resolution', and 'Photo finish: Calling for a four-year moratorium on a fashionable, far too overworked trend', in *Village Voice*, 5 March, 2004; and Robert Storr, *Gerhard Richter. Forty Years of Painting*, The Museum of Modern Art, New York, 2002.

9 Richter's *Volker Bradke* comprised the central element of an exhibition devoted entirely to the figure of Bradke held in 1966 at the Gallery Schmela in Cologne, where the painting was accompanied by photographs and an out-of-focus film of Bradke.

10 Richard Hamilton, op. cit.

11 Timothy Leary, 'Timothy Leary about Franz Gertsch', in *Franz Gertsch*, Kunstmuseum Luzern, Lucerne, Switzerland, 1972, unpaginated.

12 Vija Celmins, in Susan Larsen, 'A Conversation with Vija Celmins', in *Journal*, The Institute of Contemporary Art, no. 20, October 1978, p. 37.

13 Jean-Claude Lebensztejn, *Malcolm Morley: Itineraries*, Reaktion Books, London, 2002, p. 48.

14 Lawrence Alloway, 'The Paintings of Malcolm Morley', in *Art and Artists*, February 1967, pp. 16–19.

15 Robert Storr, 'Let's Get Lost: Interview with Malcolm Morley', in *Art Press*, May 1993, pp. 3–7.

16 Gerhard Richter, 'Notes, 1964–1965,' in *The Daily Practice of Painting*, op. cit., p. 30.

17 Ibid, p. 31.

18 Richard Hamilton, op. cit.

19 Vija Celmins, in Lane Relyea, Robert Gober, Briony Fer, *Vija Celmins*, Phaidon Press, London, 2004, p. 123.

Photography by Other Means

Kaja Silverman

In a 1986 conversation with Gerhard Richter, art historian Benjamin Buchloh suggested that there is something contradictory about the fact that Richter produces figurative as well as abstract paintings. The artist responded, 'I don't really know what you mean by the contradiction between figurative and abstract painting.'[1] This is an astonishing claim, particularly given the fact that Richter bases his figurative paintings on photographs. What is abstraction, if not one long assault upon figuration? And what is photography, if not the primary medium through which figuration has fought back?

An abstract painting, we have been taught, is autonomous. It does not stand for something else; it is, rather, a thing unto itself. Its essence also resides in its material properties. It helps us to locate this essence by turning insistently back upon itself – by being reflexive or self-conscious. Finally, an abstract painting is flat; it abolishes the perspectival illusion of three-dimensional space. The photographic image, on the other hand, offers a representation of something else. It generally does so iconically – by providing a 'likeness' of the latter. But even when a photograph does not offer an intelligible image, it points stubbornly outward, since it depends for its existence upon the transmission of light between a material form and the camera. Last, but not least, the photographic image draws upon the system of perspective in order to project a three-dimensional space. As a result, it often seems to be 'transparent' – to open directly onto the world.

Because of the radicality of these divergences, one is inclined to dismiss Richter's claim as a simple provocation. But the painter is not sparring with the critic; as his art-practice consistently shows, he really doesn't see abstract painting and photographic figuration as contradictory forms. This is not because he is blind to what distinguishes them from each other, or ignorant of the battles that have been fought on their behalf. It is, rather, because differences do not translate into oppositions for Richter. He has a profound aversion to binary formulations, both within the domain of politics

and that of art, and he cannot encounter one without attempting to dismantle it. In 1961, he crossed the boundary separating East and West Germany – a boundary that in the same year hardened into a wall. And in the early 1960s, Richter began bridging another divide: that separating abstract painting from photographic figuration. He did so by painting canvases based upon photographs, and then – while the pigment was still wet – working over their surfaces with a squeegee.[2] The works that resulted from this two-step process, which Richter calls his 'photo pictures', are often experienced by their viewers as 'blurs'. This is in part because they soften outlines and eliminate many of the details available in the original image. But the indeterminacy of many of Richter's photo pictures also has another source: they bring together abstract painting and photographic figuration without abolishing the distinction between them. They are consequently invitations to see double.

Unholy as this alliance may seem, Richter was not the first to bless it; Andy Warhol married abstract painting to photographic figuration one year before Richter painted *Mouth* (1963), the first of his photo pictures. The double vision for which Warhol is most famous is, however, ironic in nature. In early silkscreens like *192 One Dollar Bills* (1962) and *Thirty Are Better Than One* (1963), the American artist uses painting to establish a bemused distance from photography, and photography to do the same with painting. And although this is a reversible relationship, and one in which the partners can switch positions at a dizzying speed, it is not equal; one term always passes ironic judgment on the other. Richter went through a brief phase as a Pop artist, but he soon stopped passing this, or any other kind of judgment. The duality at the heart of most of his photo pictures is non-hierarchical – a relationship between equals. Each also points toward, and finds itself within, the other. The artist described how this relationship works in a 1965 note: 'Like the photograph I make a statement about real space, but when I do so I am painting, and this gives rise to a special kind of space that arises from the

Gerhard Richter
Motorboat, 1. version, 1965
Oil on canvas
170×170 cm

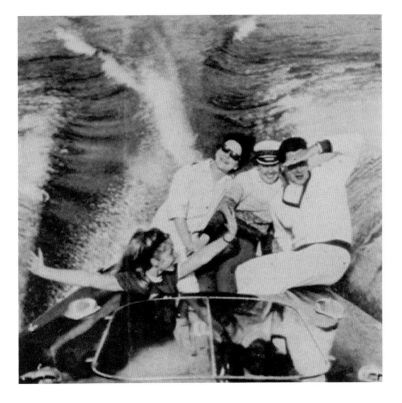

interpenetration and tension between the thing represented and the pictorial space.'[3]

The first version of *Motorboat*, a photo picture from the same year, provides a particularly striking example of this 'interpenetration' and 'tension'. The photograph from which it derives shows four people speeding across a lake in a motorboat. Their clothing indicates that they are wealthy and on holiday, and their gestures and smiles show how delighted they are to be rich vacationers. But their emotional display is so theatrical that it is ripe for parody, and Richter does not fail to take advantage of this in the painting he produces from it. With his blurring utensil, he broadens the smiles on the faces of the human figures, transforming them into caricatures of themselves.

The attentive viewer is likely to remain standing in front of this canvas a long time after he or she 'gets' this 'joke', though, because it combines two different kinds of space. In the photograph with which the painting is in dialogue, the choppy waves produced by the boat stretch out behind it, as a kind of receding prospect. They thus convey a powerful sense of three-dimensionality. The waves also have a prominent place in *Motorboat*, but by working them over systematically with his squeegee, Richter both de-articulates them and foregrounds the texture of the paint. This has a flattening effect upon the aquatic prospect. The artist also softens the outlines and details of three of the human figures. However, he leaves the head and torso of the woman in the foreground of the photograph largely untouched, so that she continues to seem closer to us than the other figures. As a result, *Motorboat* does not abolish depth-of-field. Instead, it makes room within the same canvas for two- and three-dimensionality. The waves are simultaneously 'behind' and 'above' the speeding boat and its human occupants, something that makes for an unsettling – but also a highly pleasurable – viewing experience.

Most of Richter's works reproduced in this book do not even promote this degree of merriment. They also make it harder to say where photography ends and painting begins. Unlike Warhol's depictions of Brillo pads and Campbell's soup cans, the object in Richter's *Folding Dryer* (1962, p. 60) is not a full-fledged commodity. It lacks 'name recognition', so it cannot be evoked through its packaging, and there are no secondary gains to be realised from purchasing such a humble object. Those responsible for the advertisement have

consequently mobilised an antiquated notion – 'use-value'. Richter does not pull rank either on the advert or the folding dryer; he adheres closely to the source photograph in his painting of it, and he suggests that the object really is 'useful' by cropping off everything below the sentence in which this word appears. In *Woman with Umbrella* (1964, p. 58), he shields a grieving Jacqueline Kennedy from the glare of media publicity by turning her into an anonymous woman; making her emotions unreadable; and drawing a delicate veil over her body with his squeegee. In *Nurses* (1965, pp. 21, 62), Richter corresponds with the window slats in the back of his source photograph through the horizontal strokes of his blurring device. He also uses this technique to harmonise the women with their environment and bind them even closer together.

Richter does more than dismantle the opposition between abstract painting and photographic figuration; he also bridges the gap separating art from the world. He accomplishes both of these undertakings in the same way: by creating analogies. I take the word 'analogy' from Richter himself, who uses it often in his interviews and writings.[4] It is his name for a special kind of relationship, and one that

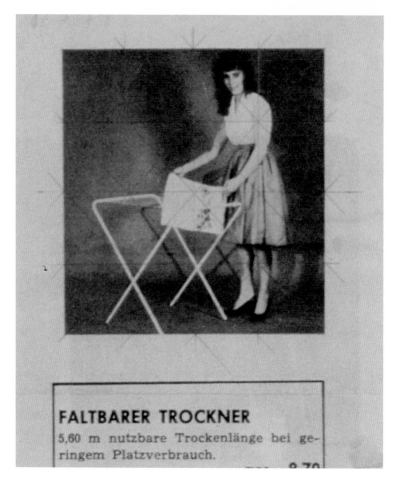

FALTBARER TROCKNER
5,60 m nutzbare Trockenlänge bei ge-
ringem Platzverbrauch.

has become more capacious with each new development in his art-making. An analogy brings two or more things together on the basis of their lesser or greater resemblance. I say 'lesser or greater' because although in some of Richter's analogies similarity and difference are evenly balanced, in others similarity outweighs difference, or difference, similarity. But regardless of the form they take, these couplings neutralise the two principles by means of which we are accustomed to think: identity and antithesis. As Richter helps us to understand, an analogy is a very different thing from a metaphor. The latter entails the temporary substitution of one thing for another. This is a profoundly undemocratic relationship, not only because the former is only a stand-in for the latter, but also because it has only a provisional reality. In an analogy, on the other hand, both terms are on an equal footing, ontologically and semiotically. They also belong to each other at the most profound level of their being. Richter does not produce them; rather, he waits for them to emerge. 'Letting a thing come, rather than creating it,' he writes in a note from 1985, 'no assertions, constructions, inventions, ideologies – in order to gain access to all that is genuine, richer, more alive: to what is beyond my understanding.'[5]

Richter grew up in a world of stark oppositions. Shortly after crossing the border separating East and West Germany, he was confronted with another set of polarities. The antinomies that were his daily bread in East Germany were of course those distinguishing it from West Germany – communism versus capitalism, and Eastern Europe versus Western Europe. Those he was asked to digest after settling in the West were internal to West Germany; they pitted the generation who grew up after the Second World War against those responsible for it, and Leftists of all stripes against the State, the military and the social and economic establishment. Richter's response to this 'either/or' thinking, which he calls 'ideology', was to debinarise difference. He turned for this purpose not just to analogy, but to a particular kind of analogy: one in which there is the smallest possible difference. He found the model for it in photography.

This might seem a baffling claim. The 'logos' in 'analogy' links the latter firmly to language and reason. Everyday usage does the same; we turn to analogy when we want to clarify an obscure point, or establish the structural equivalence of two or more things. Photography, on the other hand, is a visual form, and one appealing more to belief than to reason. The ways in which this medium has been theorised also make it difficult to see how it could perform the role Richter attributes to it. For 'realists', like French film critic André Bazin and the late French philosopher and critic Roland Barthes, a photographic image is a trace of, and perhaps even ontologically identical with, what it depicts; there is consequently insufficient distance between the two for them to constitute an analogy.[6] Those who distinguish between the two, on the other hand, generally do so absolutely. No matter how closely a photograph approximates its referent, it is ultimately a separate entity; whereas the second of these terms is real, the first is 'only' a representation. And the more striking the resemblances between a photograph and its referent, this argument goes, the more emphatically we must distinguish between them, because there is no more powerful form of ideological mystification than similarity.[7]

In Richter's view, however, the photograph inhabits the same world as its referent – the world of forms. Neither takes priority over, or constitutes a replacement for, the other; instead, the two relate the same way all other forms do: by corresponding with each other. The correspondences between a photograph and its referent are extraordinarily abundant – so much so that one can be seduced into believing that if the former were enlarged, it would match up point-

for-point with the latter. This does not mean, however, that the photograph is a false pretender. It means, rather, that it is photography's essence to be '*almost nature*'. The small but decisive difference that separates it from the referent is also not a defect, but rather the precondition for relationality. Although it is through their resemblances that the two correspond, it is only because they are at the same time distinct from each other that they are able to do so. It is also only by turning to one that we can approach the other.

Part of what drives Richter to paint his photo pictures is his desire to show us the marginal difference separating a photograph from its referent. As he wrote in the mid-1960s: 'Perhaps because I'm sorry for the photograph, because it has such a miserable existence even thought it is such a perfect picture, I would like to make it valid, make it visible – just *make* it.'[8] But by rendering the special kind of analogy that links a photograph to its referent visible, Richter also teaches us to think another way about other kinds of difference. As should be evident by now, it is through an implicitly photographic analogy that the artist brings together abstract painting and photographic figuration. He begins his photo pictures by painting a figurative analogue of a photograph. He then uses a blurring device to produce an abstract analogue of this figurative analogue. Whereas the second of the analogies I have just described operates within the frame of the photo picture, the first links the photo picture to something outside itself, just as a photograph does. The resulting canvases consequently do even more than analogise abstract painting and photographic figuration; they also analogise photography's own way of analogising. It is for this reason, I believe, that Richter claims to paint like a camera.

The analogical value of the photographic image is not exhausted once we have explored its relationship to its referent. It moves through time, in search of other 'kin'. Although these analogies are not of our making, they remain latent until we recognise them. Fortunately for us, photographs do not passively await this recognition; instead, they actively solicit it by, as Richter says, dropping 'onto our doormats', like advertising flyers.[9] This is another of the reasons why they are so important for Richter, and why he emphasises both their agency and their authorlessness. The kinds of analogies I have just described closely resemble what Walter Benjamin calls 'dialectical images'.[10] They connect our present to specific moments from the past. They also do so in the face of powerful opposition; we do not want to acknowledge the affinities upon which they insist. Our resistance strengthens the link between us and our predecessors, since what we call 'history' has been one long refusal to open the book of life.[11] Over the centuries, the pile of unacknowledged analogies has grown ever higher, impeding our vision and our capacity to change.

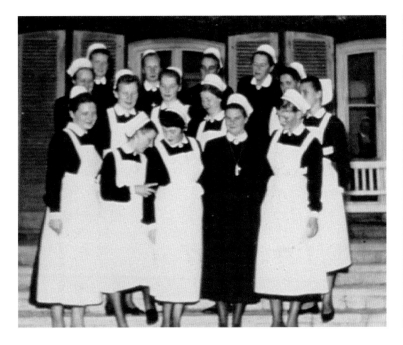
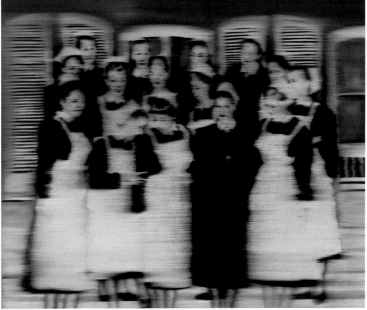

Photo source for Gerhard Richter,
Nurses, 1965 (cat. 88, reproduced right)
From Gerhard Richter's *Atlas*

But although the past prefigures the present, it does not predetermine it. It shows us not who we are, or even who we will be, but rather who we are in the process of becoming. It does so in the hope that we will prevent this particular analogy from being realised. If we do so, we will not only free ourselves from the repetition compulsion of history, but also change the 'specific character' of the past by generating an altogether different analogy.[12] It is to this mysterious reciprocity between what is, and what has been, that Benjamin refers when he writes: 'The past carries with it a temporal index by which it is referred to redemption. There is a secret agreement between past generations and the present one. Our coming was expected on earth. Like every generation that preceded us, we have been endowed with a *weak* Messianic power, a power to which the past has a claim.'[13]

There are some important differences, though, between Benjamin's notion of redemption and Richter's. Benjamin wrote the above words in the mid-1930s, when it was still possible to think of a generation as a possible engine for social redemption. By 1988, this illusion had been utterly dissipated – as much by the events of the 1960s and 1970s, as by those of the 1930s and 1940s. It had become painfully evident that the force from which the past needs to be rescued is not social or economic, but rather psychic in nature. This force is what Sigmund Freud called the 'death drive', and it threatens us from the inside, as well as the outside.[14] In 1986 Richter wrote: 'Crime fills the world, so absolutely that we could go insane out of sheer despair' – a passage that could have been lifted directly out of Freud's book *Civilization and its Discontents*. Richter continued: '(Not only in systems based on torture, and in concentration camps: in civilized countries, too, it is a constant reality ... Every day, people are maltreated, raped, beaten, humiliated, tormented and murdered – cruel, inhuman, inconceivable.) Our horror, which we feel every time we succumb or are forced to succumb to the perception of atrocity ... feeds not only on the fear that it might affect ourselves but on the certainty that the same murderous cruelty operates and lies ready to act within every one of us.'[15] As Richter intimates, the second of these fears is even greater than the first; most of us will go to far greater lengths to avoid thinking about our capacity to injure others than theirs to injure us. But this fear protects us from something even more unthinkable: our own mortality.

Only at the moment of our death will a period be inserted into the sentence of our life, thereby fixing its meaning. Since until that moment we will remain in a state of perpetual becoming, this futural relationship to ourselves makes it possible for us to change. It also links us while we are alive to every other living creature or thing, ranging from those who most closely resemble us, to those who seem most alien. It is consequently the most capacious and enabling of all analogies. The death drive is the powerful force within us that seeks to override this limit. Until we learn to live in a way that takes cognisance of our mortality – to be oriented 'towards death' – all of our attempts to devise a more equitable society will end in failure. If death is the '*eidos*', or form, of the photographic image as Roland Barthes has argued,[16] that is not only because it says 'this was', but also because it establishes such an intimate relationship between this past and our future.

Richter is not the only artist discussed in this book who views photography in these terms. Vija Celmins abandoned Abstract Expressionism in the mid-1960s because she wanted 'to go back to looking at something outside of [herself].'[17] She began her career as a figurative artist by painting the objects in her studio (an electrical fan, a hot-plate, a space-heater), but she soon began producing photo pictures. Construing the turn to photography as a step away from the world, fellow painter Chuck Close asked her in a 1991 interview why she puts an 'artificial layer' between herself and what she looks at. Celmins responded that a photograph is neither artificial nor a layer, but rather a bridge to the material world. She told Close that photographs permit her to 'unite' physical objects with the 'two-dimensional plane' of her paintings. She also maintained that her paintings have an enlivening effect upon the photographs – that they put the latter 'back in the real world – in real time.'[18]

In a published conversation with sculptor Robert Gober, Celmins confides that she is also in love with the 'look' of photographs, and that she wants to produce a similar look in her paintings.[19] As we can see from her photo pictures, 'look' means both 'appearance' and 'vision'. At the outset, Celmins was primarily focused on the first of these meanings; unlike *Fan* (1964), where the paint is thick and the colours dense, *Flying Fortress* (1966, p. 73), *Time Magazine Cover* (1965, p. 70) and *Explosion at Sea* (1966, p. 72) are grisaille, and the brushstrokes as small and unobtrusive as the grain of a good-quality

Vija Celmins
Suspended Plane, 1966
Oil on canvas
60.3×88.3 cm

photograph. But in the 1970s, when she was teaching at University of California, Irvine, Celmins began to think of the camera more as something to 'see through' than as an image-making device. She balanced her camera on the steering wheel while driving on the freeway, so she could gaze at her surroundings through the viewfinder.[20]

Celmins shot a vast number of photographs during these trips, and more later, while living in Venice, California, but she didn't pay much attention to them, because she thought that she had already seen what they had to offer. But when she examined them later, she found herself as surprised by and as 'enamoured' with their look as she had earlier been with the found photographs. The world opens itself differently to the camera than to the human eye, and this difference does not disappear when we peer through the viewfinder. It is able to see what our narcissism prevents us from seeing – the similarities connecting us to everything else, which make us part of a larger totality.

There is an even narrower margin of difference between Celmins' paintings and their source photographs than there is in Richter's – no irony, no authorial commentary and no 'blur'. It is surprising that she should have chosen to handle photographs in this way in the heyday of Pop art, but it becomes downright astonishing when we consider the biographically-significant subject matter of many of her photo pictures – German military planes from the Second World War; a German car from the same period; an explosion at sea. She was born in 1938 in Latvia, a country that was occupied first by the Red Army, then by the German army, and then again by the Russians. Her family fled to Germany in 1944, before the Russian army reinvaded Latvia, and they lived in Esslington for four years before relocating to the

United States in 1948. Like her giant pencils and erasers, her burning houses and military planes resemble those she saw as a child.[21]

However, it is precisely *because* of this history that Celmins refuses to distance herself from the military planes. She knows that they are things in the world, not agents of destruction – that *we* are the source of the violence we attribute to *them*. She also knows that this violence has no respect for borders, and that we cannot oppose it without participating in it. The will to destroy inhabits every psyche, and there is only one way to tame it: through the miracle of analogy.[22] Celmins helps us to see that we are all both bombardier and victim by giving her paintings of planes generic rather than historically specific titles, for instance, her 1966 works *Flying Fortress* and *Suspended Plane*. She also shows them to us from the perspective of a neighbouring plane, and she invites us to look *down* at her burning houses, like a military pilot at the end of a successful mission.

Both Celmins and Richter are in dialogue with Andy Warhol. Celmins' *Time Magazine Cover* analogises Warhol's *Race Riot* (1963, pp. 54–55) and her *Burning Man* (1968) references his silkscreens of automobile crashes and other disasters. Richter's photo pictures of toilet paper rolls, kitchen chairs and a drying rack relate in a similar way to Warhol's Brillo boxes and Campbell's soup cans, and his painting of Jacqueline Kennedy corresponds with the American artist's *Jackie*. This is a surprising dialogue, not only because irony is as alien to Celmins as it is to Richter, but also because Warhol seems more interested in 'sameness' than he is in similarity. His work is informed by (and has helped to perpetuate) the account of photography offered by Walter Benjamin in his famous essay, 'The Work of Art in the Age of its Technological Reproducibility'. According to this argument, a photograph is one of a potentially infinite number of identical and

unauthorised copies. It does not refer back to an 'original', and it lacks everything that gives a traditional artwork its aura: singularity, the patina of age, the traces of the artist's hand, and embeddedness in a particular place.

However, Warhol uses the silkscreen process to introduce random differences into multiple copies of the same photograph, thereby undercutting the claim that they are all 'identical', and although he treats the photographic image as a simulacrum, he does not so much jettison as redefine its referentiality. As he himself notes, his portraits gesture toward a psychic reality. 'I usually accept people on the basis of their self-images,' he writes in *The Philosophy of Andy Warhol*, 'because their self-images have more to do with the way they think than their objective-images do.'[23] Warhol also uses the concept of 'sameness' to level the distinctions between the rich and the poor, the famous and the unknown, and the 'high' and the 'low'. 'What's great about this country is that America started the tradition where the richest consumers buy essentially the same things as the poorest,' he observes in *The Philosophy*, 'You can be watching TV and see Coca-Cola, and you can know that the President drinks Coke, Liz Taylor drinks Coke, and just think, you can drink Coke … All the Cokes are the same and all the Cokes are good.'[24] When Warhol reintroduces 'difference,' as he does in many of his works, it is as a *formal* category, rather than one distinguishing one person or thing from another. The word 'gold' in the title *Gold Marilyn* refers to the colour of the painting, instead of Marilyn Monroe, and the adjective 'big' in *Big Electric Chair* to the size of the canvas, instead of the chair.

Mortality is also *the* theme for Warhol, just as it is for Richter and Celmins. In the hilarious 'Death: Everything About It' chapter in *The Philosophy*, he writes: 'I'm so sorry to hear about it. I just thought that things were magic and that it would never happen … I don't believe in it because you're not around to know that it's happened.'[25] By reproducing and silkscreening photographs of car crashes and other fatal accidents, Warhol attempts to *show* us what Freud *tells* us: the most standard way of disavowing one's mortality is to adopt a spectatorial relationship to death. He also tries to break the spell of this relationship by multiplying and tinting the photographs, inserting them into decorative panels, and giving them trivialising and overtly commodifying titles. But irony is powerless when it comes to mortality; its double-talk quickly devolves into divided belief ('yes, I know I will die, but all the same…').

Warhol clearly understood this, because he ends 'Death: Everything About It' with an uncharacteristically direct acknowledgement: 'I can't say anything about it because I'm not prepared for it.'[26] He also produced one series of works that is a powerful generator of analogical thought. In his *Electric Chair* silkscreens, Warhol installs us in the place reserved for witnesses in an American execution chamber, but without showing us what we have come to see. We wait and wait, but no 'criminal' materialises. The electric chair remains empty, and its emptiness calls out for an occupant. Since we are alone in the execution chamber, we are the only ones who can fill this void. Death finally stops being a spectator sport.

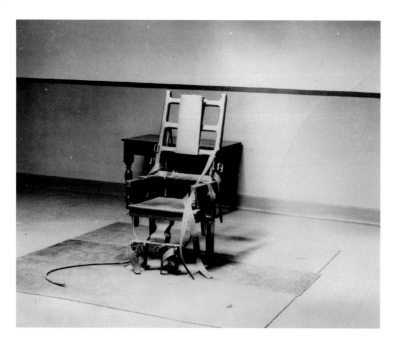
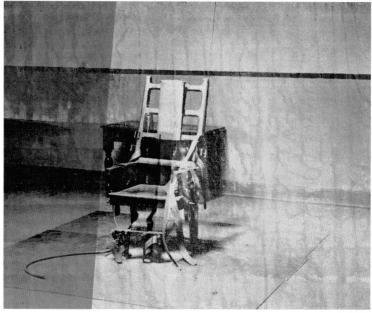

Notes

1 Gerhard Richter, *The Daily Practice of Painting: Writings, 1962–1993*, David Britt (trans.), MIT Press, Cambridge, MA, 1995, p. 146. The parts of this essay that are devoted to Richter are part of a larger argument that forms the concluding chapter of my forthcoming book, *Flesh of My Flesh*.

2 For the sake of consistency, I am referring to the device with which Richter works over the wet paint of his photo paintings as a 'squeegee'. In fact, though, it is only one of a range of implements deployed for this purpose.

3 Gerhard Richter, *The Daily Practice of Painting*, op. cit., p. 38.

4 Several other writers have also identified analogy as one of the organising principles of Richter's work. See Dietmar Elger, 'Landscape as a Model', in *Gerhard Richter: Landscapes*, Hatje Cantz Verlag, Ostfildern-Ruit, 1998, pp. 8–38; and Richard Cork, 'Through a Glass Darkly: Reflections on Gerhard Richter', in *Gerhard Richter: Mirrors*, Anthony d'Offay Gallery, London, 1991, pp. 11, 15.

5 Gerhard Richter, *The Daily Practice of Painting*, op. cit., pp. 119, 121.

6 André Bazin, 'The Ontology of the Photographic Image', in *What Is Cinema?*, vol. 1, Hugh Gray (trans.), University of California Press, Berkeley, CA, 1967, pp. 9–22; and Roland Barthes, *Camera Lucida: Reflections on Photography*, Richard Howard (trans.), Hill & Wang, New York, 1981.

7 This account of photography is by now so firmly entrenched that it belongs at the same time to everyone, and no one. Therefore, rather than attempting to document its sources, I will simply quote from a text in which it is presented with particular lucidity. 'Photography captures an aspect of reality which is only ever the result of an arbitrary selection, and, consequently, of a transcription,' Pierre Bourdieu writes in 'The Social Definition of Photography', '...among all of the qualities of the object, the only ones retained are the visual qualities which appear for a moment and from one sole viewpoint; these are transcribed in black and white, generally reduced in scale and always projected onto a plane. In other words, photography is a conventional system which expresses space in terms of the law of perspective (or rather of one perspective) ... Photography is considered to be a perfectly realistic and objective recording of the visible world because (from its origin) it has been assigned social uses that are held to be "realistic" and "objective".' (*Photography: A Middle-Brow Art*, Shaun Whiteside (trans.), Stanford University Press, Stanford, 1990, pp. 73–74).

8 Ibid, p. 33. One of the reasons the photograph is invisible is that it has been subsumed since the moment of its invention to the index, and treated as a form of evidence.

9 'Photographs ... drop onto our doormats, almost as uncontrived as reality, but smaller,' Richter told an interviewer in 1989, in the middle of a discussion of the images that gave

rise to *October 18, 1977* (Gerhard Richter, *The Daily Practice of Painting*, op. cit., p. 187).

10 For a discussion of the dialectical image, see Walter Benjamin, 'On the Concept of History', in Walter Benjamin, *Selected Writings, vol. 4*, Michael W. Jennings (ed.), Harvard University Press, Cambridge, MA, 2003, pp. 389–400; and *The Arcades Project*, Howard Eiland and Kevin McLaughlin (trans.), Harvard University Press, Cambridge, MA, 1999, pp. 456–475.

11 This metaphor was inspired by the following passage from Walter Benjamin: 'One can read the real like a text. And that is how the nineteenth century will be treated here. We will open the book of what happened.' (*The Arcades Project*, op. cit., p. 464).

12 Ibid, p. 474.

13 Walter Benjamin, 'On the Concept of History', op. cit., p. 390.

14 Freud introduces the notion of a death drive in 'Beyond the Pleasure Principle', in *The Standard Edition of the Complete Psychological Works*, vol. 18, James Strachey (trans.), Hogarth Press, London, 1955, pp. 7–64. It casts a long shadow over all of his later works.

15 Gerhard Richter, *The Daily Practice of Painting*, op. cit., p. 125. *Civilization and its Discontents*, which is included in vol. 21 of *The Standard Edition of the Complete Psychological Works*, is full of similar passages. See, for instance, pp. 111–112, as well as many of the passages quoted from this book in Chapter 2.

16 Roland Barthes, *Camera Lucida*, op. cit., p. 15.

17 'Vija Celmins Interviewed by Chuck Close at her New York Loft on September 26 and 27, 1991', in *Vija Celmins*, A.R.T. Press, New York, 1992, p. 8.

18 Ibid, p. 12.

19 'Robert Gober in Conversation with Vija Celmins', in *Vija Celmins*, Phaidon Press, London, 2004, pp. 13–14.

20 'Vija Celmins Interviewed by Chuck Close', op. cit., p. 26.

21 Lane Relyea, 'Vija Celmins' Twilight Zone', in *Vija Celmins*, op. cit., p. 51.

22 I am in the middle of writing a book about photography called *The Miracle of Nature*. The phrase comes from Marcel Proust, who uses it in *Time Regained*.

23 Andy Warhol, *The Philosophy of Andy Warhol: From A to B and Back Again*, Harcourt Publishers, London, 1977, p. 69.

24 Ibid, pp. 100–101.

25 Ibid, pp. 121–123.

26 Ibid, p. 123.

Far left: Photo source for Andy Warhol, 'Electric Chair' series, *c*.1963 (see *Big Electric Chair*, 1967, cat. 104, reproduced left) Mechanical ('Sing Sing's Death Chamber'). 'Sing Sing prison, Ossining, NY; chair in which Julius and Ethel Rosenberg were executed', Wide World Photos, 13 January 1953

Sheer Sensation: Photographically-Based Painting and Modernism

Barry Schwabsky

It has often been said that painting became abstract as the task of recording appearances devolved on photography, yet at the beginning of the 1960s a number of painters, such as Richard Artschwager, Andy Warhol, Vija Celmins, Malcolm Morley and Gerhard Richter, became interested in seeing what would happen if the appearance of their works began to approximate that of photographic images. Of course painters had been using photography in various ways for a long time – the library shelves are littered with books bearing titles like *Edgar Degas Photographe*, *Munch and Photography* and so on – but never before had they taken it upon themselves to paint photographs as they had once painted landscapes and still lifes, to take the photograph itself as their motif. Not all the painters who painted from photographs in the 1960s went so far – David Hockney often used them as source material in a fairly traditional way, as a form of sketch or notation, for example – but this was a new way for painting to question itself, and it spread with remarkable rapidity.

Historically, painting has confronted or perhaps sought out a number of points of resistance to its own autonomy: the photograph is just one. The commodity (as we saw so vividly in the art of the 1980s) or, more broadly, the object is another. Yet another is the technical rationalisation of the medium itself, to the extent that it might approximate to a mere thing or perhaps to a mere activity, and, in the end, to the simple covering of a surface with colour. The issues raised by modernism's critical re-examination of painting's autonomy are sometimes formal, sometimes social, always ideological. On the formal level, these issues have often been posed at the level of the picture plane. For critic and theorist Clement Greenberg, for instance, modernist painting was opposed to nineteenth-century academic art on account of its restoration of what he called the 'integrity' of the picture plane.[1] That is, academic painting was concerned with replacing the blank surface of the canvas with a new surface that would illusionistically appear not to be one at all but rather a view into some imaginary distance. It was there to create what Greenberg

used to deride as *holes*. The modernist painting was likewise supposed to replace the material surface of the canvas with a new one that would be pictorially complex, or at least nuanced, but by contrast, able to subsume the canvas' original unity and flatness. Greenberg wanted above all for the canvas to be as unified – as 'sole and whole' (to borrow a phrase from Yeats) – after the paint got on it as it was when it was bare. The act of painting may have tended to disrupt or wound this unity but only in order to restore or heal it. The material uniformity of the blank canvas could be replaced by the intellectual unity of the painting.

A bit later on, in the late 1960s, critic Leo Steinberg tried to overcome Greenbergian intellectualism with his notion of the flatbed picture plane, which he claimed to discover in the works of Robert Rauschenberg, whose use of photographic transfers in his paintings of the early 1960s may well have initiated the phase in the relationship between painting and photography with which this essay is concerned. The flatbed picture plane was a surface on which pictorial events and images were distributed like items scattered across a table or some other horizontal plane, or across a vertical one like a bulletin board, but in any case, 'no longer the analogue of a visual experience of nature but of operational processes.'[2] Steinberg proposed this flatbed picture plane as an even stronger, more deeply material notion of the pictorial surface and its radical impermeability.

Greenberg had a friendly curiosity toward photographs, but he never countenanced the sort of painting that directly imitated the effects of photography or confronted the place of photographic imagery and activity in contemporary life. He nonetheless set out the terms on which photographically-oriented painting would enter the discourse of art. For it was he who most clearly analysed the tendency of modernist painting towards a particular sort of surface, one whose ultimate instantiation would be what he called the 'decentralised', 'polyphonic', 'all-over' surface. This was typical of, for instance,

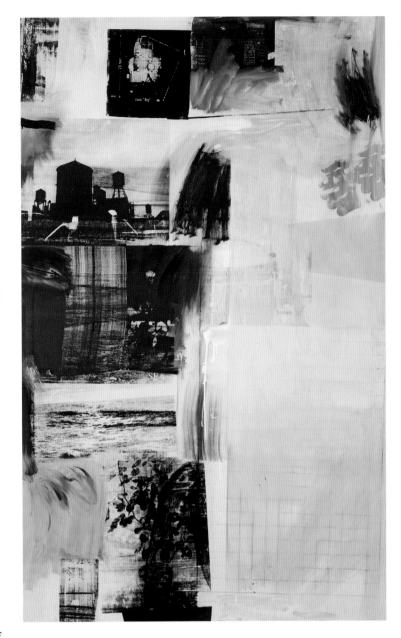

Robert Rauschenberg
Almanac, 1962
Oil, acrylic and silkscreen on canvas
245×153.5 cm

the poured paintings of Jackson Pollock, but had already been prefigured in the way Impressionist painters Claude Monet and Camille Pissarro had arrived at what Greenberg described as 'a tightly covered, evenly and heavily-textured rectangle of paint that muffled contrasts and tended – but only tended – to reduce the picture to a relatively undifferentiated surface.'[3]

The effect of this sort of surface, Greenberg saw, must inevitably be of some sort of uniformity. This was not something to be thoughtlessly celebrated, he realised, and yet, 'This very uniformity, this dissolution of the picture into sheer texture, sheer sensation, into the accumulation of similar units of sensation, seems to answer something deep-seated in contemporary sensibility. It corresponds perhaps to the feeling that all hierarchical distinctions have been exhausted, that no area or order of experience is either intrinsically or relatively superior to any other.'[4] What Greenberg does not point out is that this multiplication of sensations, and the concomitant levelling of hierarchies among different orders of experience, corresponds to social, economic and aesthetic effects of the introduction of photography into the field of image-production. While the production and reproduction of painting had been submitted to certain forms of industrialisation long before the inception of photography and photomechanical reproduction with their inherent availability to what Walter Benjamin called 'technical reproducibility', the art of painting – with its origins in the demands of church and court and its transmission through the 'closed shops' of the guild, atelier and academy – was heavily invested in an economy of scarcity and hierarchy.

Photography put image-making on a different level. Take portraiture, for example: in the eighteenth century one had to be fairly well-to-do to have a portrait of oneself; only a small number of people had the skill to make one or the means to commission one. By the twentieth century, almost everyone had a photographic portrait of themselves, and indeed it was difficult to have any legally constituted adult existence without one, since some form of photographically-validated government-issued identification document became a prerequisite for participation in many spheres of life. Whereas in the past, possession of a pictorial image of oneself was evidence of a certain social placement, today it is almost necessary for mere existence in society.

What is true of the human visage is true of everything else: in principle, absolutely everything is subject to photographic imaging – every place, every object, every action. This indeed is the reality in which 'all hierarchical distinctions have been exhausted' and 'that no area or order of experience is either intrinsically or relatively superior to any other.'[5] Moreover, what is true of photography in general is tendentially true of any photograph in particular – the camera makes no distinctions with respect to what comes before the lens, and no matter how much effort the photographer may make to eliminate all extraneous elements from its field, there is always likely to be more to be seen in the image than his or her intention would allow for. This 'something more' constitutes what Roland Barthes (in a famous analysis of a still from Sergei M. Eisenstein's 1944 film *Ivan the Terrible*) called 'the third meaning', 'the signifying accidents of which this heretofore incomplete sign is composed' and which 'exceeds

Below
Jackson Pollock
Cathedral, 1947
Enamel and aluminium paint on canvas
181.6×89.1 cm

Right
Richard Artschwager
Lefrak City, 1962
Acrylic on Celotex with Formica
113×247.7 cm

the copy of the referential motif.'[6] For poet and essayist Murat Nemet-Nejat, in a challenging study, nineteenth-century photography offered the possibility of an unprecedented kind of pictorial space, 'not an aesthetic field where beauty can express itself, but a social field where new democratic forces can take over,' which is 'the space of accidents, "failures", social movement, contemplation.'[7] This excess, these accidents and conflicts, will tend to undermine or at least distract from the stable hierarchical meaning that may have been intended by the photographer (or by the photographer's subject) and to convert the image into a mass of distinct sensations of potentially equal interest.

Thus, the field of modernist painting – at least as Greenberg understood it in the late 1940s – was one constituted by a fundamentally photographic sense of visual experience. That Greenberg himself failed to notice this is not surprising, given his own propensity to seeing photography as a fundamentally literary rather abstract art, one that 'can put all emphasis on an explicit subject, anecdote, or message.'[8] For him, the failure of a photographer like Edward Weston was precisely that 'excessive concentration on the medium'[9] rather than subject matter which he would have praised in the work of a painter or a poet. This anecdotal aspect – what Barthes would call the photograph's 'obvious meaning' – is, of course, the dialectical complement to the 'obtuse meaning' that inevitably perturbs it or what Nemet-Nejat calls the 'peripheral space' that obtrudes on the ostensible focus of the image.

Still, if the unspoken source of the antihierarchical, levelling aspect of abstract painting was its hidden kinship with the aesthetics of photography, one is entitled to wonder why the photographic gaze would not emerge explicitly into the field of painting for another 15 years after Greenberg articulated this levelling in 1948, undoubtedly as a reaction above all to Pollock's breakthrough in 1947 to his pure, all-over, poured paintings such as *Full Fathom Five* or *Cathedral*. A thoroughgoing answer to this quandary is beyond the scope of this essay, but it surely would have much to do with Greenberg's own persistent topic, painting's turn toward the medium itself as the subject of art. Without this emphasis, it might have been impossible for the photographic gaze itself to register as a subject for painting, in place of (or at least in addition to) the visible motifs that photography had already been amassing in such abundance.

In other words, it was only through the experience of abstraction that painting could have learned to approach photography, not only as a storehouse of images, a sort of sketchbook to the nth power, but as a fundamentally new structure of vision. This is what happened nearly simultaneously among otherwise unconnected artists on two continents – for instance, in such now-iconic works as Richard Artschwager's *Lefrak City* (1962), Andy Warhol's *Orange Car Crash* (1963, pp. 56–57), Gerhard Richter's *Woman with Umbrella* (1964, p. 58), Malcolm Morley's *Cristoforo Colombo* (1966, p. 82), and Vija Celmins' *Flying Fortress* (1966, p. 73). Each in its own manner, these works assert that the painterly correlative to the photographic gaze must be a certain type of surface, one that somehow or other erodes the potential pictorial organisation of its imagery in favour of a 'dissolution into sheer texture, sheer sensation' (to paraphrase Greenberg again) by means different from but just as effective as those of abstraction – among them the parodic impasto of Artschwager's Celotex support, Warhol's silkscreening (and gridded repetition), Richter's blur, and so on.

Fundamentally, though to different degrees, such paintings maintain the modernist criteria of flatness and frontality. This is perhaps most obvious in Warhol's works in which a single silkscreened photographic image is reiterated across the canvas in a gridded array, forming a sort of pattern, the visual impact of which is as important for the effect of the painting as the particulars of the image that serves as its basic unit, if not more so. The degradation of the image, its loss of detail through the multiple translations to which it has been subject – from the photographer's original print through its photomechanical reproduction in a newspaper or magazine to its silkscreening onto canvas in Warhol's 'factory' – turns it into a grainy, depthless silhouette even when it is allowed to stand as a single image.

But even some works that might seem to have much more in common with traditional representation than Warhol's paintings display a form of this internal homogenisation of the image. Consider Celmins' *Freeway* (1966, p. 74). This painting is constructed according to a strong perspectival recession; it depicts deep space rather than the shallow space (verging on flatness) typical of modernism, where forms are held nearly parallel to the picture plane. Depicting the highway as seen from within a car (Celmins placed the camera on the steering wheel), there is disquieting evenness of attention across its surface. The reason, of course, is that the look of this scene has nothing to do with one's lived experience of the highway. While, in reality, vehicles moving at a speed roughly equivalent to that of one's own can be seen with reasonable clarity, the road itself and all its immobile features – signs, etc – are only grasped fleetingly, except when there is a particular reason to fix on one of them. In a sense, a highway along which one is moving is more like a collage of disparate elements among which the eye moves discontinuously than it is like a classical picture. *Freeway*, by contrast, has no stopping points for the eye, no features that might create any discontinuity, though also no focal points such as those around which a traditional pictorial composition might be organised. Celmins' painting gets its force from the paradoxical way the stillness imposed on the scene by the camera's instantaneous view – its cut through time – contradicts the movement intrinsic to the motif. By the same token,

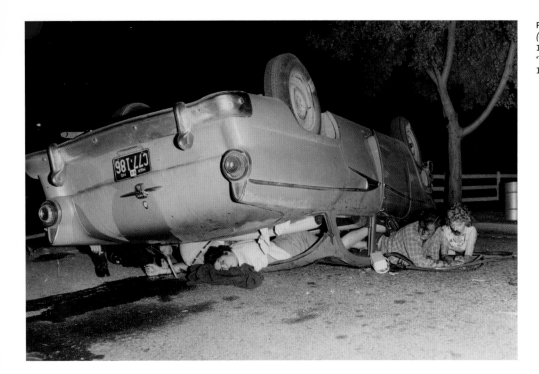

Photo source for Andy Warhol, *Orange Car Crash*
(Orange Disaster) (5 Deaths 11 Times in Orange),
1963 (cat. 102, pp. 56–57)
'Two Die in Collision', United Press International Inc.,
17 June 1959

the artist's seemingly traditional treatment of deep pictorial space is counterpointed by its treatment of light, since the distinct (and realistic) glare that envelops the scene produces an all-over evenness, and what one might call a sort of bright opacity, that gives the painting a blunt, dense unity that is more characteristic of modernism than of classical painting.

As both Warhol's and Celmins' work suggests, the monochromy that is such an insistent feature of the photographically-derived painting of the 1960s – though of course it derives from the prevalence of black-and-white photography at the time – also contributes a great deal to its dissolution of detail in favour of emphasis on the whole. Celmins in particular can easily remind one of Greenberg's description of Monet and Pissarro with their 'tightly covered, evenly and heavily textured rectangle of paint that muffled contrasts and tended – but only tended – to reduce the picture to a relatively undifferentiated surface…'[10] But what about the painters who work with intense colour, of whom Morley or, a bit later, Franz Gertsch would perhaps be the most extreme examples? In fact, they often use colour in an anticompositional manner that achieves a similar sense of nondifferentiation through opposite means.

Morley's *On Deck* (1966, p. 80) presents a postcard view of life aboard a cruise ship set within a white border. Everything within the border is rendered with scrupulous precision – in fact, with an undifferentiated precision that represents everything with equivalent crispness and point-by-point clarity, even the impossibly blue sky. This evenness of rendering evacuates all atmosphere from Morley's painting. Although the scene is constructed perspectively, every

point within the image has been depicted as if equally at hand, belying its ostensible spatial construction. Or rather, one might say that there is a strategic detachment between the painting on the one hand and the image that the painting bears on the other. The image may depict deep space, but the painting is a modernist plane of nondifferentiation – 'sheer texture, sheer sensation'.

The camera's eye view allowed painters in the 1960s to fulfil certain tenets of modernism while abandoning what had seemed to be modernism's innate tendency toward abstraction. At the same time, it inaugurated the paradox that would become typical of what later became known as postmodernism – that of a disjunction between form and content. For Steinberg, the glory of the flatbed picture plane – of which paintings of photographs, pictures 'conceived as the image of an image', furnish notable examples – was that it was 'a pictorial surface that let the world in again.'[11] With hindsight, one wants to agree and disagree. If the world can enter the painting but only at the price of becoming the image of an image, of becoming a certain sort of surface, is it really in the painting? Or is the world's translation into image a considerable loss of its substance?

Today, four decades after Morley's *On Deck*, the strategic detachment of image from painting seems so inevitable as to be troubling. Formalism turns out to be a lot harder to shed than Steinberg imagined. Painting's encounter with photography may be part of its ongoing encounter with non-art but non-art remains a receding horizon. Undifferentiated reality, in painting, is miraculously endowed with distinction. At best, painters play desperate, sombre games with the way surface and image vainly

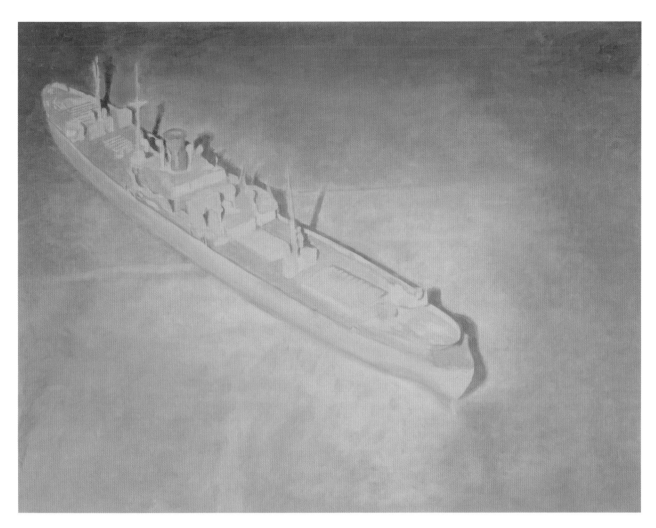

Luc Tuymans
Cargo, 2004
Oil on canvas
150×196.5 cm

pursue one another. The blurred surfaces of Johannes Kahrs' or
Judith Eisler's paintings, for example – even more than Richter's –
seem calculated to point to reality by keeping it at a poignant
distance. It's no accident that these are not just what Steinberg called
'images of images' but rather images of images of images of images.
Eisler's are paintings of snapshots of movies on a television screen,
and she says, 'My interest is not so much in the meaning of the image
but in the alterations that occur through so many layers of distance.'[12]
The eye's forced movement through the succession of images in a
film is not unlike what it experiences in the space framed by an
automobile windshield as it hurtles along a highway; like Celmins,
Eisler extracts a single moment from this flux, but unlike her
predecessor, finds the traces of motion even in the split second.
At least the image can allegorise painting's merely tenuous grasp of
the world, and in that way indicate its true difficulty. As in
Luc Tuymans' *Cargo* (2004), another ship painting, as with Morley,
another near-monochrome, and as with Celmins, where what the title
reminds us of (and the weight of the title indicates the painting's
allegorical nature) is the fact that we can never, merely by observing
the vessel, determine what freight sits in its hold.

Notes

1 Clement Greenberg, 'Modernist Painting', in *Clement Greenberg. The Collected Essays and Criticism, Volume 4: Modernism with a Vengeance, 1957–1969*, The University of Chicago Press, Chicago, 1993, p. 87.

2 Leo Steinberg, 'Other Criteria', in *Other Criteria: Confrontations with Twentieth-Century Art*, Oxford University Press, London, 1972, p. 84.

3 Clement Greenberg, 'The Crisis of the Easel Picture', 1948, in John O'Brian (ed.), *The Collected Essays and Criticism, Volume 2: Arrogant Purpose, 1945–1949*, The University of Chicago Press, Chicago, 1986, p. 222.

4 Ibid., p. 224.

5 Ibid.

6 Roland Barthes, 'The Third Meaning', in *The Responsibility of Forms: Critical Essays on Music, Art, and Representation*, Richard Howard (trans.), Hill & Wang, New York, 1985, pp. 42, 43.

7 Murat Nemet-Nejat, *The Peripheral Space of Photography*, Green Integer, Los Angeles, 2003, pp. 35, 37.

8 Ibid.

9 Clement Greenberg, 'The Camera's Glass Eye: Review of an Exhibition of Edward Weston', 1946, in John O'Brian (ed.), op. cit., pp. 61, 63.

10 See note 3.

11 Leo Steinberg, op. cit., pp. 91, 90.

12 Judith Eisler, 'Freeze Frame', www.cohanandleslie.com.

A Strange Alliance: The Painter and the Subject

Carolyn Christov-Bakargiev

Since the prehistory of photography in the Renaissance, when the camera obscura came to be commonly used,[1] visual artists have adopted photography as a memory aid and tool to achieve more accuracy of visual representation. Today, however, some painters – such as Marlene Dumas, Elizabeth Peyton, Michelangelo Pistoletto, Wilhelm Sasnal and Eberhard Havekost – are rather more interested in how painting from photographs might reveal forms of personal inaccuracy and photography's fundamental inability to instantiate subjectivity. Indeed, photography gives as much as it takes away, significantly causing disorders in the articulation of the self. Its prosthetic and mechanical origin (whether producing analogue or digital images) removes and detaches it from singularity. It causes a state of mourning.

In the nineteenth century, at the birth of what a century later came to be known as the 'society of the spectacle'[2] and when the world was only just beginning to be filled with visual imagery through photography, artists celebrated the 'instantaneity of life' represented and captured by the photograph. Édouard Manet, for instance, spoke of *instantaneity* ('Capture what you see in one go'),[3] painting his impressions quickly and directly, *à taches*, with dashes of colour. It was the speed and flow of change characterising modern life that interested him: 'Who was it that said that drawing should be the transcription of form? The truth is, art should be the transcription of life … You must translate what you feel, but your translation must be *instantaneous*.'[4] He, as many fellow Impressionists, referred to the speed of the photographic framing of scenes, made most evident by awkward cropping of figures or objects that were no longer 'centred' by any controlling pictorial gaze.[5] In Manet's *Masked Ball at the Opera* (1873), for example, the focus is on the crowd of men in black top hats and the well-dressed women in the foreground, yet the two legs dangling from the balcony suggest a partially hidden other world above, somehow still belonging to the space and scene below.

By the turn of the twentieth century, photography had established itself as a major force in the depiction of humanity. Photographs were also used as tools of surveillance and control by modern states eager to use the power of photographic 'evidence'. The rise of documentary photography and photojournalism, with the birth of co-operatives like Magnum, as well as the increase of interest in film, encouraged – by contrast – a shift within the visual arts towards less representational modes of art, modes and forms that photography could less readily achieve, such as proto-conceptual Dada art, Abstract art, Expressionism and Surrealism. Although these artists moved away from realism, they did not yet feel *threatened* by photography. Even in the first half of the twentieth century, painters were painting photographs of paintings as much as they were painting photographs of people, places and events. Yet this was not readily revealed at the time and the relationship between photography and painting was not explored as a significant cultural shift that bestowed new meaning onto painting – rather it was felt to be a form of plagiarism.[6]

In the late 1950s and early 1960s, a change appeared in the attitude of some painters, such as Richard Hamilton, Andy Warhol and Gerhard Richter, who began to reveal the photographic source of their works and express a new awareness of their potential loss of authority over visual culture in a rapidly changing society. Rather than continuing to celebrate the photographic universe (and its younger sister 'film'), artists became suspicious of it, and proposed through their art an awareness and understanding of living in a society of spectacle flooded by a massive number of photographs and their reproductions in advertising and the media – a consumer culture where the artist was rapidly losing all forms of control over the production of images.[7] These artists created an ambivalent art that celebrated Pop culture while revealing the loss of individual authenticity and agency implicit in that culture.

Édouard Manet
Masked Ball at the Opera, 1873
Oil on canvas
591×725 cm

It is in this context that British artist Richard Hamilton devised a strategy to regain some form of 'agency' over these mediated images. He became a DJ of sorts – repeating, combining, layering and collaging together various techniques by which photographs and images are processed. Hamilton reclaimed a critical space by so doing, which consisted of repeating, but also revealing and denying, the techniques of serial reproduction of imagery in the media.

Andy Warhol, by silkscreening and repeating Marilyn Monroe's image on a single canvas in 1962, acknowledged that he was 'painting from photography'. He recognised the loss of high art's ability to create and steer visual culture in a consumer world, all the while re-signifying it through the display of this awareness and positioning a form of critical consciousness of spectacle as the space of artistic practice. Gerhard Richter, too, revealed and reversed the artist's loss of authority over the production of visual culture caused by the advent of photography by 'painting' a landscape filtered through camera vision, and a world where the primary subject matter was no longer reality but its photographic representation. These and other forms of artistic practice were cases of repetition and *resistance* to

photography, which had moved away from the promised democratic tool it was supposed to have been when it was heralded in the nineteenth and early twentieth centuries towards being a tool of alienation and submission of individuality and authenticity.

Recently, more and more artists choose to paint portraits from photographs, images found in the media or on the Internet, or snapshots taken with cameras and even cell phones. Prior to the advent of photography, the painter's agency had traditionally been expressed through a strong alliance between the artist and his or her model. When transformed into an inanimate photograph, however, the model, or 'Other', has been put in the position where he or she betrays the painter and turns his or her back on their relationship, creating an *(e)strange(d)* alliance. In traditional portraiture, to paint one's subject 'from the real' means to paint not a figure but a relationship between two people – the painter and the model. It is an intense relationship, and the more it is allowed to extend leisurely in time through glances, conversations and reciprocal mental projections, the more successful the portrait usually is. What is painted *is* that relationship – an intimate dialogue. Similarly, to take

someone's photograph is just as contingent on the relationship and alliance the photographer is able to create with the subject, albeit for an instant – the more the photographer can attract his or her subject's attention, the more the subject 'performs' and 'acts' for the camera, the more 'alive' and poignant the final photographic image proves to be.

Consequently, most of the portraits made up to the early twentieth century were frontal depictions (or side views where the face is visible) made by copying a real person who was posing, where the painter's gaze and presence was instantiated by being looked upon by his or her model. This returned gaze, from the model back to the artist (the subject looking at the painter), by extension instantiates the viewer of the painting as well, at a second remove and at later time than the original act of painting.[8]

What does it mean to intersect (and intercept) these two neatly connected couples (painter-subject and photographer-model)? What happens when you *paint* a *photograph* of a subject/model? There is

one animate person (the painter) on the one hand and one inanimate subject (the photograph) on the other, and no bonding can ever truly occur, no relationship can ever develop. What is being painted is the representation of a form of inevitable distance and separation, the solitude and loss caused by photographic vision itself.

In the nineteenth and early twentieth centuries, artists still preferred to use photography only as an aid or tool for their portraits, and to finally paint their subjects from a hybrid of pose from the real and photography – the painter could select details for emphasis, edit in or out elements and change the scene. There are, however, examples from this period of portraits made only from photographs. For instance, Arshile Gorky's *The Artist and His Mother* (*c*.1926–36) is based on a 1912 photograph of the artist as a child standing next to his seated mother.[9] The result is of a more static and abstract nature than earlier portraits 'from the real': what is being painted is an exercise in remembering or evoking an absent person and consequently what is being painted is a sense of solitude. The feeling of loss evoked by Gorky's portrait of his mother's face is determined by the blankness that was already present in the source photograph, not only by the modernist abstract style of his painting. The mother is not looking at the painter, her son, and she never was; she never posed for him; he was beside her when the photograph was shot, and she was looking at another person, not the 'I' of the painter. Gorky reminds us of this ghostly nature of the photograph by placing himself in the painting as well, in a position that recalls and doubles the fact that his 'subject' can never 'look' at him.

Most cases of recent portrait painting from photographs may curiously appear more similar to early twentieth-century artists' relations with photography – such as the Gorky painting – than to those expressed by Pop artists in the 1950s and 1960s. Andy Warhol's 1960s *Marilyn* never looks at the painter (nor at us) – she smiles and stares into the void, an incarnation of collective alienation in the world of spectacle. His *Big Electric Chair* (1967, p. 52) makes manifest the absent model (the electric chair is empty) as well as emphasising through the subject-matter the aggression and violence implicit in the mechanical camera gaze. Richter's blurred portraits are also at a remove from us, and their filtered gaze is never directed to the painter/viewer. But this 'mechanical' camera vision, made manifest in Warhol or Richter's works, is of no interest to more recent painters

Arshile Gorky
The Artist and His Mother, c.1926–36
Oil on canvas
152.4×127 cm

Photo source for Elizabeth Peyton, *Arsenal (Prince Harry)*, 1997
(cat. 79, reproduced right)
From *The Daily Telegraph*, Monday 1 December 1997

FACE IN THE CROWD: *Prince Harry watches Arsenal play Liverpool in a Premier League match at Highbury, north London, yesterday. The Prince, wearing an Arsenal supporter's hat, was with a group of friends. He saw his team beaten 1-0, with a goal from Steve McManaman.* Match report: Page S3

Union may sue Fayed over phone 'taps'

By Ambrose Evans-Pritchard and Philip Johnston

UNION representing opworkers at Mohamed ayed's Harrods store in ondon is considering legal ction after it was claimed at staff telephone conver-

been disclosed by Bob Lof- tus, once head of security at Harrods. "We bugged hundreds of

said that the Harrods tele- phone of the Usdaw conve- nor Ken Tate was frequently targeted in 1994 because Mr

ever, has listened to tapes that confirm the scale and highly intrusive nature of the surveillance. Yesterday, *The*

sibility of legal redress. I can't imagine for one moment that anyone in Har- rods would instigate such a bugging without instruction from the very top."

such as Marlene Dumas, Michelangelo Pistoletto, Elizabeth Peyton and Wilhelm Sasnal. Rather than focusing on the mechanics of spectacle and the detached 'third person narration', these artists explore the effects of painting from photographs on subjectivity. Their works do not describe or enact what happens to subjectivity and the self in this universe of spectacle, media and the Internet; rather, they ask what happens to the painter's self, they experiment with the *personal* experience of being in front of a ghostly 'Other' who does not grace us, or acknowledge and instantiate us, by their gaze.

In the case of many paintings recently made from photographs, the inanimate nature of the subject/model is counterbalanced by the particularly strong presence of pictorial agency and the painter, anachronistically and solipsistically 'painting' in a society where painting is an obsolete way of producing images. The more dead and inanimate the photograph, the more vibrant and vital the painting, in a relationship resonant of necrophilia and at times an almost dandy attempt at artificial respiration. Unheroic, the people in these paintings are often far from Pop icons of mass culture, for instance Marilyn Monroe or John F. Kennedy. The subjects are often known only to the artists themselves – friends, family, other artists – suggesting the world of private, 'home-made' photography. By referring to the 'anybody', these figures seem familiar to all of us.

By not being known to us, however, they retain their *unheimlichkeit* and we are estranged from them. Even when the titles of these works do suggest famous people, such as Elizabeth Peyton's *Arsenal (Prince Harry)* of 1997, the figures look more like personal friends than celebrities.

Martin Kippenberger decided to become an artist when he spent nine months in Florence, Italy, between 1976 and 1977, and created his series of pictures *Uno di voi, un Tedesco in Firenze* (pp. 104–109), all painted on canvases roughly the same size (50×60 cm or 60 x 50 cm) that he had bought prior to starting the series. Ultimately, within just a short three months at the end of his stay, he painted around 100 pictures[10] from postcards, newspaper images, reproductions of artworks, and his own snapshots of daily and private life in Italy – the Ponte Vecchio, a birthday cake, people in stores, artisans he would meet and talk to, glow worms at night, things he found somehow 'Italian'. He painted quickly, one canvas each morning and one in the afternoon. *Uno di voi* can be translated 'One of you' and suggests a generic subjectivity, a familiarity, randomness and casualness of encounters, but also an affection for the subjects/models and a certain amount of grace. To paint such a profuse number of paintings meant to recognise that we live in a world flooded by images. But just as an innumerable number of photographs are 'bad' or

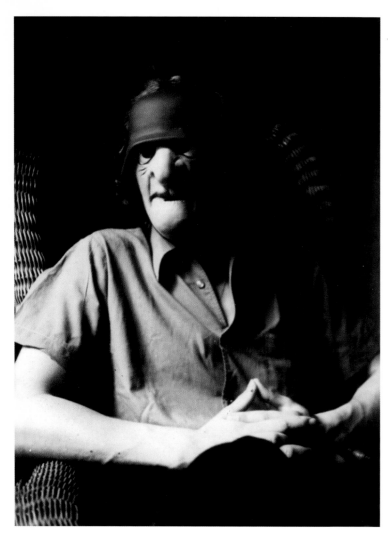

Photo source for Martin Kippenberger, *Uno di voi,
un Tedesco in Firenze*, 1977 (cat. 56, p. 107)
Artist's photograph

Moving against any philosophical view of absolute and autonomous Being, typical of traditional metaphysics and ontology from Parmenides up to Martin Heidegger, French philosopher Emmanuel Lévinas suggested that only in the encounter with the Other we *are*. The 'I' exists only insofar as it answers the 'you' who questions it. In particular, it is the encounter with the Other's face that makes us understand we are human. Yet, 'the face makes sense only to itself. You are you.'[13] The Other's face according to Lévinas is where irreducible otherness is located; it marks the unknowable and thus an inevitable distance. Ours is a 'relation without relation'[14] because the Other remains unknowable: 'A face enters our world from an absolutely alien sphere – that is, precisely out of an absoluteness, which in fact is the name for fundamental strangeness.'[15] In the extremely mediated universe made up of a plethora of images of others that do not question us, this encounter assumes a new set of problems and forms of visual and relational imbalance.

This visual and relational imbalance, this lack of a reciprocal gaze, emerges most clearly in those paintings where the painter chooses to portray or to refer to a 'faceless' subject: seen from behind, blindfolded, indistinguishable, hands covering the face, these figures are portraits of 'failed' photographs, just as much as they are portraits of ghosts and of longing. To paint from a photograph of a person is not to paint the dynamic process in life of encountering gazes that instantiate one another, it is to portray the attempt to remember that process of encounter that has been lost. Thus, to explicitly portray faceless people, or people seen from behind, or people who are blindfolded – as in Marlene Dumas' triptych *The Blindfolded* (2002), which makes reference to Palestinian prisoners blindfolded and condemned to death – *makes* this state manifest. It repeats the necrophilic act itself of photography at a remove, and by so doing makes manifest the act of mourning that is embedded in the act of painting today. Dumas' painting is empathetic and morally more truthful than the source photographs she begins with: 'Paintings exist as the traces of their makers and by the grace of these traces. You can't "*take* a painting", as with a photograph, "you make a painting".'[16]

Historically, only a handful of precedents emerge, such as Jean-Auguste-Dominique Ingres' *The Bather of Valpinçon* (1808), portraying from behind a nude woman sitting on the edge of a canapé,[17] some portraits of lonely figures in cafés by Henri de Toulouse-Lautrec, and

useless, and almost nobody will ever look at them, so too Kippenberger's paintings, by being quickly made and within a series, would often be 'bad' painting, far from the lofty and neo-conservative work of the *Neue Wilden* (Neo-Expressionist) artists of the time. Like a drop-out, he mimicked productivity and did something utterly useless and very cheaply that took up most of his time. However, these failed photographs represent the survival of the private space, where the 'advent of myself as other' described by Roland Barthes as the disturbance to civilization caused by photography[11] – almost a collective Lacanian 'mirror stage' narcissistic disorder[12] – suggests a preceding moment of symbiosis one tries to remember. We once did know these people, they seem to suggest.

One could say that in traditional portraiture, it is the subject/model's gaze onto the painter that returns to the painter a part of him or herself through the model, so that every portrait is always partially a self-portrait. If, however, you paint a photograph of a subject/model who was originally looking into a camera eye (returning the photographer's gaze), this structure and movement is deflected and cannot be set up or even occur, and the act of painting becomes a solipsistic and almost autistic endeavour.

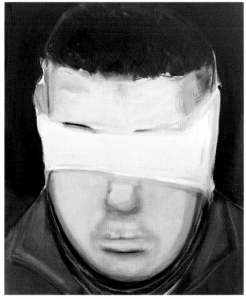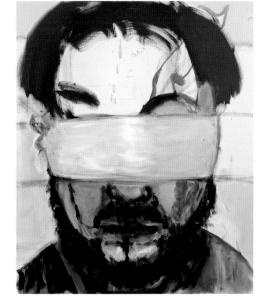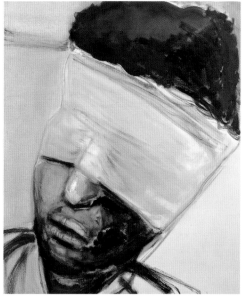

Top: Photo source for Marlene Dumas, *The Blindfolded*, 2002
(cat. 20, 3 panels, reproduced above)
'Palestinians are blindfolded after several hundred surrendered
to the Israeli army outside a refugee camp in the West Bank
City of Tulkarm', 8 March 2002

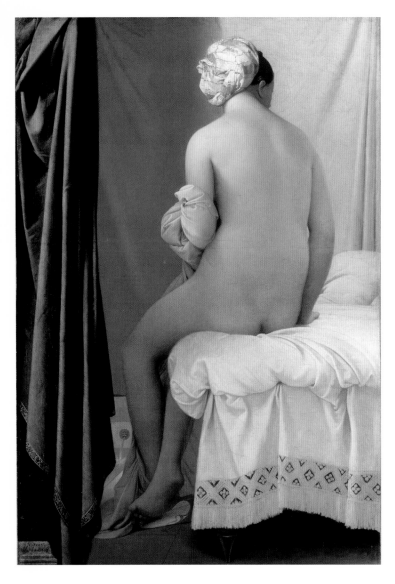

Left
Jean-Auguste-Dominique Ingres
The Bather of Valpinçon, 1808
Oil on canvas
146×97.5 cm

Right
René Magritte
Not to be reproduced, 1937
Oil on canvas
81×65 cm

Richard Hamilton's series of works titled *Swingeing London 67* (1968– 69, pp. 11, 86) is a key and emblematic project in terms of this discussion. Hamilton has always been interested in the limits of the legibility of a photograph – degraded by enlargement, or otherwise made unreadable or altered by various techniques. He also understood early on that the artist works today in the context of a super-abundance of images and visual stimulus, and that 'private life' is nothing but that zone of space and time where we are not a photographic image nor an object. The series *Swingeing London 67* began with the press photograph of his dealer Robert Fraser with Mick Jagger (who had both been arrested on drug charges) as they appear handcuffed together on arrival at court for their trial. The image had been certainly retouched before coming out in the paper. Hamilton's many variations on this image focus on the handcuffs and show the two characters with raised arms covering their faces from the paparazzo's camera. Hamilton paints the resistance to photography that they enact, as well as – implicitly – the denial of the Other's gaze when sacrificed to the media.

In Franz Gertsch's *Kranenburg* (1970, p. 102), the artist depicts a group of friends seen from behind as they walk down the street in Kranenburg on the Dutch German border towards an art opening. Monica Raetz is the farthest away, as she walks ahead of the others with Maria Gertsch; then Markus Raetz, Jean-Christophe Ammann, Pablo Stähli, Balthasar Burkhard and Ritsaert ten Cate follow. The artist is presumably behind the group as he took the snapshot from which the painting derived. They do not look at him and are intent on their walk and their conversations. The hyper-real and objective style of the painting is heightened by the absence of exchanged gazes portrayed.

David Hockney painted *Le Parc des Sources, Vichy* (p. 94) in 1970, the same year as Gertsch's *Kranenburg*. Two friends, Peter Schlesinger and Ossie Clark, are seated on two of three chairs that face away from the viewer, towards an alley of trees in a park. The third seat is empty, pointing to the painter / photographer who is absent from the scene: he stands outside and behind as an onlooker. Although the artist has stated that what was most important to him in this composition was the false perspective of the alley of trees ('the actual trees there form a triangle, not an alley just disappearing into the distance'[18]), what we really are looking at are people who are looking at a scene, and away from the painter. In some key later works by Gerhard Richter, such as

a number of Dada and Surrealist examples including Man Ray's *Marcel Duchamp Tonsured by Zayas* of 1920, where the back of Duchamp's head shows a shaved form of a star, and a number of paintings by René Magritte. In particular, Magritte's *Not to be reproduced* (1937) portrays a man seen from behind who is looking into a mirror where even his image reflected in the mirror, which logically should show us a frontal view of him, is a view from behind.

Since 1960, Michelangelo Pistoletto has also explored the images of figures seen from behind in a number of paintings where photographic images were painted and later silkscreened onto shiny mirror-surfaced stainless steel, such as *Ragazza che cammina* (c.1960, pp. 78–79). For Pistoletto, by facing inwards, into the space of the mirror, the gaze of the portrayed figures would instantiate the relation between self and other within the space of the mirror, since they would be facing our mirror image that faces back outwards towards the space in front of the painting. In these works, the relationship is transferred into the virtual space of the mirror, not denied.

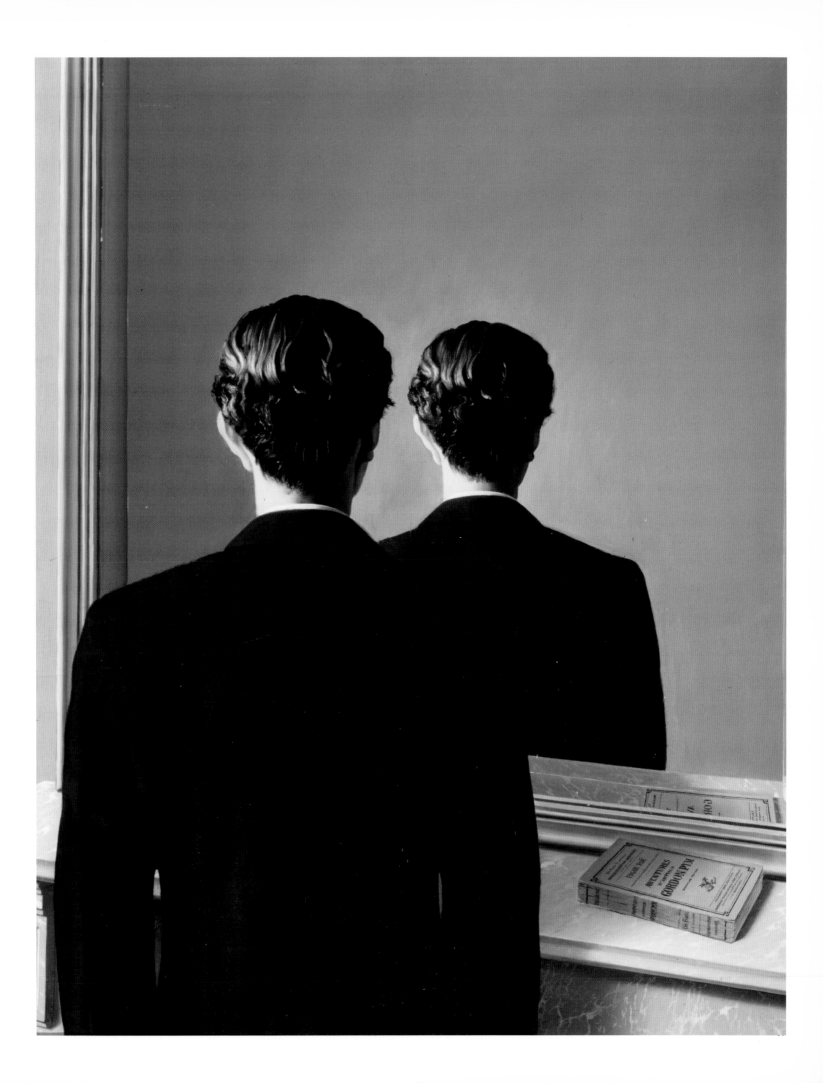

the portrait of his daughter *Betty* (1988) and the two versions of *I.G.* (1993), which portray Iza Genzken, the figures are also seen from behind, or turn away from the painter.

The sheer abundance of portraits of faceless figures today, because they are seen from behind, or veiled, is striking, marking a significant shift in the history of portraiture. In Elizabeth Peyton's *Julian with a broken leg* (2004), the portrayed figure has hair that fall over his cheek and cover his features. We know nothing of the event described by the title, nor who Julian might be (the painting is actually of Julian Casablancas of the band The Strokes), only that the subject's concern with walking with a broken leg (which we cannot see), perhaps with crutches, causes his head to look downwards, away from the photographer, the painter, and us.

Human figures are often disguised or masked in Eberhard Havekost's paintings, denying eye contact. Beginning with his own photographs or with images taken from the media, the painter scans them and digitally processes them before turning to canvas to paint them. In *National Geographic* (2003, p. 176) we do not see the popular

magazine that publishes articles on far-away places, but we do see a figure with an American flag, his body completely covered in clothes and apparel for extremely cold weather, including mittens, a helmet and goggles, to the point that he is 'distanced' and unrecognisable to the onlooker.

Wilhelm Sasnal understands the world as fundamentally mediated and often uses greys and blacks to heighten the contrast between light and dark and thus suggest photographic imagery. His works have drawn from press reports of catastrophes to sports news, 1960s Polish films, images from the Internet of cult figures, and snapshots of family and friends. The very visible painterly gesture, such as smearing and smudges, expresses pictorial agency as much as it suggests forms of powerlessness. In an interview, Andrzej Przywara tells the artist: 'You are trying to portray Luther's face from a black-and-white computer printout of a picture you saw earlier in the museum in Frankfurt. These pictures give the impression of being abandoned half-way through, as if there is no way to finish them … In the case of Luther's father, you seem completely helpless: his eyes look like empty sockets.'[19] And Sasnal shortly thereafter remarks, 'I was thinking that I would like to paint a lot of portraits of Anka, particularly her back, when she's naked, but the first thing I would have to ensure was that the pictures did not look like those of Richter. It is hard to paint backs today. I would also like to paint a series of profiles and silhouettes. Although actually I don't really want to be a portrait-painter.'[20] His ambivalence around portraiture, and his suggestions of its impossibility, are present in works such as *Girl Smoking (Anka)* (2001), and point to the disrupted and dysfunctional contemporary relationship between painter and subject – as well as, indirectly, a form of possible empowerment through the exploration of the absent face.

The woman on the right hand side of Manet's *Masked Ball at the Opera* stares at the painter/viewer while she proudly wears a mask over her face, reversing the usual voyeuristic structure of viewer/viewed embedded in the camera's gaze. She looks at us, but we cannot truly see her; she is looked at by the men in the picture, but cannot truly be seen by them. Without a face, Manet's masked lady had already sent us intimations of the effect that photography would have on consciousness – and of the possibility of portraiture and agency within the space of the veiled face.

Elizabeth Peyton
Julian with a broken leg, 2004
Oil on board
35.6×27.9 cm

Wilhelm Sasnal
Girl Smoking (Anka), 2001
Oil on canvas
45×50 cm

Notes

1 The fact that light entering a small aperture into a dark room projects a reversed image of the scene outside was known since the ancient Greeks.

2 The Situationist Guy Debord coined this term to define our society in his book *The Society of The Spectacle*, 1967.

3 Édouard Manet, untitled statement, *c.* 1850, in Juliet Wilson-Bareau (ed.), *Manet by Himself*, Little, Brown and Company, London, 2000, p. 26.

4 Ibid, p. 52.

5 See Timothy J. Clark, *The Painting of Modern Life: Paris in the Art of Manet and His Followers*, Princeton University Press, Princeton, NJ, 1984.

6 Van Deren Coke quotes as an example Emily Genauer's 1964 comment: 'Has the painter who relies strongly on photographs without absorbing them into a fresh, intensified, transcendent statement any more right to be called an artist than a journalist who composes an article with facts, or an editor who works on someone else's manuscript? What would happen to a writer who found in someone else's writing a fresh image, a provocative idea, an effective turn of phrase, and simply lifted them without quotes? He'd be sued for plagiarism...' (Preface, Van Deren Coke, *The Painter and the Photograph*, University of New Mexico Press, Albuquerque, 1972, unpaginated.)

7 Following on Walter Benjamin (1936) and Guy Debord (1967), Susan Sontag points out this relationship between consumer culture and photography, 'Whatever the moral claims made on behalf of photography, its main effect is to convert the world into a department store or museum-without-walls where every subject is depreciated into an article of consumption.' (Susan Sontag, *On Photography*, Picador, Farrar, Strauss and Giroux, New York, 1977, pp. 9–12, 1st edition 1973.)

8 Giulio Paolini's *Young Man Looking at Lorenzo Lotto* (1967) deals specifically with this relationship.

9 Gorky painted two versions of this subject. The two paintings (respectively *c.*1926–36 and *c.*1926 – *c.*1942) are at The Whitney Museum of American Art in New York and the National Gallery, Washington D.C.

10 On 23 October, Balduin Baas counted 83 pictures in Hamburg. Kippenberger is said to have left about 15 of the original 100 paintings in Florence.

11 Roland Barthes, op. cit., p. 12.

12 The 'mirror stage', as described by Jacques Lacan in 1936/49, represents the stage in our early development when we recognise ourselves as 'other'. It is only when we recognise our reflection in the mirror that we fully separate from our mother and become autonomous selves. The subject identifies with the image through a libidinal relationship with the body-image. But subjectivity is already partially structured even before the mirror stage, during a symbiotic stage when the child recognises him/herself through the act of being looked at by the mother. The child learns to smile by seeing the mother smile at him or her, and it is thus the other's gaze that first determines the existence of our own subjectivity. Jacques Lacan presented his theory first as a lecture in 1936 (Marienbad Congress) at the meetings of the International Psychoanalytic Association and then again in 1949 in Zurich as 'The mirror stage as formative of the function of the "I" as revealed in psychoanalytic experience'.

13 Emmanuel Lévinas, *Ethique et Infini*, ed. Le Livre de Poche, Paris, 1984, p. 80.

14 Emmanuel Lévinas, *Totality and Infinity*, Duquesne University Press, Pittsburgh, PA, 1969, p. 79.

15 Emmanuel Lévinas, 'The Trace of the Other', in Mark C. Taylor, *Deconstruction in Context: Literature and Philosophy*, University of Chicago Press, Chicago, 1986, p. 352.

16 Marlene Dumas, in Dominique van den Boogerd, Barbara Bloom, Mariuccia Casadio, *Marlene Dumas*, Phaidon Press, London, 1999, p. 122.

17 Man Ray's *Violon d'Ingres* (1924) is inspired by Ingres' painting but is less radical insofar as the artist has his model turn her face to the left so that we can a glimpse of it, even though she is seen from behind her back.

18 David Hockney, in *David Hockney – My Early Years*, Nikos Stangos (ed.), Thames & Hudson, London, 1976, p. 202.

19 Andrzej Przywara, 'Interview with Wilhelm Sasnal', in *Wilhelm Sasnal. Night Day Night*, Hantje Cantz Verlag, Ostfildern-Ruit, 2003, p. 34.

20 Ibid, p. 35.

Rehearsing Doubt: Recent Developments in Painting-After-Photography

Martin Herbert

'The photograph is never anything but an antiphon of "Look", "See", "Here it is"; it points a finger at certain *vis-à-vis*.'[1] That is Roland Barthes. 'Painting is the making of an analogy for something non-visual and incomprehensible; giving it form and bringing it within reach. And that is why good paintings are incomprehensible.[2] That is Gerhard Richter. Now, harmonise these two statements – written a year apart, in the early 1980s, and not without currency today – with regard to paintings based on photographs. Something, naturally, has to give. For the painting to succeed, the photograph catapulted into Richter's empire of unmanageability must surrender its claim to simple veracity, to here-it-is-ness.

How does Richter's painting *Woman with Umbrella* (1964, p. 58), one of his earliest photo-based works, depart from the original photograph? That photograph is of Jacqueline Kennedy; it was taken on 22 November, 1963, in Dallas, Texas, shortly after President John F. Kennedy was shot. The white stripe running down the left-hand side of the painting signals that Richter's image was sourced from a newspaper; but whereas the press picture would have been captioned, Richter does the inverse. In various ways, he removes contextualising information, and in doing so distinguishes emphatically between the respective *métiers* of painting and photography. A photograph is typically intended to convey visual information about something that actually exists or existed, and is tied to time, place, subject; a painting more easily partakes of the symbolic, and of ambiguity. Richter's painting is not inseparable from the Kennedy assassination. It is of Jacqueline Kennedy, yes. But it is simultaneously of Everywoman-in-grief, thanks to the anonymous title, the choice of an image in which the subject is at her least recognisable, the lack of contextual detail and, not least, the blurry manner in which it was painted, which betrays an awareness of what painting *can't* do, or would be unwise now to attempt.

Consider Richter's 1965 painting *Nurses* (pp. 21, 62). Again it is based on a newspaper clipping, one preserved in Richter's monumental transformation of research materials into an archive-as-artwork, *Atlas*. The photograph, naturally, is crisp and clear; the painting is a dissolute grey blur. On the subject of this softening, here seen at an extreme but characteristic to some degree of his figurative paintings as a whole, Richter said in 1972: 'I can make no statement about reality clearer than my own relationship to reality; and this has a great deal to do with imprecision, uncertainty, transience...'[3] If *Nurses* reduces the individuality of its subjects, transforming them into an emblem – and one inevitably thinks of death and/or loss, given the way that these nurses seem to be blurring out of existence – it does so because it can't speak with confidence of the specific. Accordingly, whatever emotional effects arise from Richter's practice, they are to some degree side-effects of a foundational honesty about the limits of representation, one that photography refuses. In this sense, his photo-based paintings – and, to varying extents, those by a continuum of younger artists toiling in the space he opened up – are not *about* photography *per se* but inquire into the limits of knowledge production, with photographs standing in for supposed facts, wobbling and blurring in the slipstream of scrutiny.

Richter, it would seem, nevertheless sees substantial compensations in the practice of painting. If it cannot mirror reality's surfaces, it has an unmatchable aptitude for reflecting and poeticising broad human struggles. It is not a huge leap from this accommodation of painting's parameters, however, to a more pessimistic take on what painting is able to say – or, rather, what it isn't. This is clarified by the work of Luc Tuymans, whose beat for over two decades has been the failure of representation within painting: its 'belatedness', its incapacity to offer anything that matches the violence and violations of both recent history and the contemporary world.

Luc Tuymans
Gas Chamber, 1986
Oil on canvas
50×70 cm

Tuymans often proceeds by subterfuge, the tension that animates his images resulting from our discovering something that isn't immediately apparent about them. Frequently, too, he turns his gaze to the peripheries of a cataclysm. Tuymans appears unconvinced that painting has the assumed authority to look directly upon the disasters of the last and present centuries. It is characteristic that when Tuymans paints Adolf Hitler in *De Wandeling* (1991, p. 112), he does so from behind. In a manner that deepens horror for being so unmelodramatic, the dictator is seen having left his house in the picturesque Bavarian Alps for a pensive stroll with an escort (Albert Speer). Hitler is little more than a silhouette. The photographer who recorded the image pads behind him; painting, metaphorically speaking, lags even further behind.

Tuymans, while marked retroactively by the Second World War, is not wholly consumed by historical events. *Altar* (2002, p. 118), for instance, is a washed-out view of the bridal altar in a Mormon temple in Salt Lake City, ringed by seating. It is based on a still from a Mormon publicity film; the view, however, is through a security camera. One could hardly imagine a more trenchant symbol of the ubiquity of authority's gaze than this glimpse into the secretive, congregants-only world of Mormonism; as with Richter, though, Tuymans' image moves beyond its local context, past sectarian details to emphasise photography's generally invasive nature. Even intimate and personal moments such as wedding vows, the painting suggests, are now under power's watchful eye. What can painting do about it? It's notable that this is an uncommonly large canvas for Tuymans; no matter how loudly painting speaks, he suggests, it is virtually mute in the face of inexorable assaults on our privacy.

Tuymans draws on isolated filmed images far more than he draws on photography. But whereas his interest in cinematic moments relates to their mnemonic capacity ('after seeing a film I try to figure out which single image is the one with which I can remember all the moving images of the movie,'[4] he has said), his approach to painting is the inverse. Ideally, the painting itself dissolves in a welter of associations and mental images, at least partly because it so obviously can't hold the weight of what it alludes to. A painting of an innocuous room that becomes a death trap (Tuymans' well-known *Gas Chamber*, 1986); and a painting of four hazy faces, mug-shots arranged in a grid, entitled *Prisoners of war* (2001, p. 119) – these are calculatedly weak

strikes against the vast desolations referenced. And, of course, Tuymans' desiccated brushwork, bloodless palette and rationing of pictorial information all add to the sense of tottering insubstantiality. Looking askance or at some piece of sanctioned information, making a painting that the wind might blow away – these are confessions of cultural defeat, situating Tuymans' expanding *oeuvre* as a perpetual death rattle or a performance enacted after hours, on a dusty stage before a dropped curtain.

A photograph can't easily reflect on its efficacy in this way. While a camera, whether still or cinematographic, locks its jaws on the subject in a split-second, a painting requires time. In a painting based on a photograph, the very act of remaking infers that the photograph was *not sufficient*. We bring to its reception an awareness of the painter's subjectivity, the way they have prowled around the photographic image, altering its emphases through painting it, memorialising their reflections of the photograph's effect with each brushstroke. We may privilege this to a delusional degree, but nevertheless the notion persists that decisions made in painting have a significance that they don't in photography, where they might be contingencies, slips caused by the mindless recording machine.

In 2001, Wilhelm Sasnal made a series of five paintings based on inked panels from Art Spiegelman's graphic novel, *Maus: A Survivor's Tale* – selecting images of concentration camps while, almost

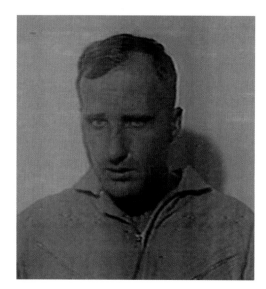 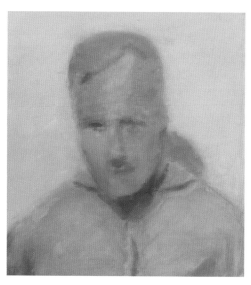

Far left: Photo source for Luc Tuymans, *Prisoners of war*, 2001 (cat. 99, p. 119, detail reproduced left) Television still

without exception, editing out the figures. Enlarged, the clean-lined illustrative style directly recalls Pop art, specifically the paintings of Roy Lichtenstein; the rhetorical effect of Sasnal's elision is to bring the Holocaust, and the world of assembly-line production and consumerism that was Pop's particular focus, into uneasy dialogue. The paradox that such a removal of information can have an additive effect, one of few constants in Sasnal's restless art, is also visible when he works from photographic imagery.

There's a ghost of a photograph in *Kielce (Ski Jump)* (2003, p. 144), one taken, to judge from the painting's title , in Poland. Here hard data runs out. Any verifiable sense of scale has absconded: the grey landscape is built from broad, loose brushstrokes; its vegetal fringes could be rushes or trees. The spindly, silhouetted, man-made slope that dominates the competition looks resolutely non-functional but, reduced to an outline, otherwise resists classification. It threatens to morph into an oil derrick, or a lookout tower. The latter association is characteristic, since sleepless spectres of the past flit through Sasnal's canvases. A painting such as *Tarnow, Train Station* (2006, p. 148) may depict contemporary African immigrants and guest workers in Poland, but it is hard to look at without considering, to some degree, the doomed human cargo that the country's railroads carried some 60-odd years ago (As Sasnal noted in one interview, 'I constantly get the feeling that we are not living in the post-1989 but the post-1945 period.'[5])

Then again, post-communism is hardly a dismissible aspect of Sasnal's work; in particular, it seems an activating context for his formal decisions. When he ranges about stylistically, rehearsing the pursuit of an adequate pictorial language in a manner that analogises a search for identity, it feels inseparable from Poland's post-Communist reconstruction process. But what's consistent in Sasnal's restless aesthetic, his resistance to detailing, also serves a purpose;

several, in fact. On the one hand, it can be seen as an approach tailored, sardonically so, to the increasingly Capitalist ambience of post-Communist Poland – reflecting a leaching of individuality as anonymous international corporations move into the country. One discerns this in paintings such as *Gas Station 1* (2006, p. 149), a featureless fuel stop in a landscape that itself seems to be losing its individuality, and in *Factory* (2000, p. 147), an image of unruffled production featuring two female workers manipulating unidentifiable jars. At the same time, however, there's another angle to Sasnal's limiting of pictorial information, one that gives some kind of symbolic power back to the audience. The diminution of detail takes the image out of a verifiable world, turning it into an instant icon, but also opening it up to new potential meanings as viewers fill in the blank spaces. A pale echo of Barthes' 'Here it is' is accompanied by questions, whys and wherefores: your best guesses are welcomed.

Painting-after-photography, one might say, is chiefly concerned less with the specific image than with how the painter remakes it, and how the painter's querulous engagements with, or diversions from, the photographic reflection of reality function as implicit comments *on* that reality. Yet it's possible for the painter to speak eloquently by choosing to do very little to the photographic image. Liu Xiaodong's paintings, which tend to be based on his own photographs, survey an estranged environment. His eye drifts, as in *A Transsexual Getting Down Stairs* (2001, p. 141), to society's elective outsiders. In *Three Girls Watching TV* (2001, p. 140), off-duty prostitutes sit on a bed together, gazing blankly at an out-of-frame screen. Their expressions run a gamut from bored to semi-satisfied; overall, as they sit marooned in this dead time between engagements, one senses they have been fleeced of a real life.

Liu's painterly style, which suggests an unbuttoned, down-at-heel photorealism, has been dubbed Cynical Realism. It's an approach –

minted by him and several others in the disheartened wake of the Tiananmen Square protests in 1989 – that holds up a cracked mirror to the Cultural Revolution's impersonal painterly aesthetics by focusing on endemic disaffection and disharmony in contemporary China. What one feels is a subtle dislocation from the photographic original, whose source can be hard to place: sometimes Liu substitutes backgrounds from another image, sometimes he collages figures together. This nagging sense of wrongness, of displacement, situates photography's clarity as synonymous with normality, and painterly deviations from it as reflecting something having gone awry. But at the same time one feels, in Liu's art, something like performed exhaustion: as if contemporary China were enervating the artist to the point that he can only just begin to editorialise on it.

Johanna Kandl, in paintings often based on her own snapshots of life in post-Communist Eastern and South-Eastern Europe, also works

in a relatively realistic style that carries critical echoes of Socialist Realism. What she paints, though, is far from triumphant or ideological: rather, her subjects are the street markets and backyard sales, and the economic underclass that frequents them, at the unregulated fringes of societies entering the globalised economy. A favoured technique of hers is to juxtapose a downtrodden vista with an upbeat textual overlay redolent of advertising slogans or marketing-speak. So, in *Untitled (Love it,…)* (2005, p. 150), a discordant sprawl of stalls scattered with car tyres and people who've evidently nowhere else to go, on wasteland at a city's edge, bears the overlaid legend: 'Love it, leave it, or change it.'

Not that Kandl always requires the use of sardonic textual counter-weights, as *Carnival Liberty* (2006, pp. 154–155) clarifies. Fusing snapshot photography's mobility with a cool gravity that belongs to painting, its image of immigrant bag sellers by the waterside – with a sleek luxury liner in the background – speaks eloquently enough through stark juxtaposition. Asked to define truth, Bob Dylan once gave the example of 'a photo of a tramp vomiting into a sewer, and next to it a picture of Rockefeller.'[6] That's the kind of truth we have here. There are other kinds, of course. It's notable that to varying degrees, numerous painters working thoughtfully with photography take on board the profound indeterminacies of painting and instrumentalise them, make them serve a latent argument. There's a deep purpose, for example, to Thomas Eggerer's remodelling of photographs. The citizens in his loosely-painted canvases – such as

Above: Photo source for Liu Xiaodong, *Three Girls Watching TV*, 2001 (cat. 71, p. 140). From Liu Xiaodong's series 'A room in Beijing'

Left: Photo source for Liu Xiaodong, *A Transsexual Getting Down Stairs*, 2001 (cat. 70, p. 141). From Liu Xiaodong's series 'Transvestites in Singapore'

The Fountain (2002, pp. 158–159) and *Mezzanine* (2004, p. 161) – can seem dangerously disenfranchised by their quivering milieus. As the art historian David Joselit has noted, there is a twenty-first century social analogy to be made here: 'Through the abstraction and decontextualisation of their movement,' he writes, 'these characters seem alternately aimless and stunned. Subject to both violence and the law, they are the true citizens of terror.'[7] Eggerer highlights the hidden substrate of anxiety in what was, presumably, superficially serene photographic source material. He points out, generally, how near the landscape of modernity is to an outright rejection of its inhabitants and, specifically, that public spaces – frequently riddled with security cameras – are designed more for containment than for civic pleasure.

So photography and filmic media partake of this architecture of control, contributing in various ways to widespread anomie and fear. They also mould our vision, as is further clarified by the paintings of Eberhard Havekost. His *Hotelsprung* (2003, p. 172), featuring a half-dressed woman bouncing on a hotel bed, suggests not only a photographic source but an actively manipulated, Photoshopped one. The figure, thickly outlined, looks pasted on; her features are weirdly blurred in a way that the rest of her moving body isn't, and her limbs seem disproportionate to her head. But only mildly so, considering Havekost's other paintings where one typically scents wrongness before one sees it, and viewing becomes an exercise in applied paranoia. The real is gone.

Gone too, entirely so, is any sense of the viewer's agency. Havekost has made all the moves in advance. In *American Lip Gloss, B06* (2006, p. 177), descended from a crime photograph of a car-jacking that became a murder, the dead victim is doubly distanced from us: first through photography and evident processes of digital distortion – the colour is jacked-up and unrealistic, the car's interior is stretched and wrenched – and then through painting. Havekost makes paintings that are both icy and beautiful, but there's never any question that his technique is another distorting filter, pushing us further away from an empathetic relationship to the (here, catastrophic) subject. Again, this is a moral position. Our ability to countenance life and death as more than some kind of realistic video game, Havekost suggests, is continually diminished by the technologies through which we're permitted to perceive it.

Clearly artistic temperament has some bearing on this stance, as one might note by comparing Havekost's attitude to celebrity against that of Elizabeth Peyton. In 2006, Havekost painted *Before the Oscar, B06,* a diptych comprised of a smeary image of the American actress Reese Witherspoon at the Oscars hung beside a painting (again based on a freeze-framed TV image) of a Palestinian man shot in the neck. Peyton's approach, however, seems wildly removed from Havekost's alienation techniques and upfront pessimism. She prefers intimate off-duty moments where the true personality behind the mask might be glimpsed. Were she to paint Witherspoon, the established context of her art thus far might suggest it would be out of unfeigned admiration.

Admittedly, the American actress isn't quite her type: Peyton has previously gravitated towards delicate figures – man-child pop vocalists like Kurt Cobain, Liam Gallagher and Eminem (who, in 2002, she painted as a little boy in a birthday crown); her svelte bohemian friends in the *demi-monde* of the art world; and British royalty. One pictures her studio as scattered with fashion, music and celebrity gossip magazines, with Peyton working from torn-out, pinned-up images. The photographic source in her paintings, where one is apparent, whiffs of the teenage bedroom wall.

Again, though, the motherlode of meaning resides in *how* Peyton paints: her degree of departure from the photograph (which potentially belongs to everyone, this being the sphere of collective fantasising) to the painting, whose handling narrates her response to the image. A superficial reaction to Peyton's paintings of famous people might be that each stroke made personalises a relationship to this given envoy from our pop-cultural aristocracy – bringing them closer, in some borderline-creepy way. But her art seems more melancholic than this, less about the artist's longings than about the travails of her subjects, those fragile butterflies pinioned in the limelight. She painted Prince Harry repeatedly in 1997, the year that Princess Diana died. The motherless prince typically appears alone, a little-boy-lost look in his eye. Even in a group, as in *Arsenal (Prince Harry)* (p. 137) – his face lit white beneath a football supporter's beanie hat and far more beautiful and feminine than in life – he seems miles away. What Peyton does here, and what she does best, is to record the transfiguring pressure of private life on public faces. Harry, however, is an exception in that a long stay in the spotlight is

his birthright; for many others whom Peyton paints, their fame or notoriety will likely be as insubstantial as the pointedly wispy brushstrokes with which she concertedly portrays them.

Still, Peyton leaves space for the viewer to manoeuvre. She does not overtly editorialise. Her paintings are not blurred, exactly, but there is a cognitive haze around the subjects: she pictures them as ciphers for a culture, at once brittle and larger than life. This is the metaphysical machinery of painting clanking into life, transforming what it touches. All of this, the way in which the painting is a screen for the viewer's own negotiating process, is seen even more clearly in Judith Eisler's paintings. If Tuymans seeks in cinema the moment from which he can construct the whole, Eisler – watching arthouse DVDs with a finger on the pause button, then making paintings from her stolen moments – halts the flow at *unmemorable* images; the ones we'd blink and miss, but which attain an unlikely power when painted. *Gena (Opening Night)* (2003, p. 168) features an interstitial instant from John Cassavetes' 1977 film *Opening Night* in which the actress, Gena Rowlands, barely remains in the frame. Thanks to Eisler's glossy, smeary style, in which contours seem to overlap and meld, Rowlands' cropped head and body shimmer and vibrate, seemingly sustaining the moment before the frame was frozen and even anticipating what comes next – which, one feels, is no longer predetermined by the film's narrative, but whatever we choose. The story is ours.

Yet painting can equally deny access into the filmic or photographic image, or leave our reception of it relatively open yet overwhelmingly paranoid, as Johannes Kahrs ably demonstrates. Kahrs' dark, defeated-feeling paintings (he also works in charcoal, which suits his inferences of gloomy sex and violence) originate in fragments of found imagery. These he subjects to processes of cropping, photocopying, rephotographing of photocopies, engendering blurs

Eberhard Havekost
Before the Oscar, B06, 2006
Oil on canvas
Diptych; left: 57×40 cm; right: 35.5×37.5 cm

and exacerbating contrast, and then paints the distorted outcome and exhibits it behind darkened glass. From the fragment of reality we can see, such as in *Figure Turning (large)* (2006, p. 162) with its cropped, dehumanised image of a woman twirling awkwardly in a revealing dress, we can guess that the image originated from an unhappy place. But Kahrs' rigorous mediation ensures that it also seems unreachably far away, instilling an almost suffocating sense of fatality.

Even when his selected scene curves back towards comforting familiarity – e.g. two paintings entitled *La Révolution Permanente* (2000, pp. 164–165) and *93'09"* (1997, p. 166), the first featuring Mick Jagger in Jean-Luc Godard's 1968 documentary on the Rolling Stones, *Sympathy for the Devil;* the second, Robert De Niro's sociopathic Travis Bickle in Martin Scorsese's 1976 film *Taxi Driver* – there's an attendant anxiety. Particularly in the latter case, with its fuzziness and glaring light, we might imagine Kahrs zooming in on a film playing on television, in a dismal apartment where some troubled character is nursing his alienation. Maybe we know what happens next in the movies referenced, but the larger story – what happens after this fictional character turns off the film and continues his life – is troublingly opaque.

Mediums tied to time, when film and photography are interjected within painting they can turn the latter medium temporal, emphasising through a compounded displacement that the pictured event is in the unreachable past. If the event is sour, as in Kahrs' art,

it is irreparable. If sweet, it is unreachable. The urge to revisit is palpable in Peter Doig's paintings; even though his work's evocation of lost moments invariably opens onto a past embroidered and distorted, gone symbolic, by the operations of memory. In Doig's early work *The Hitch-Hiker* (1989/90), a charged particle of narrative set on the road between Montreal and Toronto, close to where the artist's father lived, a red truck cuts across a green landscape beneath a lowering sky, beaming its headlights forth; a tiny figure is visible in the cab. A photograph couldn't convey the impression of drama, in which the idea of a place departed from and a place headed towards attain portentous weight; it's down to Doig's dribbling layers of paint on the raw surface of postal bags, the sodden sky that presses downward, the fragile-looking vehicle negotiating the night.

Again, here is painting pushing photographic specificity towards something cloudier, larger. *Concrete Cabin II* (1992, p. 130) stems from photographs of a subject Doig compulsively returned to between 1991 and 1999 – Le Corbusier's Unité d'Habitation de Briey-en-Forêt, a 1956 Brutalist block nestling in now-overgrown woodland in Northeast France. Co-opting a suspenseful point of view familiar from horror films (some of Doig's early paintings were inspired by *Friday the 13th*), it's suffused with foreboding, and yet clearly the disaster – the annihilation of Modernism's ideals – has already happened. The undergrowth might be analogous to the faultiness of recall; but the painting, in fact, remains open-ended, a collision of the natural and the man-made which creates a poetic spell and opens itself to numerous readings.

Working drawing for Johannes Kahrs, *La Révolution Permanente*, 2000 (cat. 47, pp. 164–165). Painted film still from *Sympathy for the Devil*, 1968

Working drawing for Johannes Kahrs, *93'09"*, 1997 (cat. 46, p. 166) Painted film still from *Taxi Driver*, 1976

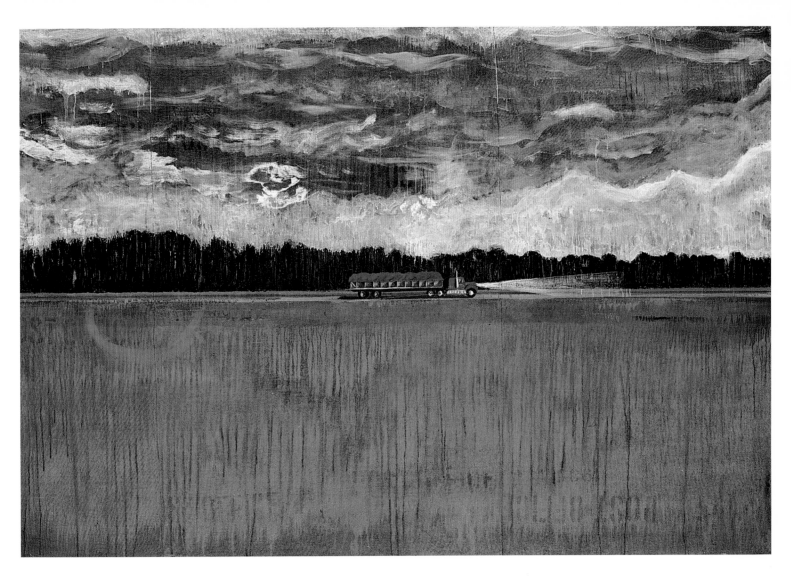

As such, it activates the mortal appetite for mystery. There's a tendency, when considering painting-after-photography (and, of course, –film), to presume the painter is making cool-headed, fundamentally tactical moves, but this is not always the case. In this loosely convened subgenre there is frequently a seeming reflection of the world as it appears, the glimmering obscurity that it turns out to be, and the perpetual rehearsal for uncertainty that accompanies any attempted understanding of the image. With regard to this last aspect, the stakes are matchlessly high, as Gerhard Richter reminds us. Having avowed that 'good paintings are incomprehensible', five years later he compared the experience of painting to psychoanalysis, which, said Richter, 'takes away prejudices and turns us into responsible adults, autonomous beings who can act more rightly and more humanely in the absence of authorities, or God, or ideology.'[8] The notional space between the photographic image and the painted one is frequently, as these works amply disclose, a pleasurable destination. It may also be a vital one.

Notes

1 Roland Barthes, *Camera Lucida*, Editions du Seuil, Paris, 1980, p. 5.

2 Gerhard Richter, 'Notes, 1981', in *The Daily Practice of Painting: Writings 1962–1993*, Hans-Ulrich Obrist (ed.), Thames & Hudson, London and New York, 1995, p. 99.

3 Gerhard Richter, 'Interview with Rolf Schön, 1972', ibid, p. 74.

4 Luc Tuymans interviewed by Juan Vicente Aliaga, ibid, p. 12.

5 Wilhelm Sasnal interviewed by Andrzej Przywara, in *Night Day Night*, Hatje Cantz, Ostfildern-Ruit, 2003, p. 39.

6 Bob Dylan, interviewed in *Don't Look Back*, D.A Pennebaker (dir.), 1967.

7 David Joselit, 'Terror and Form', in *Artforum*, January 2005, p. 45.

8 Gerhard Richter, 'Interview with Benjamin H.D. Buchloh, 1986', ibid, p. 150.

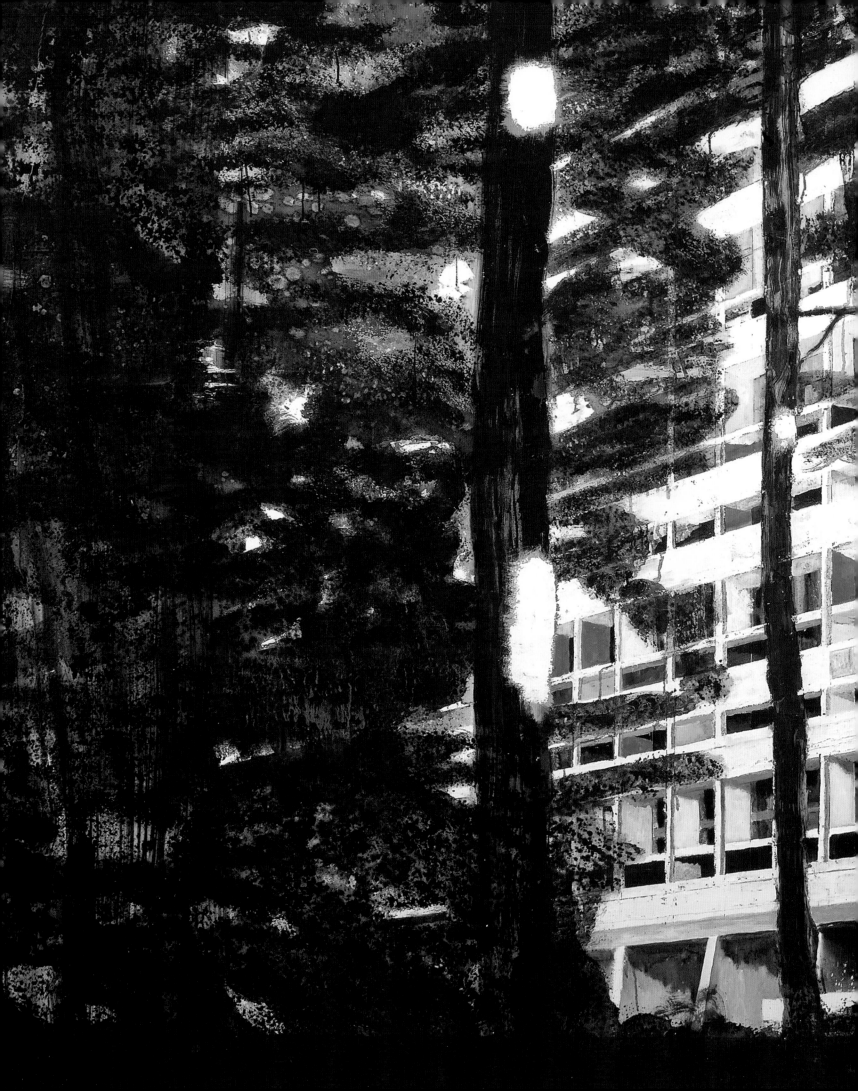

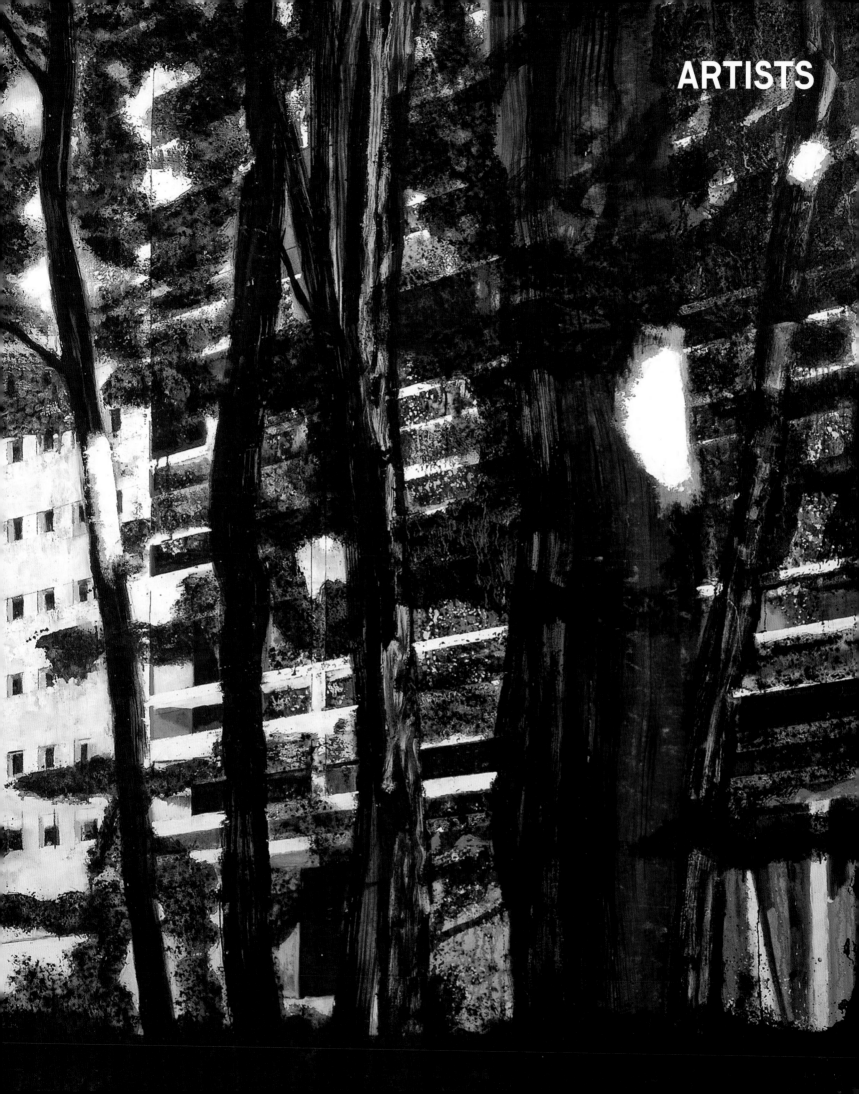

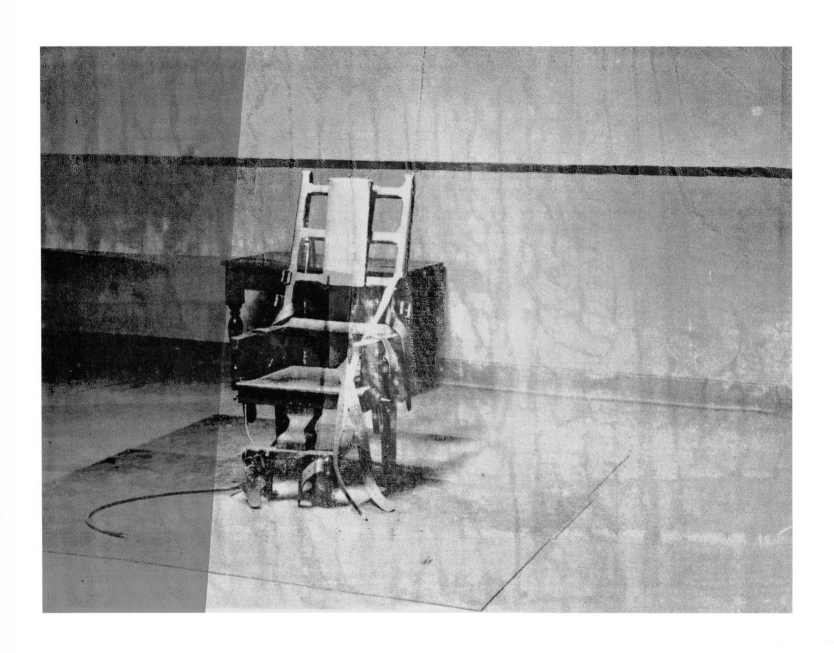

ANDY WARHOL

Born in 1928, Pittsburgh, USA. Died in 1987, New York, NY, USA

I don't choose images randomly, but make a careful selection through elimination … As for the paintings, the images I've used have all been seen before via the media. I guess they're media images. Always from reportage photographs or from old books, or from four-for-a-quarter photo machines. I don't change the media, nor do I distinguish between my art and the media. I just repeat the media by utilizing the media for my work. I believe media *is* art … No one escapes the media. Media influences everyone. It's a very powerful weapon.[1] **I started [using photo silkscreens] when I was printing money**. I had to draw it, and it came out looking too much like a drawing, so I thought wouldn't it be a great idea to have it printed. Somebody said you could just put it on silkscreens[2] … I've had to resort to silkscreens, stencils and other kinds of automatic reproduction. And still the human element creeps in! A smudge here, a bad silkscreening there, an unintended crop because I've run out of canvas – and suddenly someone is accusing me of arty lay-out! I'm anti-smudge. It's too human. I'm for mechanical art. When I took up silkscreening, it was more to fully exploit the preconceived image through the commercial techniques of multiple reproduction.[3] **I read an article on me once that described my machine-method of silkscreen copying and painting**: 'What a bold and audacious solution, what depths of the man are revealed in this solution!' What does *that* mean? My paintings never turn out the way I expect them to but I'm never surprised.[4] **I just like to see things used and reused**. It appeals to my American sense of thrift.[5] **The death series I did was divided into two parts: the first on famous deaths and the second on people nobody ever heard of** and I thought that people should think about them sometime: the girl who jumped off the Empire State Building or the ladies who ate the poisoned tuna fish and people getting killed in car crashes. It's not that I feel sorry for them, it's just that people go by and it doesn't really matter to them that someone unknown was killed so I thought it would be nice for these unknown people to be remembered by those who, ordinarily, wouldn't think of them. **When I read magazines I just look at the pictures and the words**, I don't usually read it. There's no meaning to the words, I just feel the shapes with my eye and if you look at something long enough, I've discovered, the meaning goes away.[6]

Andy Warhol
Big Electric Chair, 1967
Silkscreen and acrylic on primed canvas
137.2×185.5 cm
cat. 104

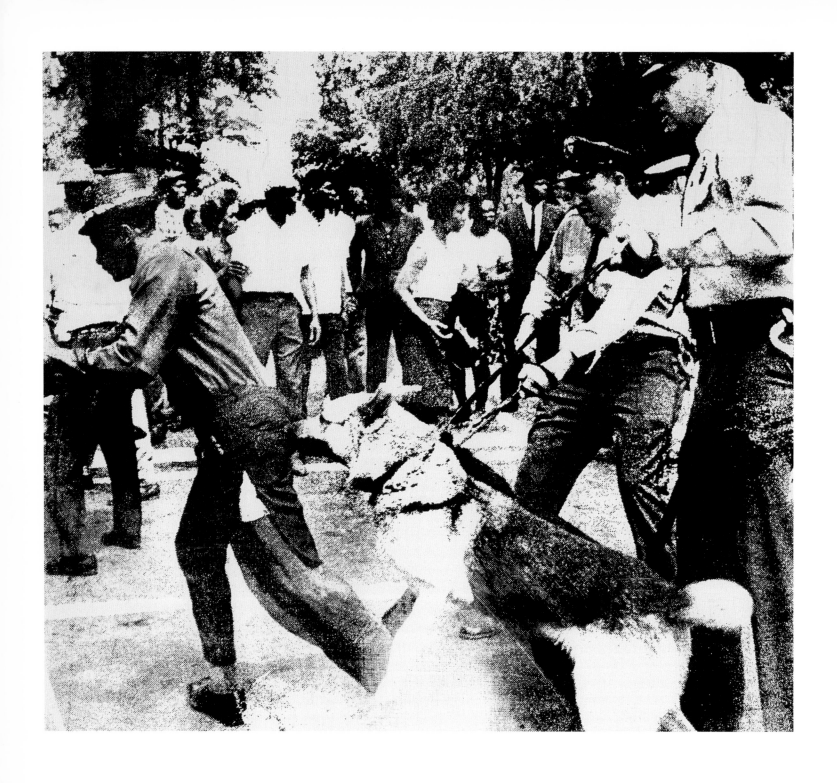

Andy Warhol
Race Riot, 1963 (detail above)
Silkscreen ink on linen
307×210 cm
cat. 103

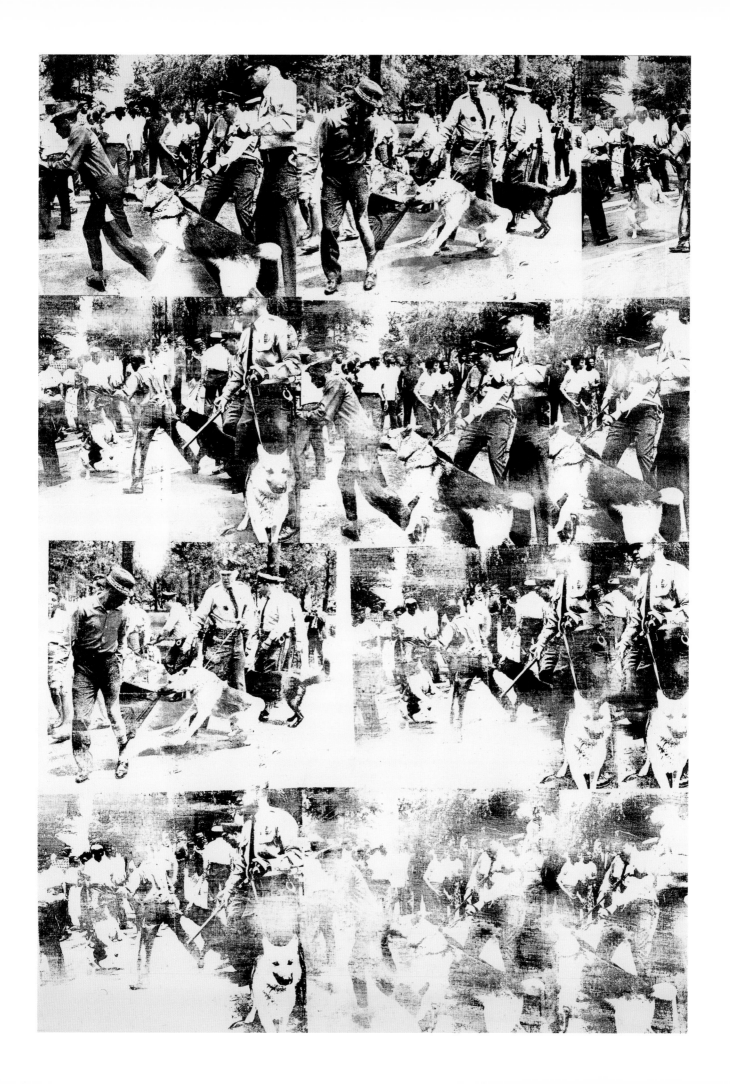

Andy Warhol
Orange Car Crash (Orange Disaster) (5 Deaths 11 Times in Orange), 1963 (detail below)
Acrylic and silkscreen ink on linen
220×210
cat. 102

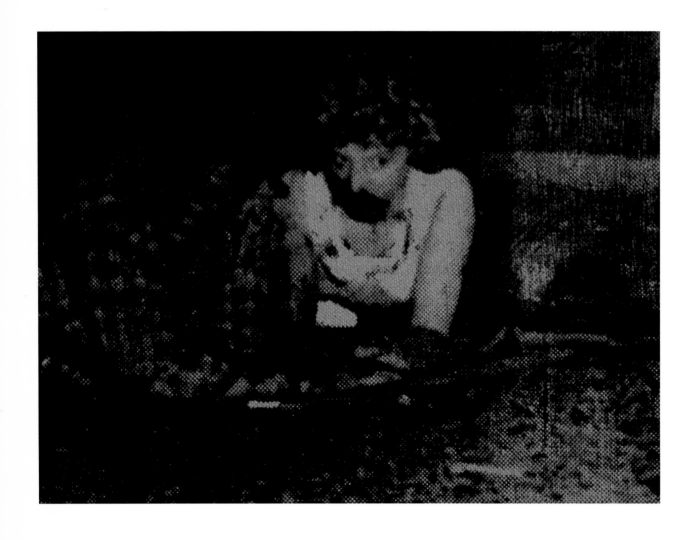

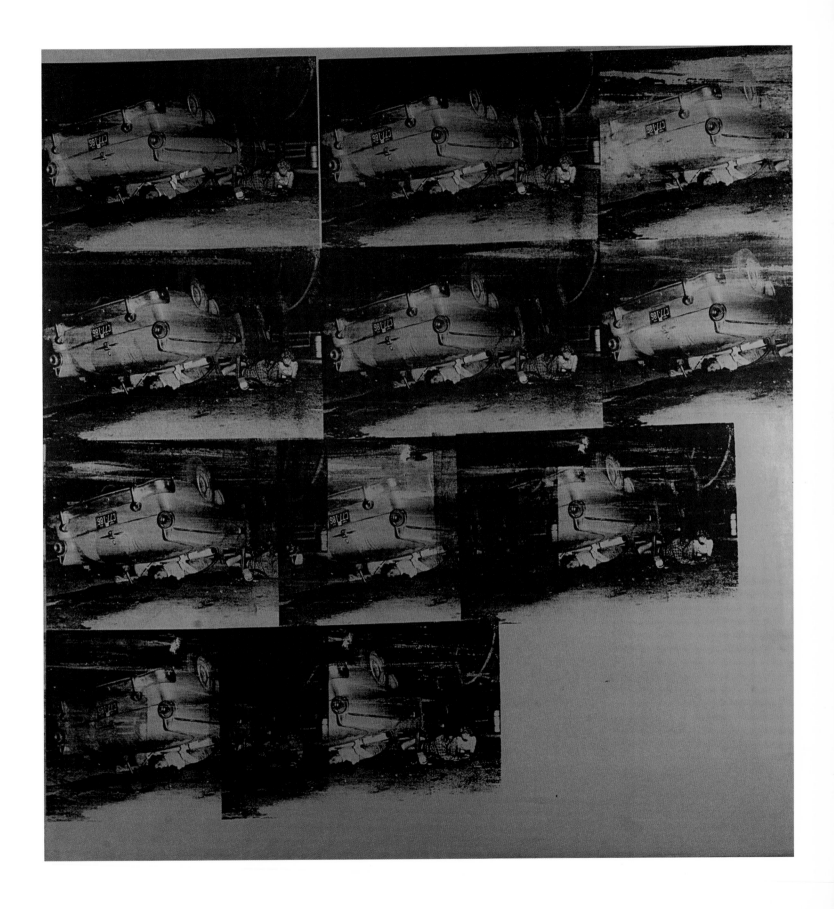

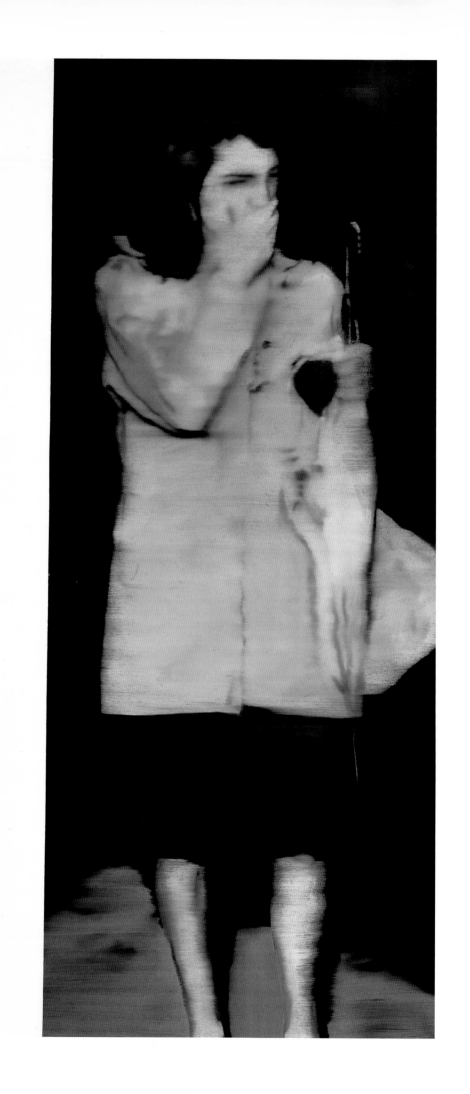

GERHARD RICHTER

Born in 1932, Dresden, Germany. Lives and works in Cologne, Germany

Photography had to be more relevant to me than art history: it was an image of my, our, present-day reality. And I did not take it as a substitute for reality but as a crutch to help me get to reality.[1] **Do you know what was great? Finding out that a stupid, ridiculous thing like copying a postcard** could lead to a picture. And then the freedom to paint whatever you felt like. Stags, aircraft, kings, secretaries. Not having to invent anything any more, forgetting everything you meant by painting – colour, composition, space – and all the things you previously thought and knew. Suddenly none of this was a prior necessity for art.[2] **I looked for photographs that showed my present life**, the things that related to me. And I chose black-and-white photographs because I realised that they showed all this more effectively than colour photographs, more directly, more inartistically and therefore more credibly. That's why I picked all those amateur family pictures, those banal objects and snapshots.[3] **Life communicates itself to us through convention** and through parlour games and laws of social life. Photographs are ephemeral images of this communication – as are the pictures that I paint from photographs. Being painted they no longer tell of a specific situation, and the representation becomes absurd. As a painting, it changes both its meaning and its information content.[4] **I'm not trying to imitate a photograph; I'm trying to make one**. And if I disregard the assumption that a photograph is a piece of paper exposed to light, then I am practising photography by other means.[5] **Composition is a side issue**. Its role in my selection of photographs is a negative one at best. By which I mean that the fascination of a photograph is not in its eccentric composition but in what it has to say: its information content.[6]

Gerhard Richter
Woman with Umbrella, 1964
Oil on canvas
160×95 cm
cat. 86

Gerhard Richter
Folding Dryer, 1962
Oil on canvas
99.3×78.6 cm
cat. 85

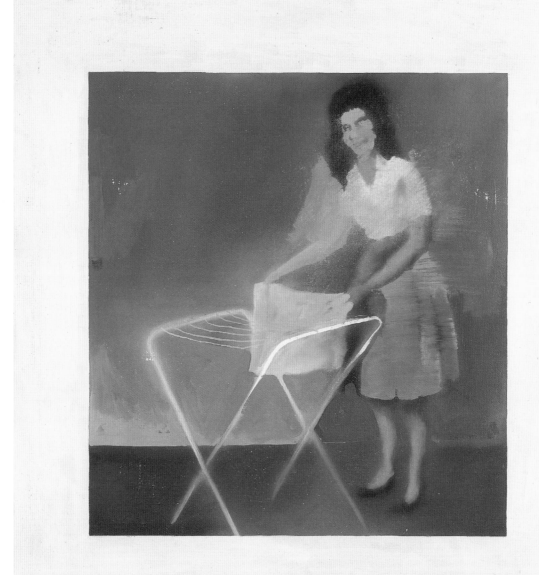

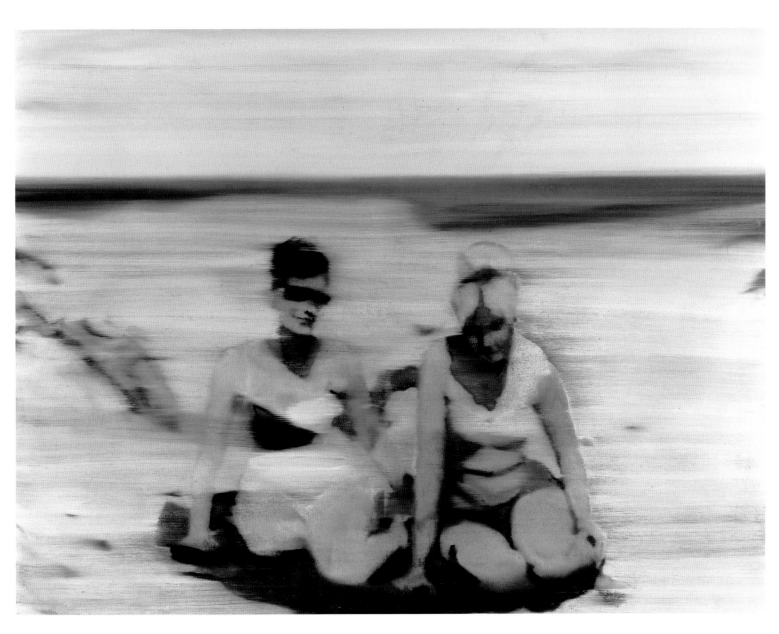

Gerhard Richter
Renate and Marianne, 1964
Oil on canvas on board
135×170
cat. 87

Gerhard Richter
Nurses, 1965
Oil on canvas
48×60 cm
cat. 88

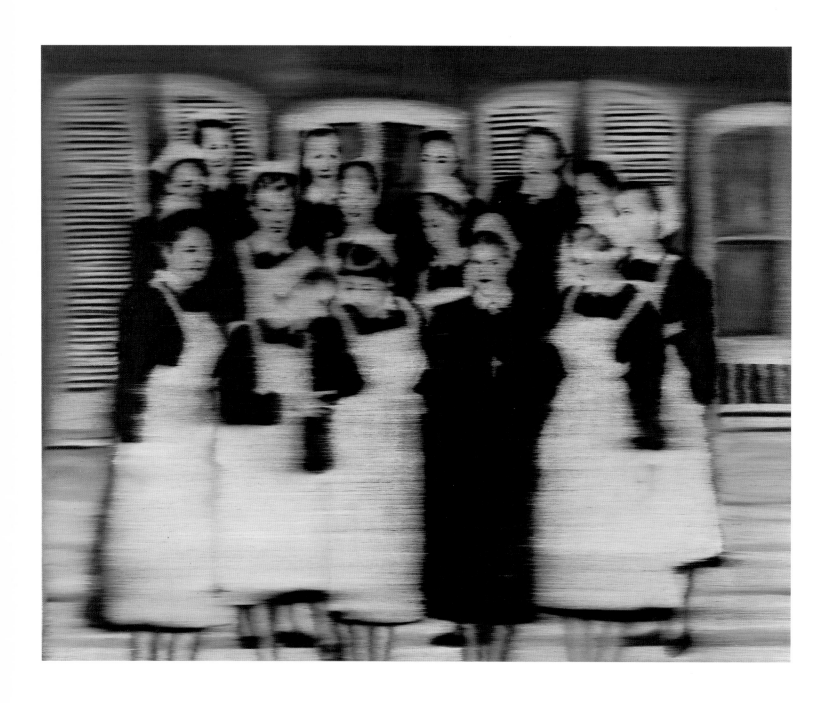

Gerhard Richter
Volker Bradke, 1966
Oil on canvas
148.7×199.2 cm
cat. 89

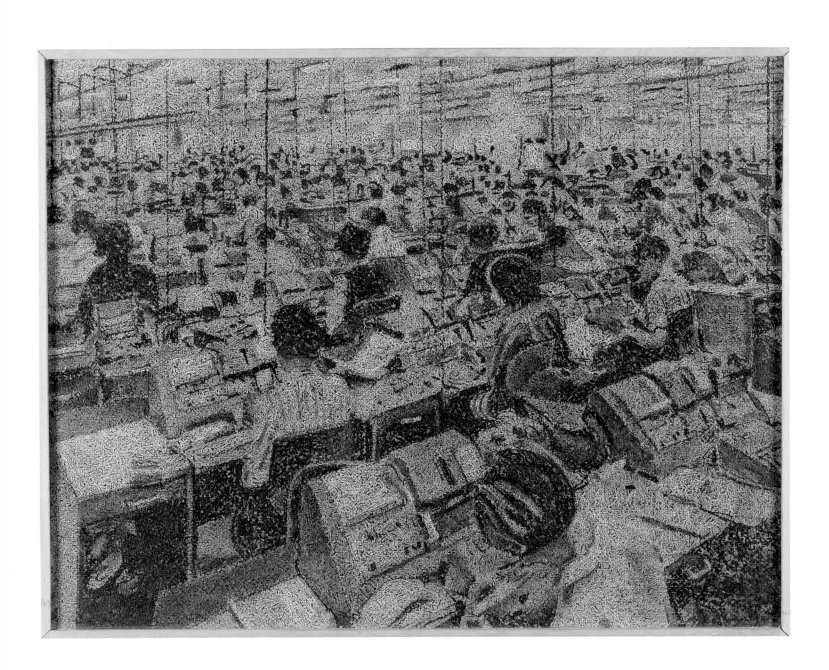

RICHARD ARTSCHWAGER

Born in 1923, Washington, DC, USA. Lives near Hudson, NY, USA

I started by taking photographs and making paintings of them. One of the very first was an architectural photo, 5×10 centimeters, which became a painting over 2 meters in size … I wasn't exactly trying to make paintings; I was trying to make … drawings on a heroic scale, of a large size, ambitious drawings that would have consequences … I thought in terms of making everything bigger, enlarging … The format and size has to be bigger, the drawing instrument has to be bigger, my arm has to be bigger. **At first, I was only concerned with photos from newspapers because there was something about the quality that I could exploit**, a kind of pathos that I could make use of and expand on to a degree, invent and so on. They were also certain kinds of newspapers, Spanish-language newspapers. In 1950, you started getting a lot of Hispanic people in New York, mainly from Puerto Rico, and that was around the time I came to New York.[1] **In the paintings themselves, there is a kind of fanatical detail** that wasn't translated directly into paint. I use dots, dashes, Xs, etc., and I do it a square inch at a time.[2] **Now I'm not clear why I picked up on photo imagery, but at the time I picked up on it** I thought that this could be my little terrain, and nobody else's … It would be something for me to … specialise in, as it were, in a low branch in the big tree.[3] **I shared with [Malcolm] Morley my idea of gridding of an 'anonymous' photograph** and reproducing it square by square, giving oneself to the making of each square independently of the whole, indifferent to the whole one might say. I elaborated a technique that embodied drawing, painting and some chemical action vaguely akin to photography, sticking to black and white. Morley normalized the procedure by using paint and canvas in a most direct fashion and, of course, color. He made a revolution using everybody's techniques and materials.[4]

Richard Artschwager
Fabrikhalle, 1969
Liquitex on Celotex with Formica on chipboard
57.5×76.5 cm
cat. 3

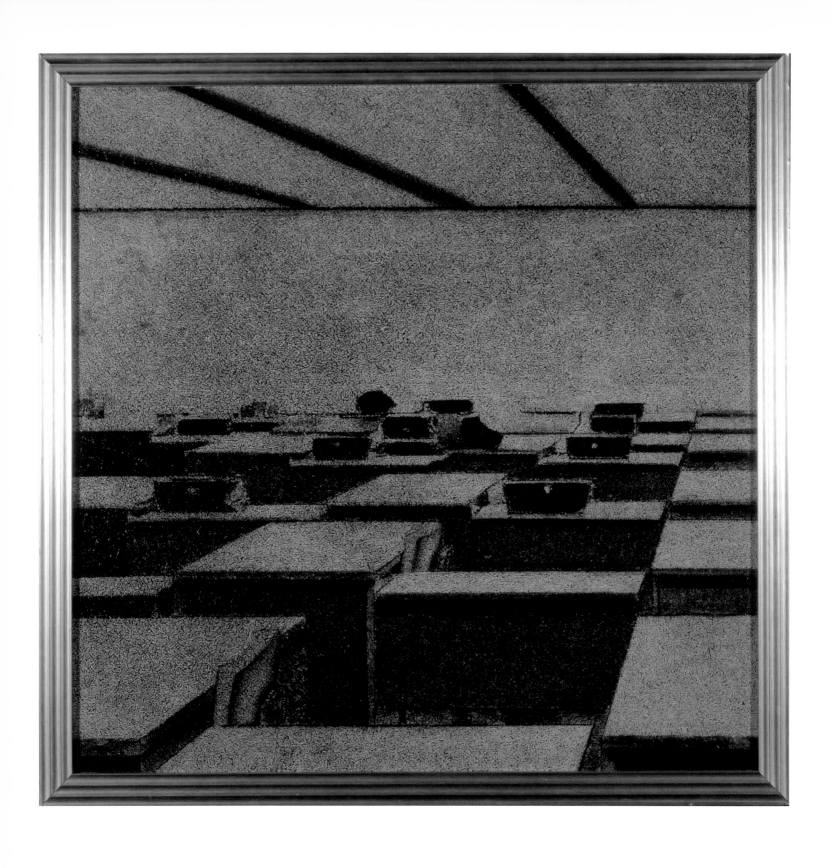

Richard Artschwager
Office Scene, 1966
Acrylic on Celotex with metal frame
106.5×109 cm
cat. 1

Richard Artschwager
Dormitory, 1968
Liquitex on Celotex with metal frame
84×69 cm
cat. 2

Richard Artschwager
Destruction III, 1972
Acrylic on Celotex, 2 panels
188×223.5 cm
cat. 4

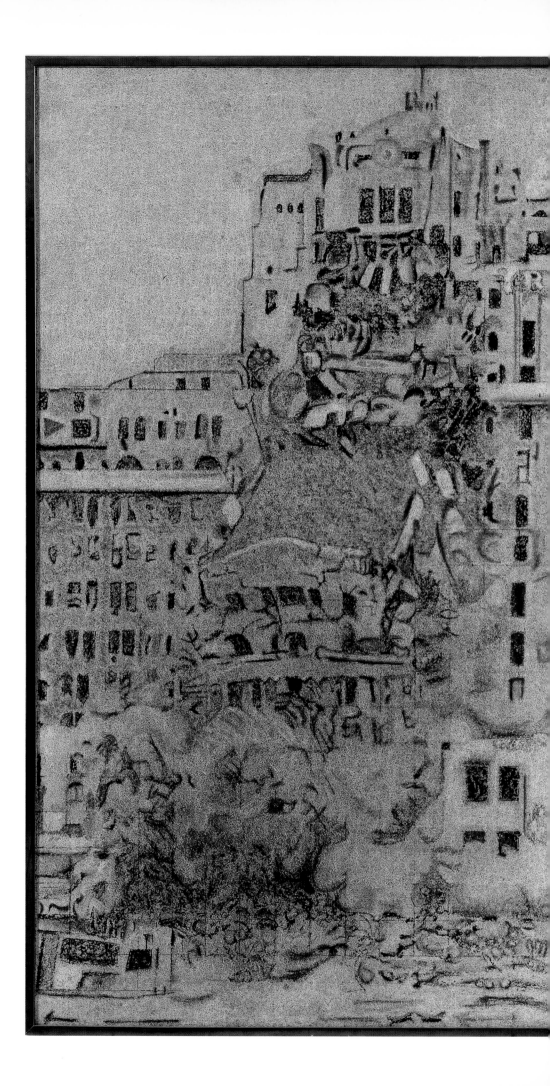

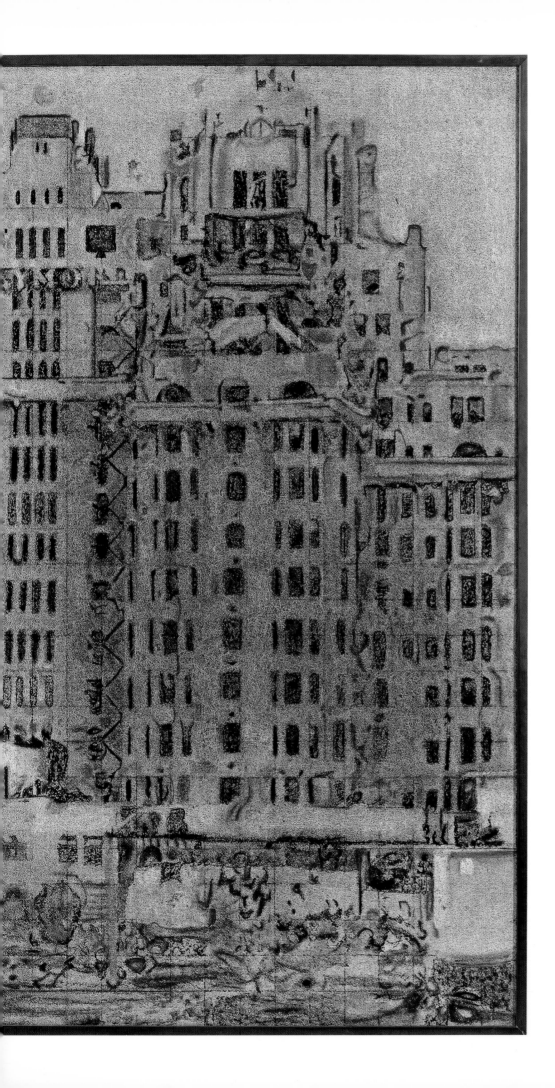

THIRTY-FIVE CENTS

AUGUST 20, 1965

TIME

THE WEEKLY NEWSMAGAZINE

THE LOS ANGELES RIOT

VOL 86 NO. 8

VIJA CELMINS

Born in 1938, Riga, Latvia. Lives and works in New York, NY, USA

Sometimes people think I just sit down and copy the photograph. It is precisely that I reinvent it in other terms that gives it another quality. It is the opposite of being mechanical. It is also not image-oriented. The image is one of the elements to work with.[1] **The photo is an alternate subject, another layer that creates distance**. And distance creates an opportunity to view the work more slowly, a chance to explore your relationship to it. I treat the photograph as an object, an object to scan. Actually, the first time I used photographs was really because I had been away from my family and was lonely. I had been going through bookstores finding war books and tearing out little clippings of aeroplanes, bombed out places – nostalgic images … I thought of it as putting the images that I found in books and magazines back in the real world – in real time. Because when you look at the work you confront the here and now. It's right here.[2] **I liked the surface of all those war photographs**. I painted them as objects that have a secondary image. Because it already has a surface, the photograph allows you to move away from the image. **I have always maintained the image in order to first present a sort of illusion**, and then deny it by making it flat in a way that we work to get through. I like the place in the middle where it shifts back and forth.[3] **In a way, the photograph helps unite the object with the two-dimensional plane**. Although I think that with the airplanes there is this kind of wonderful place where they really float, and then they become dimensional, and they take off as well as staying flat. I did not realize it then, but now I can see that the subject matter has a kind of internal tension that also exists in the work. The paintings tend to have an internal feeling, as if there was something behind what you see.[4]

Vija Celmins
Time Magazine Cover, 1965
Oil on canvas
56×40.6 cm
cat. 8

Vija Celmins
Explosion at Sea, 1966
Oil on canvas
34.3×59.7 cm
cat. 9

Vija Celmins
Flying Fortress, 1966
Oil on canvas
40.6×66 cm
cat. 10

Vija Celmins
Freeway, 1966
Oil on canvas
43.8×66.7 cm
cat. 11

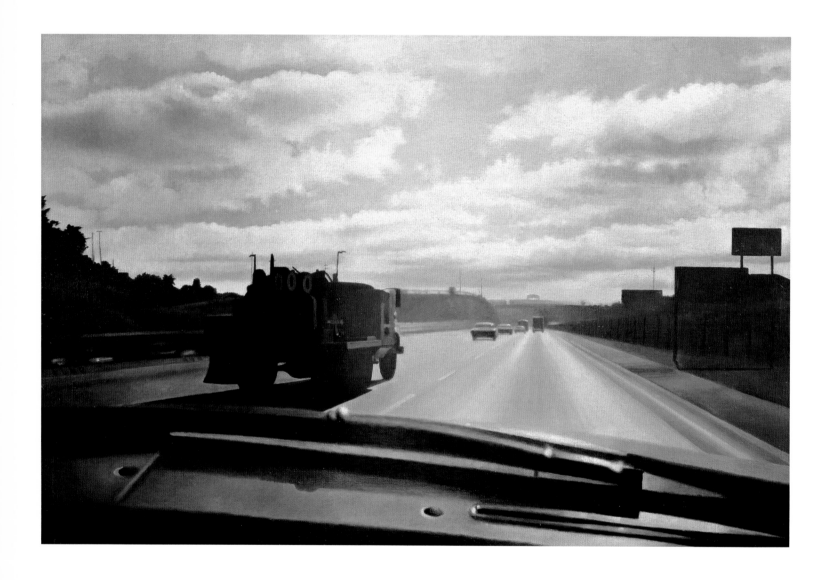

Vija Celmins
Tulip Car #1, 1966
Oil on canvas
40.6×68.5 cm
cat. 12

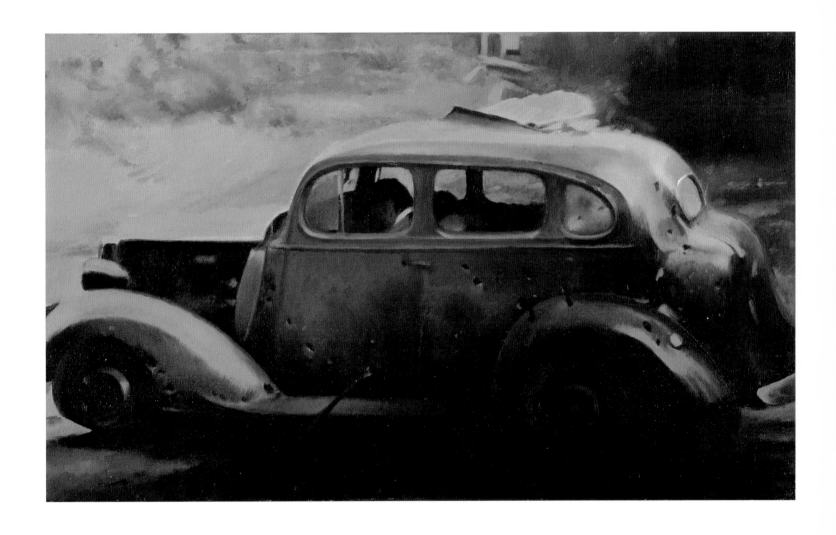

MICHELANGELO PISTOLETTO

Born in 1933, Biella, Italy. Lives and works in Biella, Italy

If art is the mirror of life, I am the mirror-maker.[1] **In 1961, the first
mirroring painting**. The painted figure stood out from the background,
becoming independent, while the 'mirroring background' received the image
of the spectator and the space behind him.[2] **A mirror is always ready to give
us accurate images** of the things that happen right in front of us, or of those
that take place a little further away, which we may not see. I even reached the
point of making *Mirror Paintings* with images of the Vietnam War. That was in
1965. These events clearly didn't take place on the street in front of me, but I
became aware of them through newspapers and television – I felt close to
them after all. Modern media bring us distant images instantaneously. In the
self-portraits, I started with my own image, then replaced it with images of
my friends and family, of everything that appeared around me … The mirror
is always there, waiting, for what will happen tomorrow, or in the future.
The image I put on the mirror is the image of an experience that immediately
becomes memory. As soon as one takes a photograph, the present becomes
a memory. One tries to hang onto the present via the memory, but one
knows that the present passes swiftly, that tomorrow is already here.
Why photography? Because the reflecting surface I used after 1962 demanded
a painting, a fixed image that had the same objectivity as the image reproduced
by the mirror. Only photography makes the image work as the eye sees it.
Photography alone creates the sense of memory. A painting, even a very
naturalistic one, responds to its own condition. A photograph truly represents
a past moment. So, memory is there. And it was very important for me to let
memory, the past, the present, and the future, come together at the same
time, in the same place.[3] **The purpose and result of my mirror paintings
was to carry art to the edges of life** in order to verify the entire system in
which both of them function.[4]

Michelangelo Pistoletto
Ragazza che cammina, c.1960 (installation shot, detail on right)
Painted tissue paper on steel
230×120 cm

cat. 83

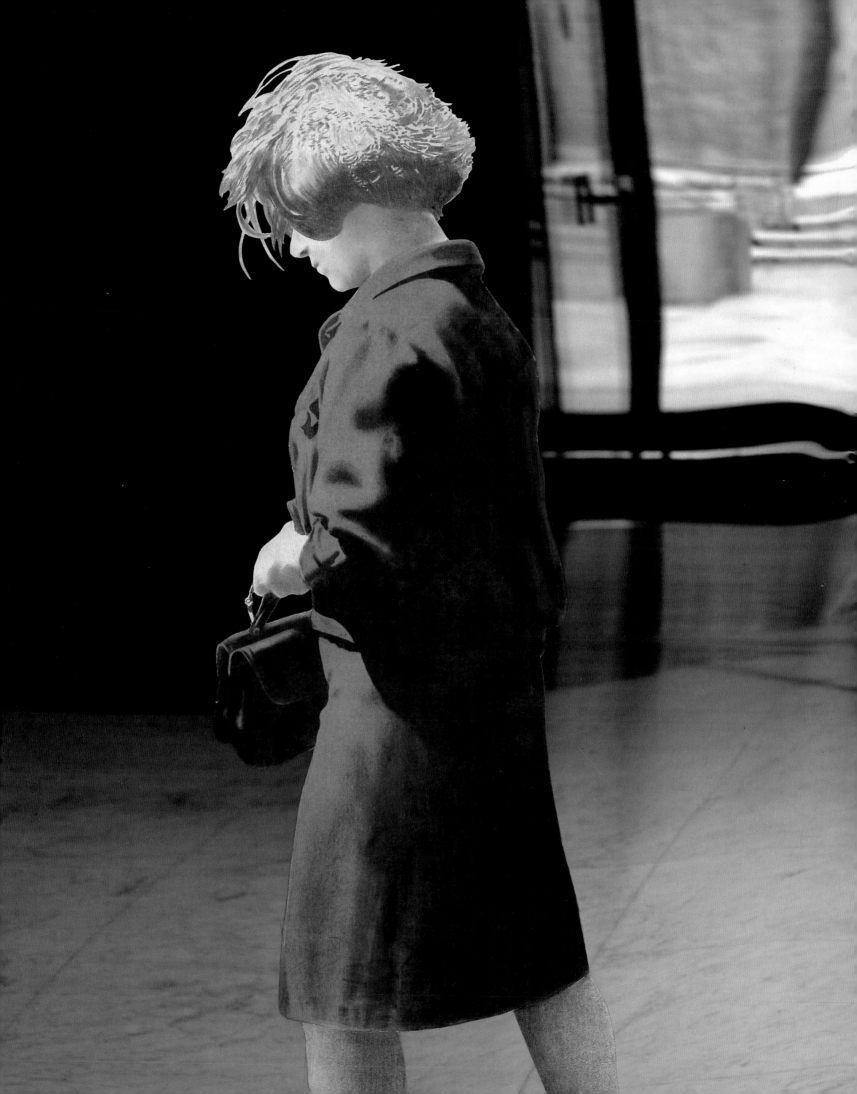

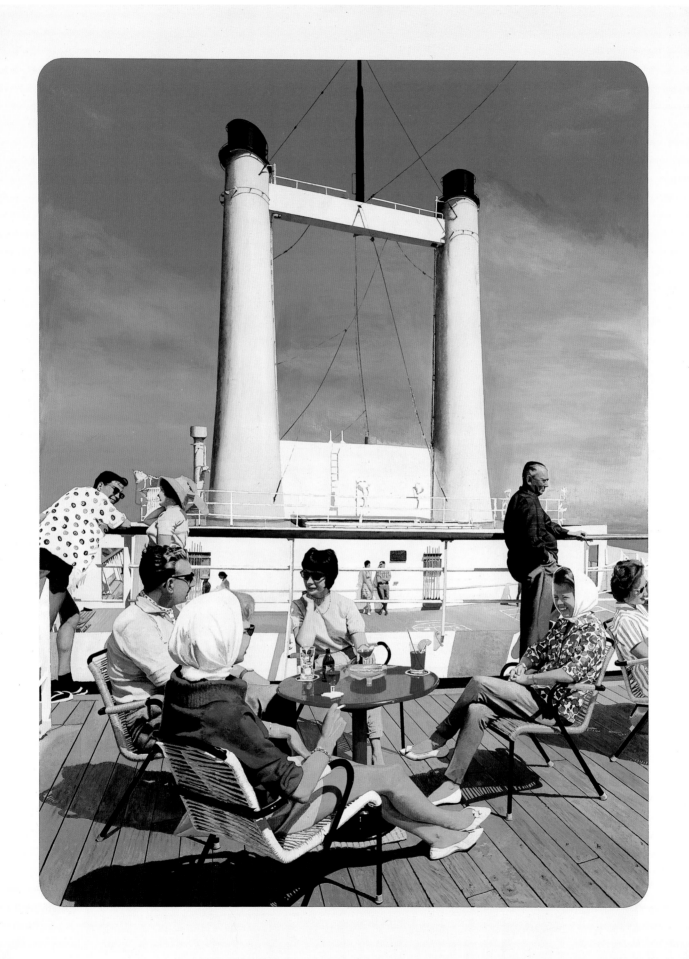

MALCOLM MORLEY

Born in 1931, London, UK. Lives and works in Bellport, NY, USA

When I began making my paintings from reproductions in the 1960s it enlarged the gene pool of images for me, as it opened up a vast variety of content. **When I said my super-realist paintings were a 'Dada' gesture**, I was referring to the idea that basically painting from a reproduction was painting a still life, because the image itself on paper still has three dimensions (including the edges). It is irrational to copy a reproduction and call it art. It is as irrational as Duchamp calling a snow shovel *In Advance of a Broken Arm*. **I don't think of the [photographic] source of a painting as second-hand [information]**. For me it is first-hand. I am relating to the print of the image. I am not relating to where the image came from. The relationship I have to it has to be on a one-to-one basis. It is the image I am looking at. Not only that, but to reinforce this idea I can look at a photograph but I couldn't paint a photograph because the surface is invisible. It coalesces, so to speak, whereas printed ink on top of paper is more of a physical entity that I can feel as paint. **The greatest difference between the Pop artists and me is that they wanted to get rid of touch** and a sense of the hand-made. I make a hand-made painting from a ready-made. **On a very mundane level, the borders [in my early paintings] were there because they were there in the source image**. And fidelity is the key word. They were justified because they were actually seen. I tend not to edit. Once I make the decision on an image I accept the totality of that image. In a sense, with the use of the borders I am putting the image in parenthesis or quotation marks. And it has a very striking clearness to it that distinguishes it from its environment. **The collapse of the foreground and background [in my paintings] is a by-product of the process**. I take a whole image and divide it into a certain amount of manageable parts cut up into separate pieces. In the process of painting those pieces I am looking at individual cells that on their own are a whole thing. There is no background and no foreground. In fact, I can paint them any way up I want because there is no right way up in terms of the perception of that cell, even though there is a right way up in terms of the image itself. It is a way of organising information, simplifying it so that I can comprehend it. I don't want to 'O.D.' on too much information. In fact, the less information there is in the cell, the more painting invention occurs in the corresponding place on the canvas. The scale itself of the cell is pretty paramount in terms of determining how it gets resolved as paint on canvas. For example, if the cell is too large and there is a lot of information in there, the organisation of all of that information tends to take away a certain sort of spontaneous inventiveness. The painting becomes more literal.[1]

Malcolm Morley
On Deck, 1966
Magna on canvas
212.5×162.3 cm
cat. 74

Malcolm Morley
Cristoforo Colombo, 1966
Liquitex on canvas
35.6×50.8 cm
cat. 73

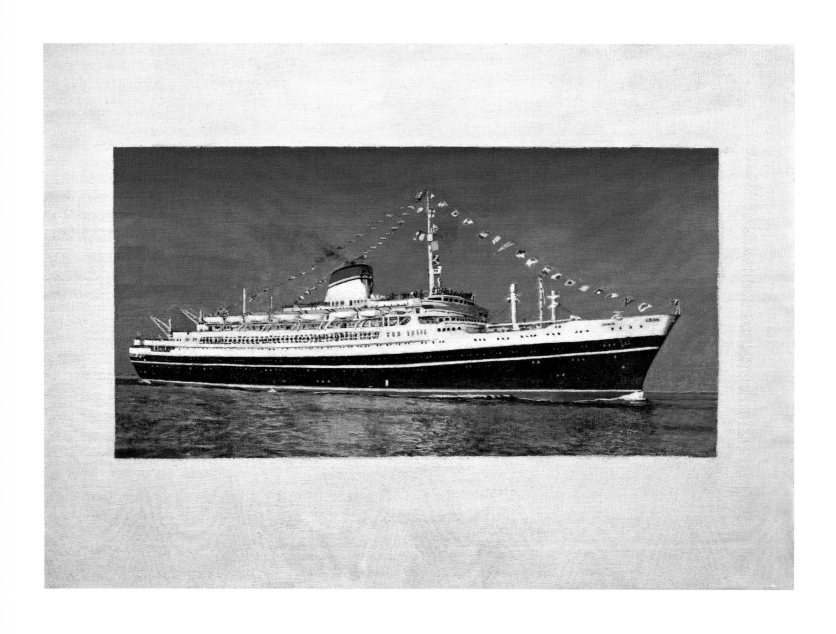

Malcolm Morley
Family Portrait, 1968
Acrylic and oil on canvas
172.7×172.7 cm
cat. 75

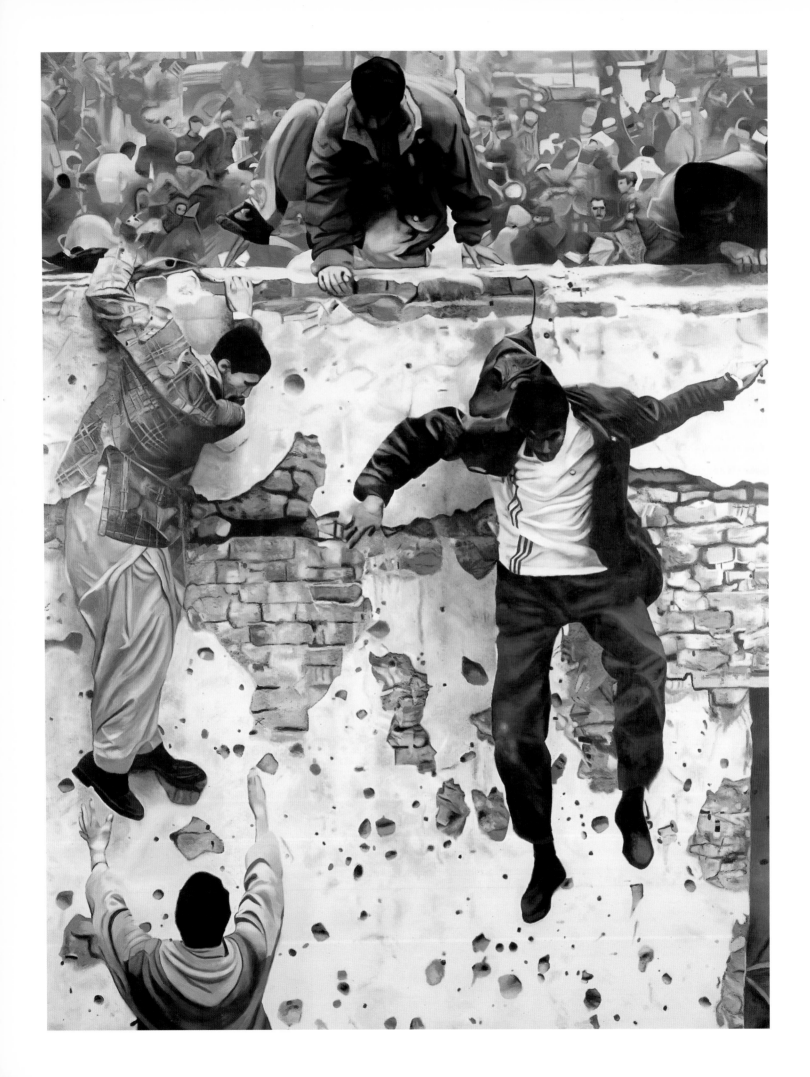

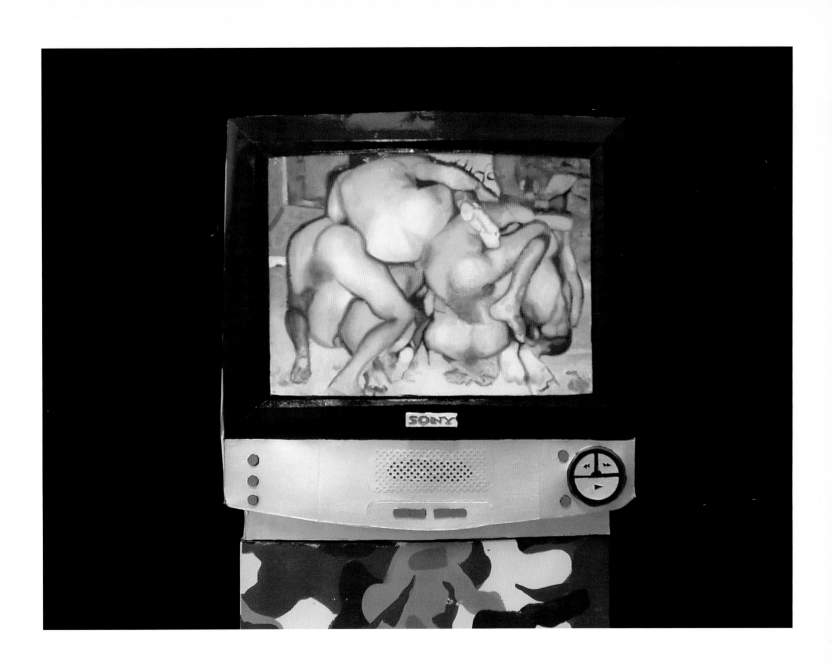

Left
Malcolm Morley
Wall Jumpers, 2002
Oil on canvas
228.6×175.3 cm
cat. 76

Above
Malcolm Morley
Military Object #1, 2006 (detail)
Acrylic paint, lettering enamel on paper, oil on linen, magnets
147.3×47.6×38 cm
cat. 77

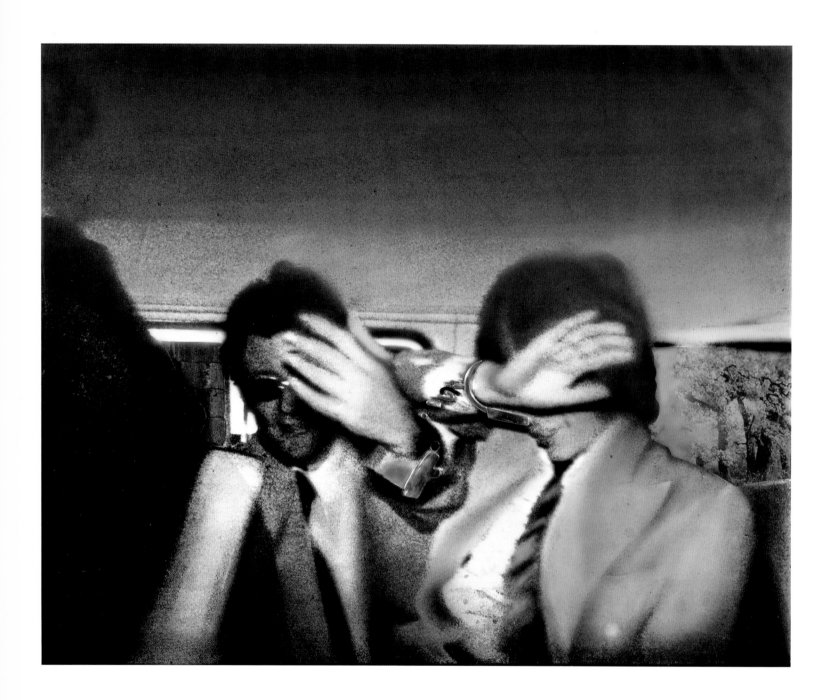

RICHARD HAMILTON

Born in 1922, London, UK. Lives and works in Oxfordshire, UK

I made abstract pictures at one time until, in the mid-fifties, like a good many other painters, I began to move back to figuration. The return to nature came at second hand through the use of magazines rather than as a response to real landscape or still-life objects or painting a person from life. Somehow it didn't seem necessary to hold on to that older tradition of direct contact with the world. Magazines or any visual intermediary could as well provide a stimulus. **In the fifties we became more aware of the possibility of seeing the whole world, at once, through the great visual matrix that surrounds us,** a synthetic 'instant' view. Cinema, television, magazines, newspapers flooded the artist with a total landscape and this new visual ambience was photographic, reportage rather than art photography in the main. **The fascination that photographs hold for me lies in this allusive power of the camera's imagery**. The attempts of some abstract artists to create paintings or objects without external references (however admirable the results) seems to me to be not only futile but retrograde; like a race to see how slowly the participants can move. I marvel that marks and shapes, simple or complex, have the capacity to enlarge consciousness, can allude back to an ever-widening history of mankind, can force emotional responses as well as aesthetic ones and permit both internal and external associations to germinate the imagination of the spectator. I suppose that I am much more concerned with ideas about paint than with paint for its own sake, or even a subject for its own sake. **I would like to think that what I am doing is questioning reality**. Photography is just one way, the most direct we know, by which physical existence can modulate a two-dimensional surface. Painting has long been concerned with the paradox of informing about a multi-dimensional world on the limited dimensionality of a canvas. Assimilating photography into the domain of paradox, incorporating it into the philosophical contradictions of art is as much my concern as embracing its alluring potential as media. It's necessary, at the moment, to pry out a whole new set of relationships. After all, photography (perhaps we should establish a broader base and think of what I am talking about as lens-formulated images whatever the chemistry or electronics involved) is still fairly new compared with the long tradition of painting, and there are many adjustments of thinking yet to be made.[1]

Richard Hamilton
The citizen, 1981–83
Oil on canvas, 2 panels
200×100 cm each
cat. 36

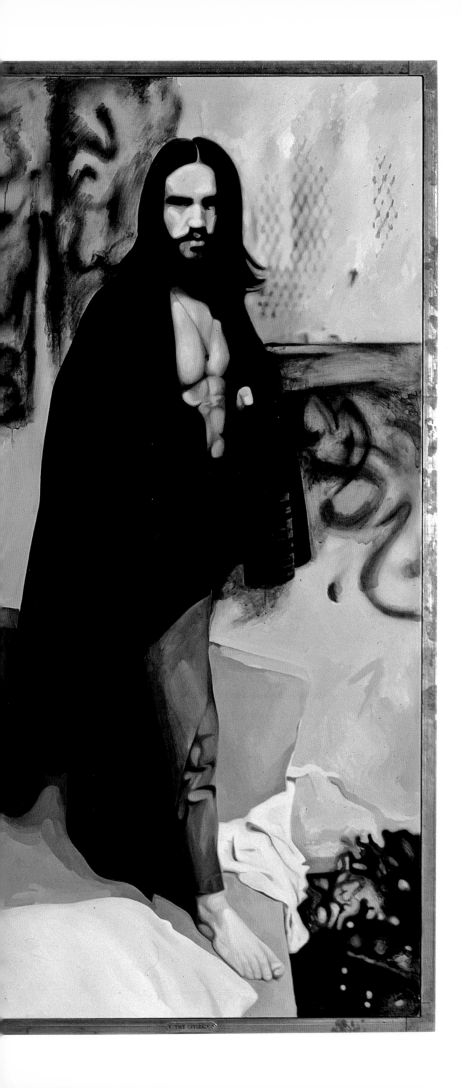

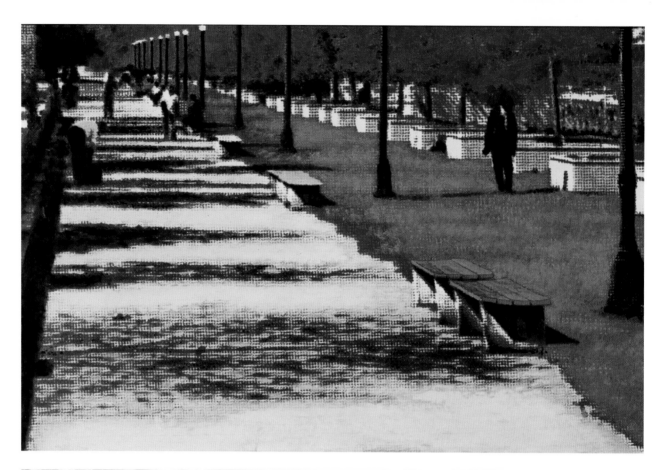

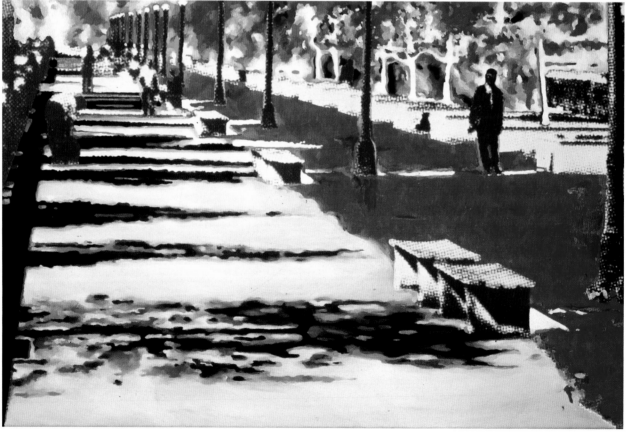

Top
Richard Hamilton
Chicago Project I, 1969
Acrylic on photograph on board
81×122 cm
cat. 34

Bottom
Richard Hamilton
Chicago Project II, 1969
Acrylic on photograph on board
81×122 cm
cat. 35

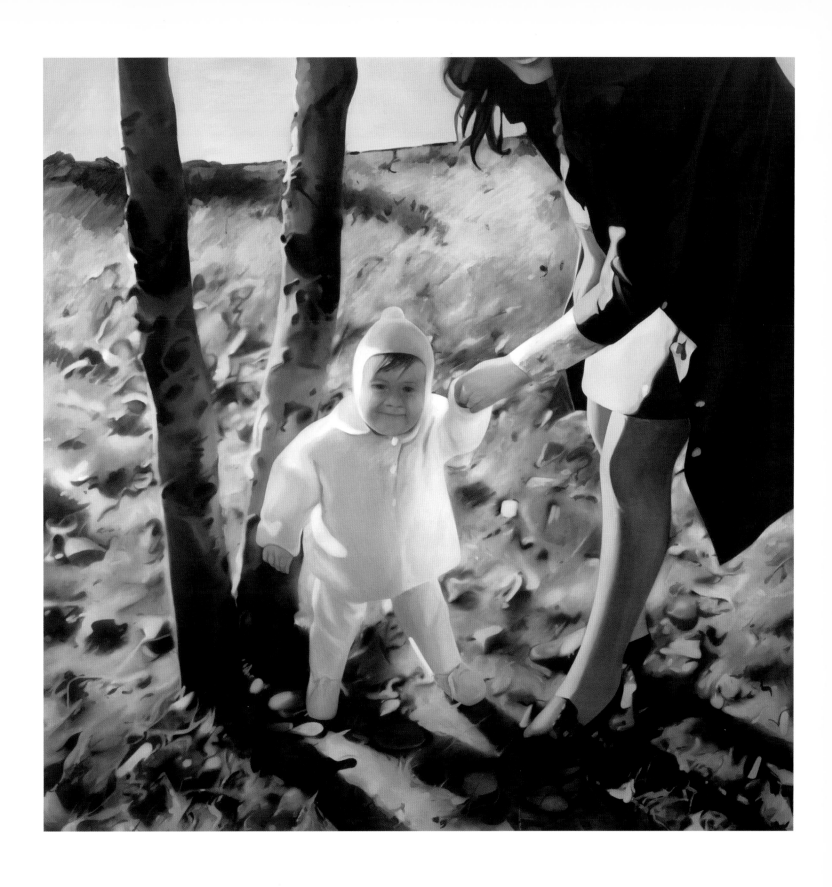

Richard Hamilton
Mother and Child, 1984–85
Oil on canvas
150×150 cm
cat. 37

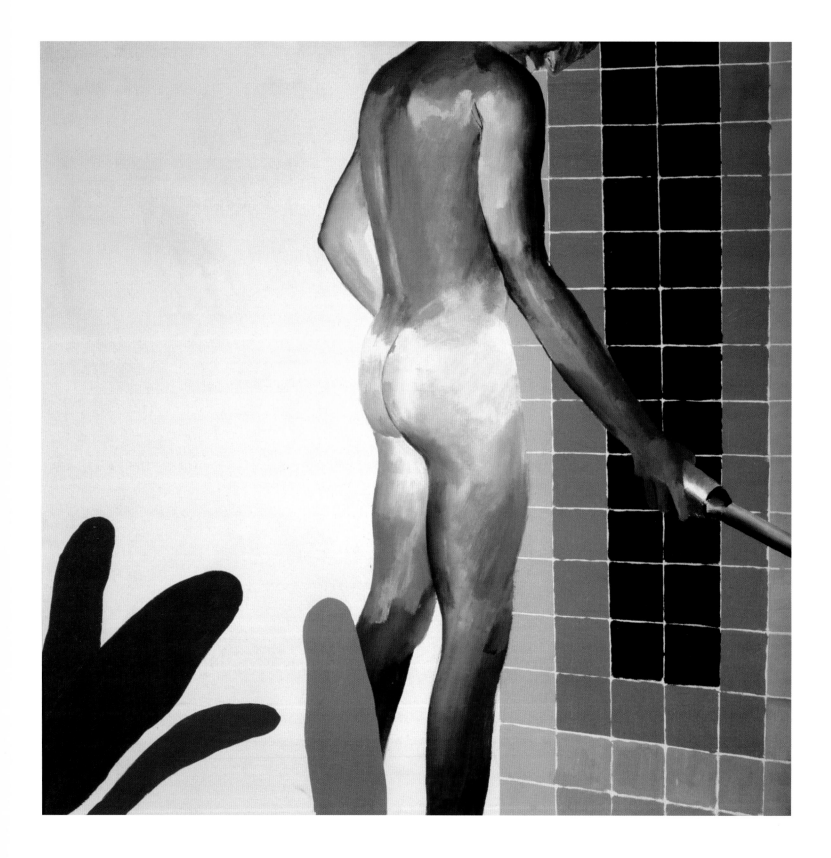

DAVID HOCKNEY

Born in 1937, Bradford, UK. Lives and works in Los Angeles, CA, USA,
and London and Bridlington, UK

When people say painting is dying, I think it's the other way around; I think photography is. I think photography has let us down in that it's not what we thought it was. It is something good, but it's not the answer, it's not a totally acceptable method of making pictures and certainly it must never be allowed to be the only one; it's a view that's too mechanical, too devoid of life.[1]
When you begin taking pictures you become intensely aware of light. I discovered that light is the essence of the picture; without light there is no picture. This discovery informed my painting as well, and a kind of symbiotic relationship began to form with photography. I may have painted from a photograph occasionally – as a suggestion or an idea – but in 1968 I began to use photographs extensively in my painting. Through 1972, there are a lot of paintings that are, in their faithfulness to a certain perception of reality, photographic. **The problem in my paintings is always one of naturalism.** I never use photographs the way photorealists use them: projecting a colour slide on the canvas and painting from that. I think I draw well enough to have no need for that. I use photos to jog my memory or to recall some little detail, even though I interpret more freely now. Similitude is unreal; it's a kind of lie.
I am not, after all, a photographer. I just happen to take photographs – more like a draftsman I think. I believe most photographers tend to think flat. The moment you look through the camera you become concerned with edges. The painter does not see things that way, he cares less about the edges of the picture. A painter's pictorial thinking is different; he accepts peripheral vision and includes it in the picture. It's possible in painting to present a vision that extends all the way around. That's why for me painting is more interesting than photography. **A painting, of course, has time in it**; it took time to paint it, so there are layers of time in whatever you've painted. You can't deal with time in a simple image. The photograph represents the time it took to shoot it – most of the images are chosen and taken in five seconds … That photography should replace painting is a primitive idea: photography will, in fact, replace only the photographic aspects of painting, which of course photography often *can* do better.[2]

David Hockney
Boy About to Take a Shower, 1964
Acrylic on canvas
91×91 cm
cat. 43

David Hockney
Le Parc des Sources, Vichy, 1970
Acrylic on canvas
213.5×305 cm
cat. 44

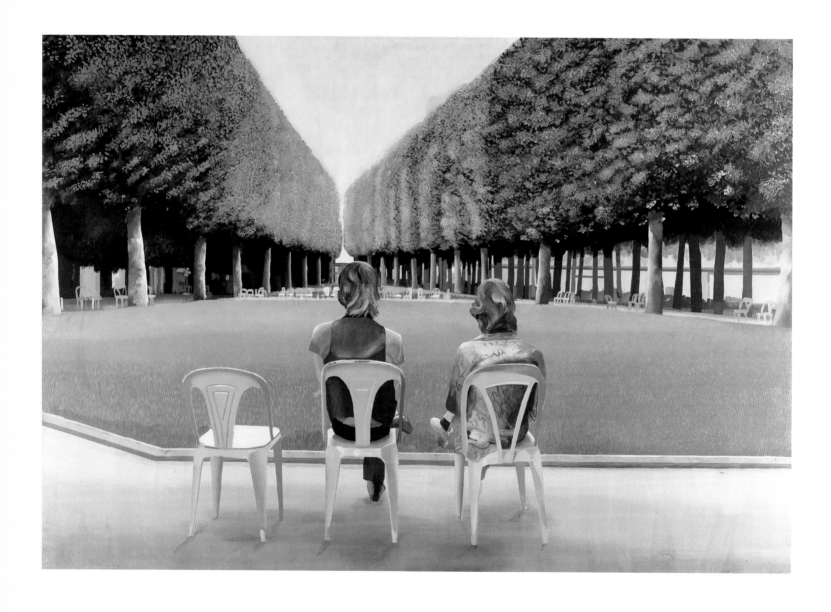

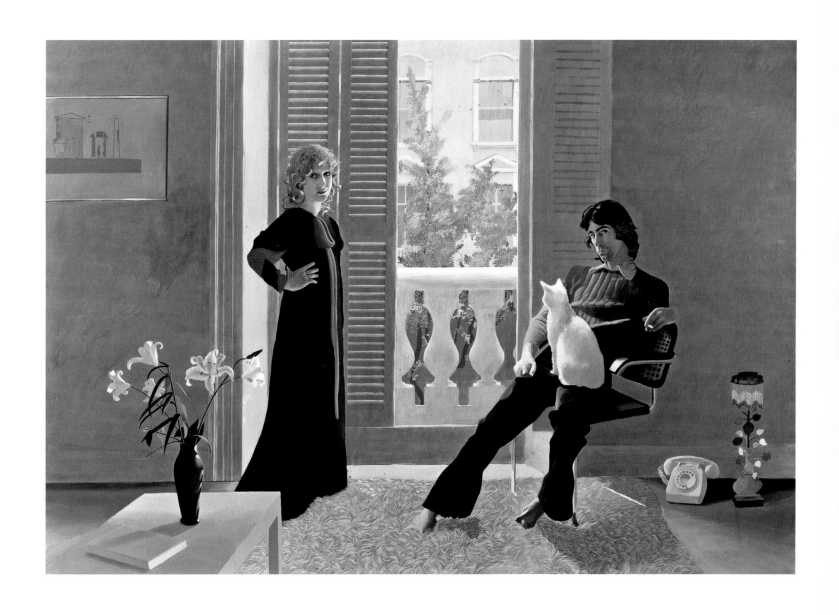

David Hockney
Mr and Mrs Clark and Percy, 1970–71
Acrylic on canvas
213.4×304.8 cm
cat. 45

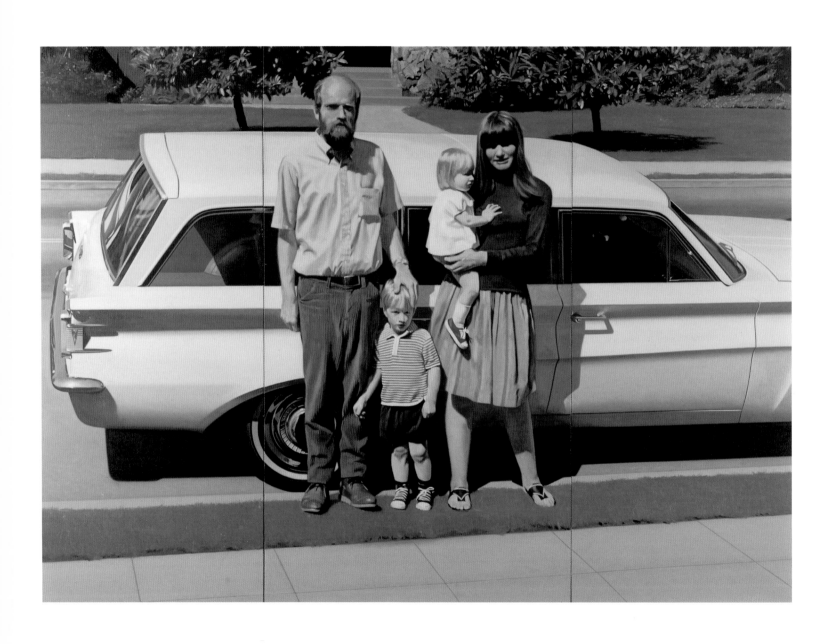

ROBERT BECHTLE

Born in 1932, San Francisco, CA, USA. Lives and works in San Francisco

I try to think of it [photography] as a tool. That's how I started using it, to enable me to paint things that I couldn't paint otherwise. You can't very well paint a car by setting your easel up on the street for three months. But of course the use of photographs starts to affect the way you think and see too. It can't be just a tool … I have to be careful that they are really lousy photographs that will allow the completion to take place in the painting. If the photograph is too good and can stand as a finished work of art by itself, there is no reason to make a painting from it. **A photograph often gives the feeling of a particular moment in time**, and you get the sense of how that is bracketed in with the before and the after. I like the kind of photograph that tends to just be. You sense that what came before was exactly the same as what is shown, and that what comes next is going to be exactly the same. It is a kind of extension of time, which is a very traditional aspect of painting … Painting is essentially a static art. I try to find and use that particular static quality to advantage, to make something happen, perhaps, that doesn't happen in a photograph. **The awareness of surface and picture plane is so much a part of our** background. This, I suppose, is one of the main differences between realist painting in 1972 and traditional nineteenth-century painting. There's a completely different attitude toward surface. The equalized surface is so different from the older tradition of treating a head, say, more carefully than the background – which implied that the head was more important than the background. Also, the space now tends to be projecting rather than receding space. We set up a shallow space just in the actual surface of the canvas, and the activity seems to project forward from there.[1] **I try for a kind of neutrality or transparency of style that minimizes the artfulness** that might prevent the viewer from responding directly to the subject matter. I would like someone looking at the picture to have to deal with the subject without any clues as to just what his reaction should be. I want him to relate to it much as he would to the real thing, perhaps to wonder why anyone should bother to paint it in the first place. **I think of the photograph, in addition to its being a reference source, as a kind of structure** or system for the painting which limits the choices of color and placement. It allows me to keep some of the traditional concerns of the painter – drawing, composition, color relationships – from assuming too important a role, for they are not what the painting is about. Most of the choices are made when the photograph is taken … On the other hand, the rather subtle choices that are made as the painting progresses, as I try to re-invent the information in the photograph and make it convincing as painting, may be what gives it its 'art'.[2]

Robert Bechtle
'61 Pontiac, 1968–69
Oil on canvas
153.7×215.9 cm
cat. 5

Robert Bechtle
'67 Chrysler, 1973
Oil on canvas
121.9×175.3 cm
cat. 6

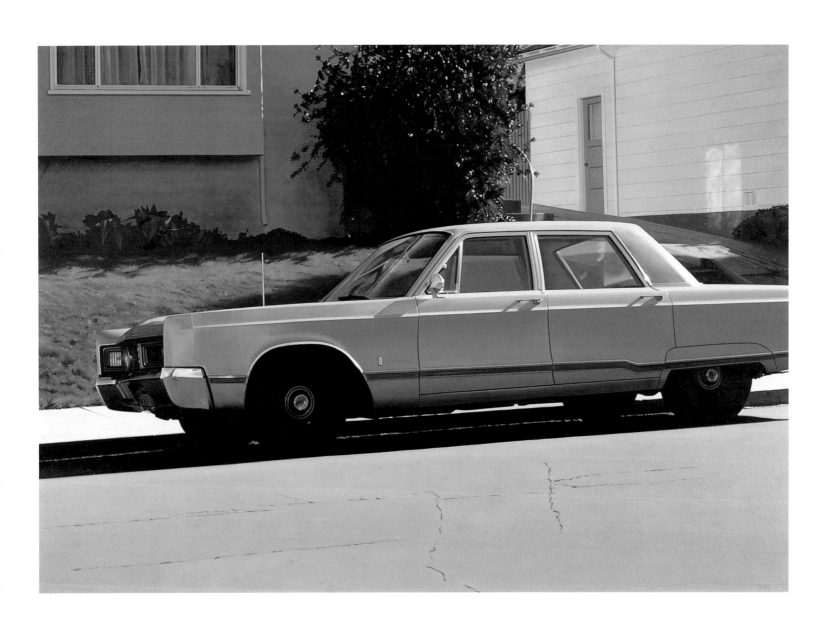

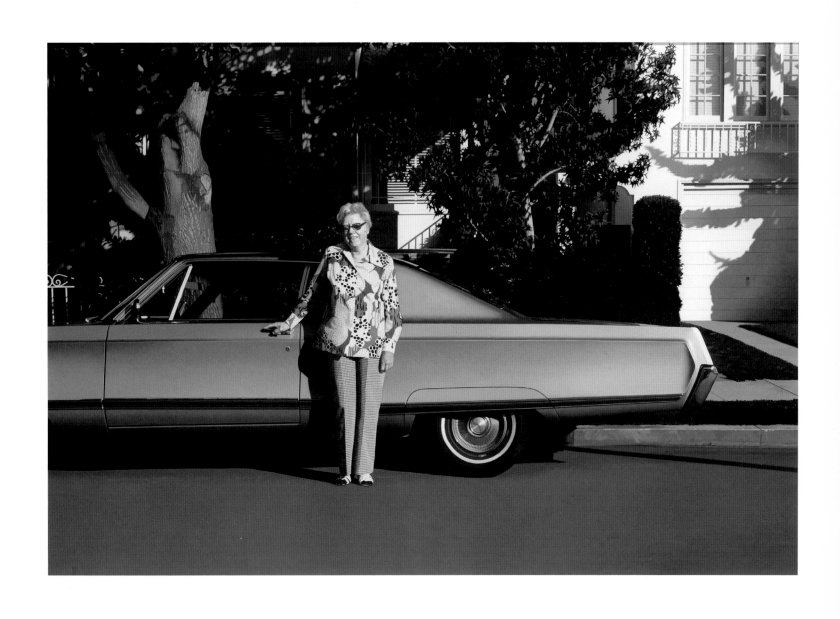

Robert Bechtle
Alameda Chrysler, 1981
Oil on canvas
121.9×175.3 cm
cat. 7

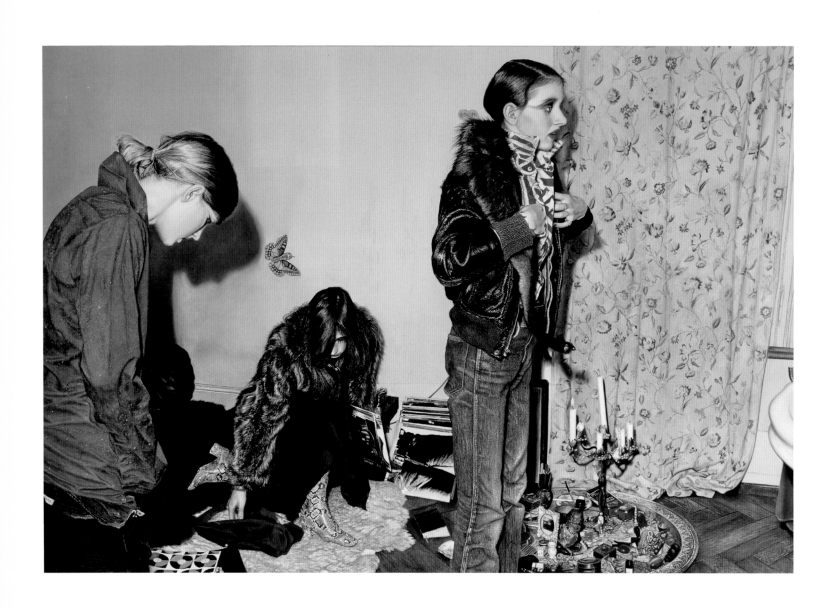

FRANZ GERTSCH

Born in 1930, Mörigen, Switzerland. Lives and works in Rüschegg, Switzerland

I choose the subjects for my paintings from hundreds of slides that tend to be the result of encounters – they are never staged. The criterion for this choice is a dramatic iconography. In other words, I need to see the workings of my pictorial technique aimed at capturing life in the primary documentation. These documents are never exceptionally great photographs but they are the right iconographic documents for my specific way of working. **In the Autumn of 1968, I painted my first naturalistic paintings** based on photographic documents. I had come to understand that, in this day and age, reality can only be captured by a camera because we have got used to considering photographed reality as the highest possible rendering of reality. In a painted copy of a photograph, evidence of the real content can become diluted. The shock of the real is all that is left. We are familiar with these shock effects since the emergence of filmic advertising techniques and Pop art (Rosenquist). In fact, these techniques had not been exploited to their full and brutal extent. Instead of veering towards irony, frivolity and the grotesque, it was therefore essential to reveal reality in the absolute.[1] **It was very important to me to have the experience of liberating myself from my emotionalism**, which was far too strong, through the medium of photography. I could renounce, so to speak, responsibility for the things depicted, as if I had suddenly arrived on earth from some other planet and knew nothing more about the things around me than what I was able to perceive in a purely visual manner.[2] **I am close to my aim when the depicted objects present the same degree of reality** as they do in the photograph … I do not want to be a painter of art for art's sake because life is what interests me in painting.[3]

Franz Gertsch
At Luciano's House, 1973
Acrylic on unprimed cotton
243×355 cm
cat. 32

Franz Gertsch
Kranenburg, 1970
Dispersion on unprimed half-linen
200×300 cm
cat. 30

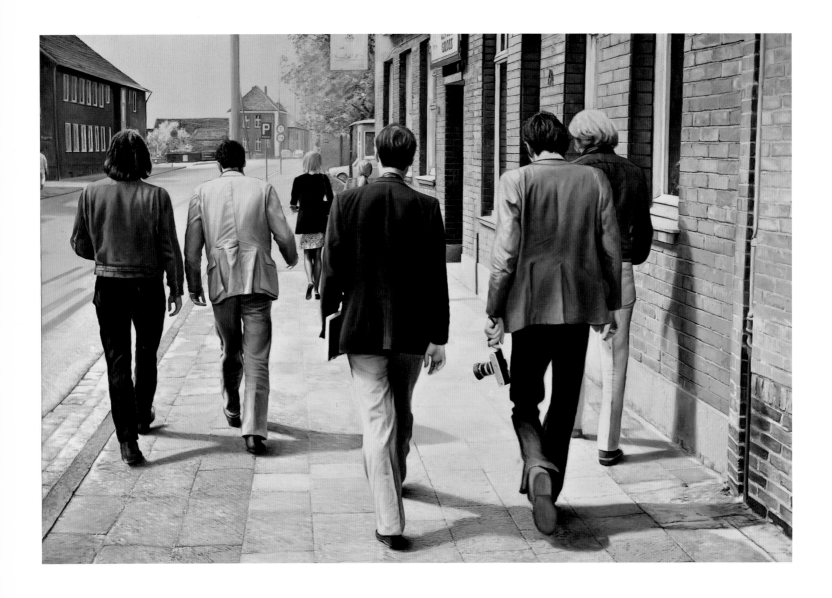

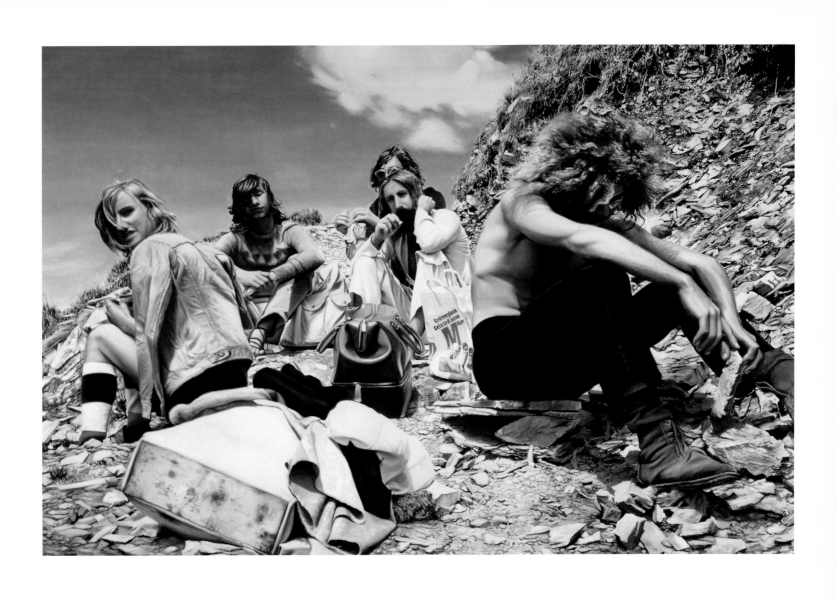

Franz Gertsch
Aelggi Alp, 1971
Dispersion on unprimed half-linen
350×525 cm
cat. 31

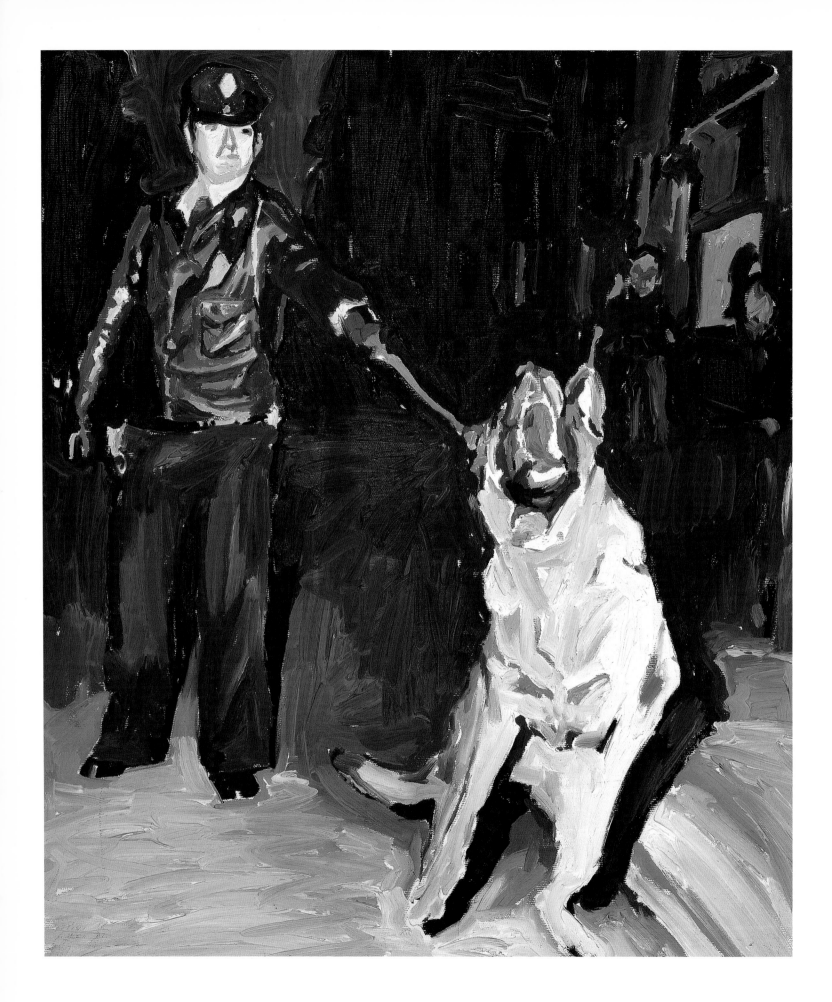

MARTIN KIPPENBERGER

Born in 1953, Dortmund, Germany. Died in 1997, Vienna, Austria

In 1976, I decided to do art professionally … I went to Florence, Italy …[1] I ordered canvases; when you stacked them up they reached 1 metre 89 centimetres, my own height, a whole stack of canvases. Each morning and each afternoon I painted a picture, working from an original. In-between times I took photographs and cut up newspapers, so I always had plenty of originals. My paintings were always in the same format, always grey and white. In a way, Richter was still a role model for me then. I'd fallen for his trick. When you're young, you're always impressed by gifts that you yourself don't have, you're bluffed by them.[2] **I don't have a style**. None at all. My style is where you see the individual and where a personality is communicated through actions, decisions, single objects and facts, where the whole draws together to form a history. In any case, people always look at art with hindsight, and always from the outside, hardly ever in the moment it first appears. I'd say usually about twenty years afterward. People come along later and can say what the work and the artist were really all about. What people will say about me then, or maybe not say, will be the only thing that finally counts. **Jörg Immendorf's old idea of 'Give up painting!'** is something we can always return to, expressing it once again, since it's an order that was never followed. But today you have to understand it differently, since it no longer comes across as a way of raising some fundamental question; now it's another luxury, rather than part of the expression of a science. Painting can no longer be reduced to various types, like different kinds of French berets. Art treated as a science has the very same kind of listless beauty as a pointless joke; but with numberless subtleties, it has to be very well told, and very nicely reported.[3] **I am a travelling salesman. I deal in ideas**. I do much more for the people than just paint them in pictures. **I am not an easel-kisser** … I actually have nothing to do with painted pictures. That's why one of my solutions for this problem has been to let others paint for me, but only in the way I need it, the way I see it.[4]

Martin Kippenberger
Uno di voi, un Tedesco in Firenze, 1977
Oil on canvas
60×50 cm
cat. 57

Martin Kippenberger
Uno di voi, un Tedesco in Firenze, 1977
Oil on canvas
50×60 cm; 60×50 cm; 60×50 cm
Left to right: cat. 65; 56; 58

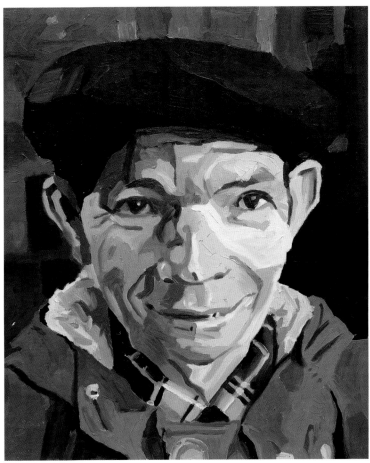

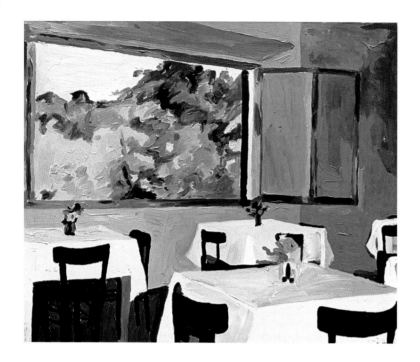

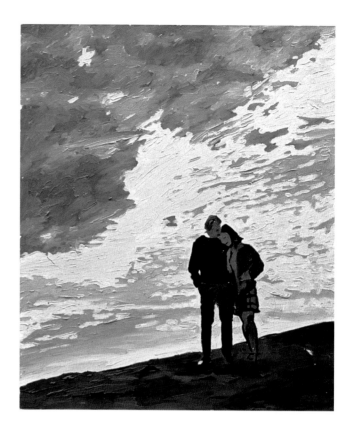

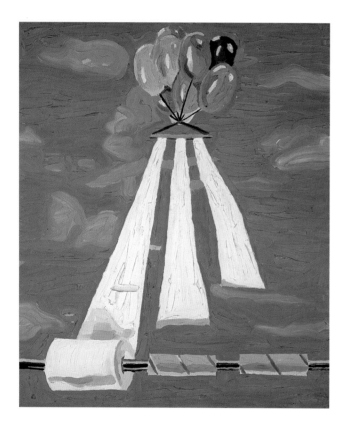

Martin Kippenberger
Uno di voi, un Tedesco in Firenze, 1977
Oil on canvas
60×50 cm or 50×60 cm
Clockwise from top left: cat. 61; 64; 63; 59; 60; 66; 62; 55

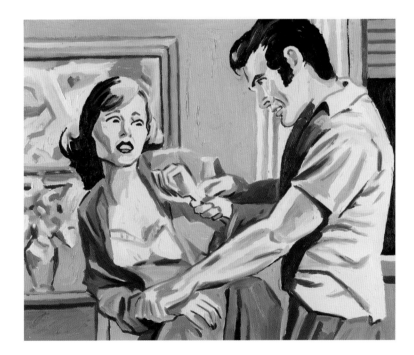

Martin Kippenberger
Ohne Titel, from the series 'Lieber Maler, male mir', 1981
Acrylic on canvas
300×200 cm
cat. 67

Martin Kippenberger
Ohne Titel, from the series 'Lieber Maler, male mir', 1981
Acrylic on canvas
300×200 cm
cat. 68

LUC TUYMANS

Born in 1958, Mortsel, Belgium. Lives and works in Antwerp, Belgium

Most of [my work] is about derivative imagery – that is, imagery which already exists, and which I have reworked. I have dissected the material. I look at the imagery until it's completely dead, I've analysed it until there's nothing left. Then the painting can begin, when I'm sure there's nothing more to see, there are no more alternatives. That's the cruel act of painting. It's looking at something completely dead.[1] **[My painting] is borne out of a genuine distrust of imagery**, distrust in terms of not only comprehending it but also making it. And that probably is new, I mean that could be seen as contemporary. Because I work of course with the figurative image, I could be easily seen as a person who works with the representation of representations that already exist, but on the other hand through the mimicry of that there is also the element of reconstructing that imagery, and that is something else, and in terms of history it's not just history painting, it's the realising of history which is an important difference.[2] **The act of painting really involves a kind of aggression or violence**. I've thought a lot about my work in relation to the cinema and techniques of cutting and montage. The violence in question is fierce, but also distant and abstract.[3] **For an artist like Gerhard Richter, the fight of true painting against photography was very important**; for me it's much more interesting to think of films, because on a psychological level, films are more decisive.[4] **The psychological element in the cinematic image** has the same mobility as the painting … One goes towards the image. Photography doesn't do that. Photography is stuck to the moment … In spite of the so-called antiquarian aspect of painting, it is a highly mobile medium … The speed of the medium is underestimated.[5] **What you can do with painting is make a more understated type of imagery** that approaches an idea from a different angle. It's another medium, in another timescale. And that produces a cognitive image which is sort of branded in the brain. It has something to do with the idea of remembering the imagery but it's also to do with reconstructing the memory, because memory is something that is completely inadequate. That is where painting also comes in because it has its own inadequacy in that it is never complete.[6] **After seeing a film I try to figure out which single image is the one** with which I can remember all the moving images of the movie. Painting does the opposite; a good painting to me denounces its own ties so that you are unable to remember it correctly. Thus it generates other images.[7]

Luc Tuymans
De Wandeling, 1991
Oil on canvas
37×48 cm
cat. 96

Luc Tuymans
Imperméable, 2006 (detail on right)
Oil on canvas
224×94 cm
cat. 101

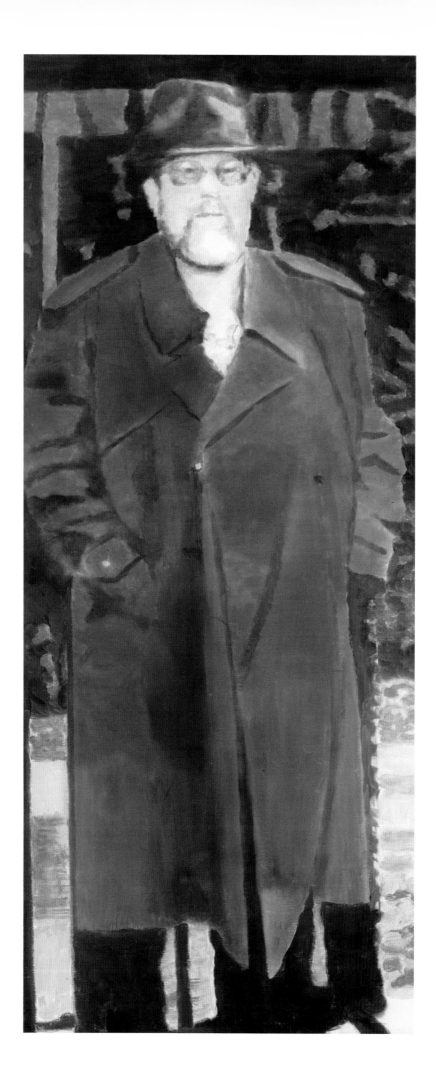

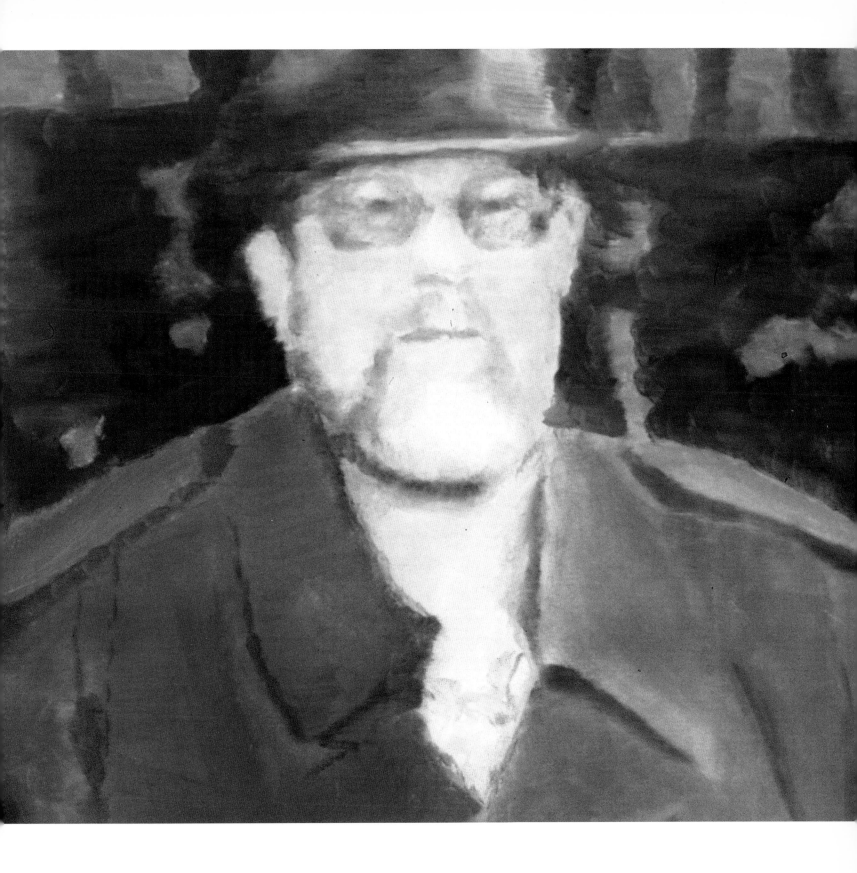

Luc Tuymans
Passenger, 2001
Oil on canvas
90.2×60 cm
cat. 98

Luc Tuymans
G.I. Joe, 1996
Oil on canvas
68.5×62 cm
cat. 97

Luc Tuymans
Altar, 2002
Oil on canvas
232×313
cat. 100

Luc Tuymans
Prisoners of war, 2001
Oil on canvas
124.5×117.5 cm
cat. 99

MARLENE DUMAS

Born in 1953, Cape Town, South Africa. Lives and works in Amsterdam, The Netherlands

When I was at art school I wanted painting to have a stronger connection to reality, to be more like 'real' life. I wanted to be a photographer because I thought it was closer to real life … When I started to embrace the ambiguity of the image, and accepted the realisation that the image can only come to life through the viewer looking at it, and that it takes on meaning through the process of looking, I began to accept painting for what it was.[1] **Unlike photography, in painting there is nothing to start with**. You start with emptiness, or at least that's how I do it. Even if you use photographic sources as inspiration, you don't manipulate the photo. You make something else out of it.[2] **A painting is not an image**. A painting is not like its reproduction. A painting is physical even if you may compare it to a corpse. An image is closer to a ghost. Everyone loves images. Everyone looks at reproductions. No one really looks at paintings. By its limited nature the painting stays singular; it will never be as famous as its photographic image. **Whether you start with a photographic source or not**, that doesn't change the basic assumption that a (modern) painter is more interested in images than in the actual living of modern life; and that painters are more interested in their own intentions than in their subject matter. When Picasso told Brassaï that photography had liberated painting from the subject, he meant it in a positive way, but this could also be understood in a negative way – one could say that painting is also free from the responsibility of caring for and about its subjects. We can paint anything without asking the permission of, or negotiating with, the original subject that has been photographed, because our 'model' – i.e. all photography – has become mass property. We do not have to be where the scene is taking place. But this is part of the tension of a good artwork, that one cares and at the same time does not really care.[3] **When I had my first show in New York, *Not from Here*, a critic wrote that I was 'trafficking in images of misery'**… [But] I don't use anyone else's misery. I use second hand source material but I have to have first hand experiences. I have to know what I'm doing.[4]
Even though it seems to be the amateurs that take the most dangerous and important historical pictures of these days with their mobile equipment, painters can remind us of the fact that while there is no progress in art like the 'old' moderns believed, that's no reason not to portray the never-ending cross-dressing and makeovers, the camouflaged ways, in which history repeats itself in our own times.[5]

Marlene Dumas
The Teacher (sub a), 1987
Oil on canvas
160×200 cm
cat. 18

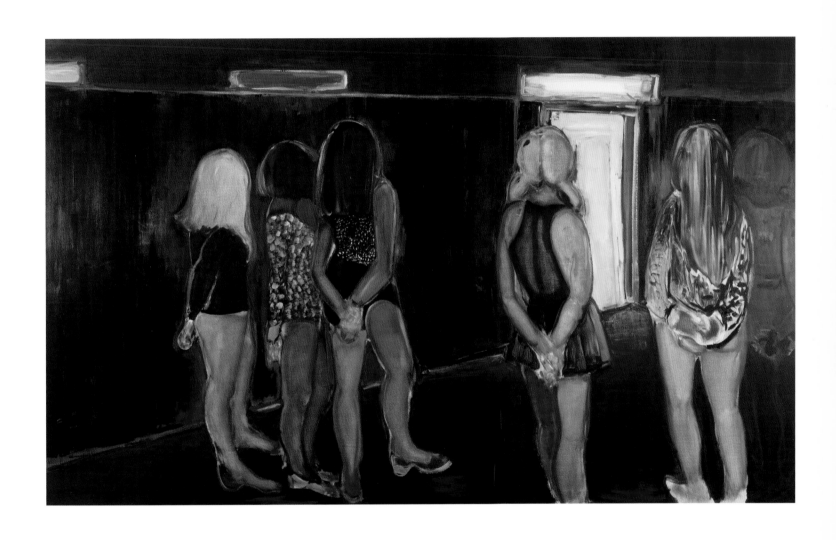

Marlene Dumas
The Visitor, 1995
Oil on canvas
180×300 cm
cat. 19

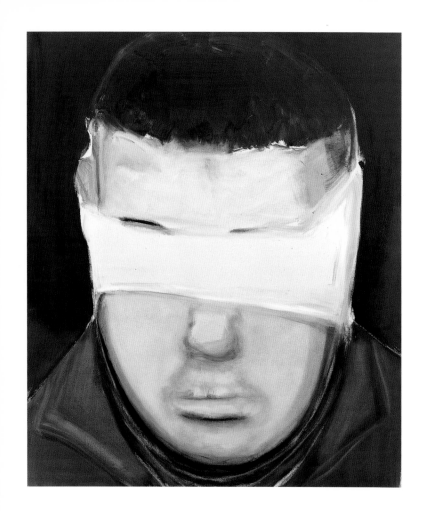
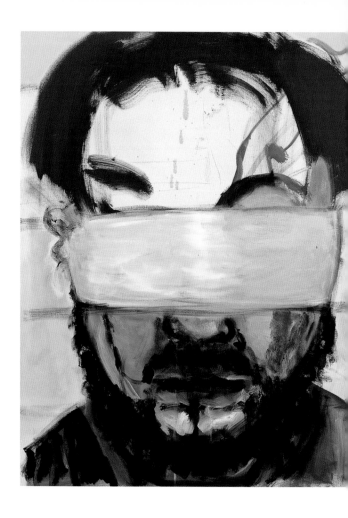

Marlene Dumas
The Blindfolded, 2002
Oil on canvas, 3 panels
130×110 cm each

cat. 20

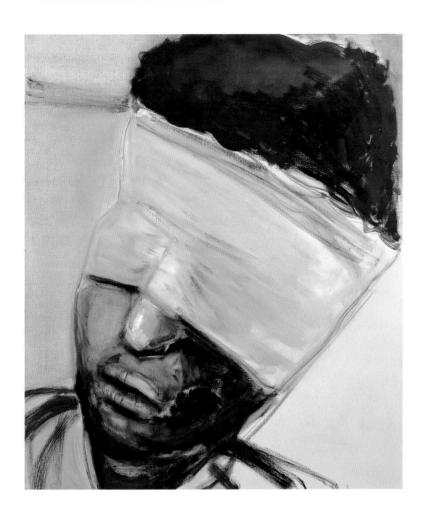

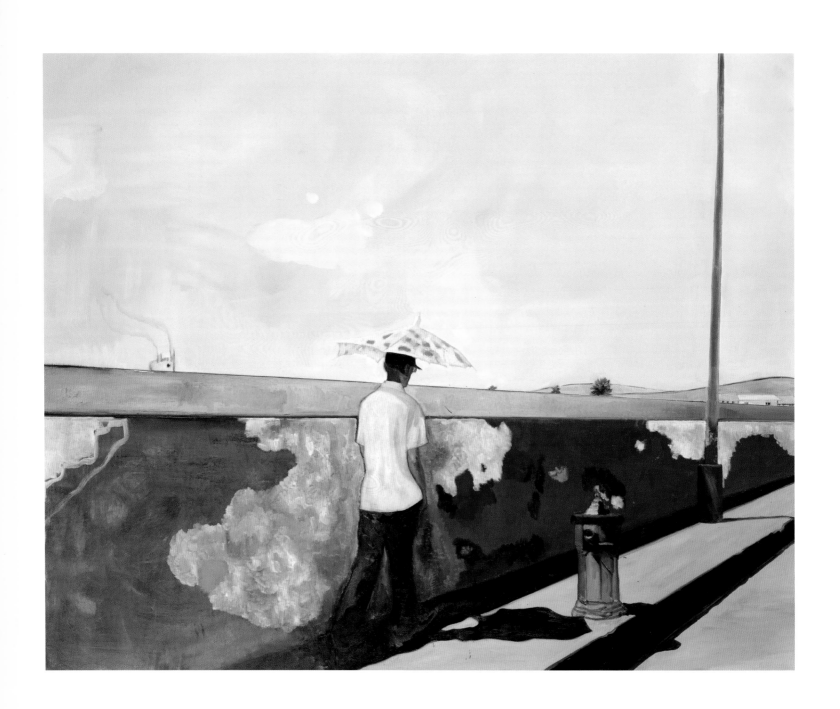

PETER DOIG

Born in 1959, Edinburgh, Scotland. Lives and works in Trinidad and London, UK

The imagination has to be fuelled by image. I'm interested in mediated, almost clichéd notions of pastoral landscape, in how notions about the landscape are manifested and reinforced in, say, advertising or film … I've never made a painting entirely from the imagination. They are always made from photographic sources that I have either found or taken myself. In many ways these images refer back to memories or particular experiences. Some paintings make references to real people and real events, but not so much that I think that I am making a psychological portrait of someone. I never want to be too specific about memory. I want to use it in a more general way – sometimes it is autobiographical, but not explicitly so. I use photography simply as a way of imaging memory. The photograph acts as a starting point. It is in the actual act of making a painting that invention takes over. The photographic source is often too banal, too limited. It acts primarily in relation to the basic composition for a painting. I use photography in the way that some painters in the latter part of the nineteenth century used photography. I am almost using photography as a map, a way to map out the image.[1] **The photos I use aren't always that interesting or distinguished**. That's deliberate – I like the fact that they're bland: they leave a lot of space for invention.[2] **The advantage [to me] and the great difference between painting and photography** is that paintings absorb light and are constantly changing according to the time of day, available light, etc. Photographs remain the same regardless. A painting's slowness is also important for me in its making because it allows a lot of time to make decisions – to allow things to evolve through the making process over a long time (if need be). **I would hope that the painting of the photographed image would somehow bring the image into the present day** (when painted) and if really successful render the image timeless. You see this in photo-based paintings by Munch for instance. You don't think about the date when they were made. They seem to operate in a space outside of time. I would hope that my painting is of its time and also has the potential (at its best) to transcend its time.[3]

Peter Doig
Lapeyrouse Wall, 2004
Oil on canvas
200×250 cm
cat. 17

Above
Peter Doig
Buffalo Station I, 1997–98
Oil on canvas
175.3×269.2 cm
cat. 15

Right
Peter Doig
Lump (Olin MK IV Part II), 1995–96
Oil on canvas
295×200 cm
cat. 14

Peter Doig
Concrete Cabin II, 1992
Oil on canvas
200×275 cm
cat. 13

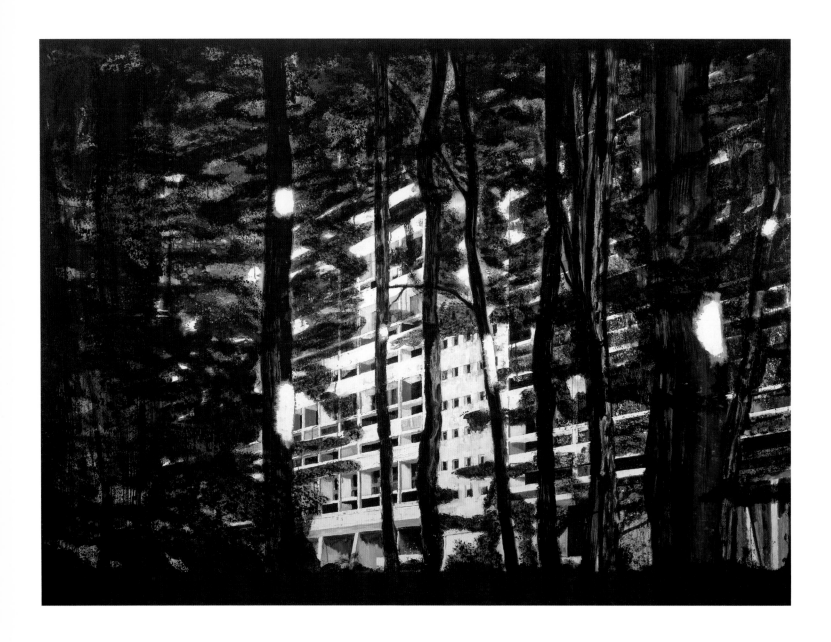

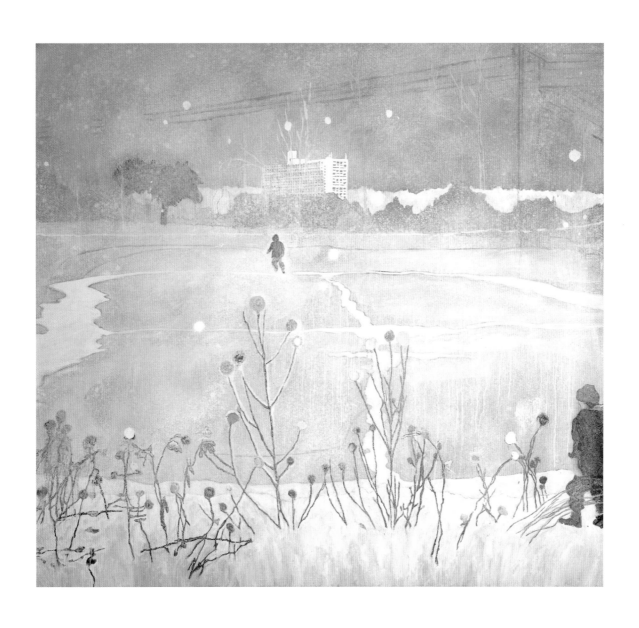

Peter Doig
Untitled, 2001–02
Oil on canvas
186×199 cm
cat. 16

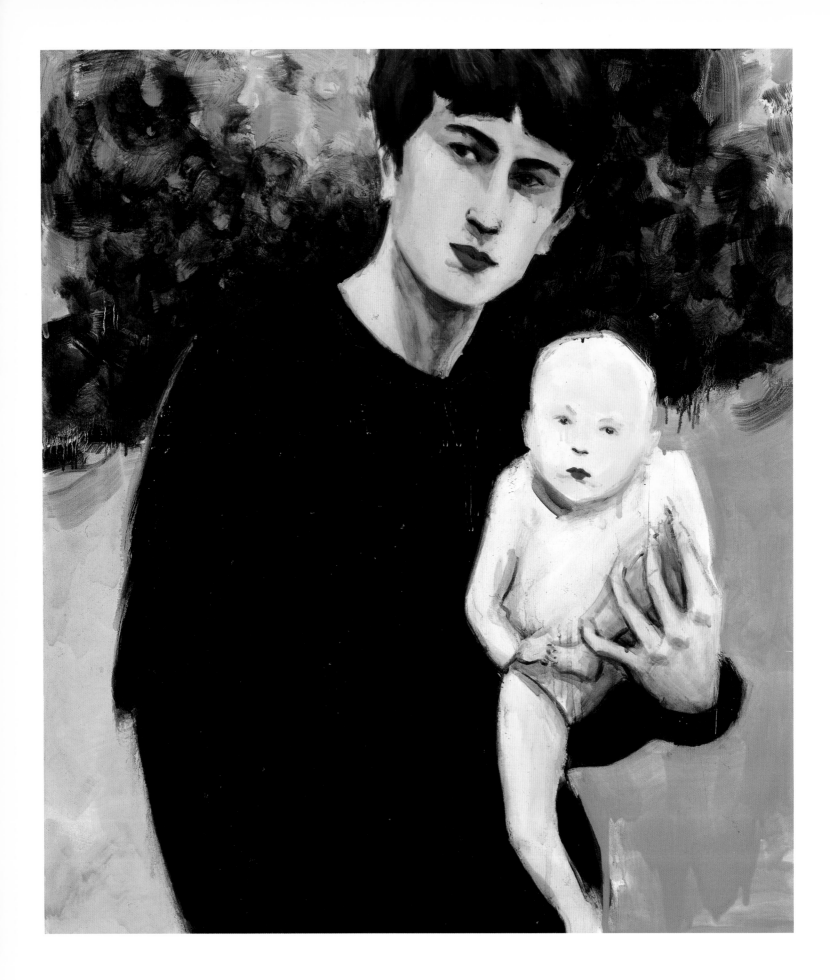

ELIZABETH PEYTON

Born in 1965, Danbury, CT, USA. Lives and works in New York, NY, USA

I can't really say how I choose an image to work from. Usually it is a picture I can't stop thinking about. Maybe it reveals something about the subject that I think is elemental to that person – or that person in the context of their time – doing something quite normal and everyday, but that says so much about them, their impact, and their time. **Paintings have the ability to be a site for many ideas,** where emotions can be distilled over a period of time. And, without thinking about it, there appears a translation of a photo – viewed – re-seen in the brain via the hand, with help from the memory. I want to slow down the reading of an image: I want to say, this is important – look at this.
I prefer working from photos that are incidental and anecdotal, rather than formal – they have more information to pick and choose from when it comes to making a composition … I think there has to be a process of interpretation between a photo and a painting – otherwise why do it? I am noticing now that I have trouble working with photos that are very 'good' already. I was trying to work with some Mapplethorpe images – but they are so complete there isn't anything for me to add.[1] **Portraits made from photos** sometimes have a better composition. I can get a shirt from one image and a smile from another and the eyebrows from yet another to reach the idea I have of the person.[2] **With photographs you notice that you don't even see people sometimes.** There's so much else going on that you don't really know what they look like. But familiarity is the best for me, actually knowing them. And a lot of times people will say, 'These men don't look like that. There's no way they have red lips like that, and such skin.' But they do.[3]

Elizabeth Peyton
Mendips, 1963, 1996
Oil on canvas
81.2×71 cm
cat. 78

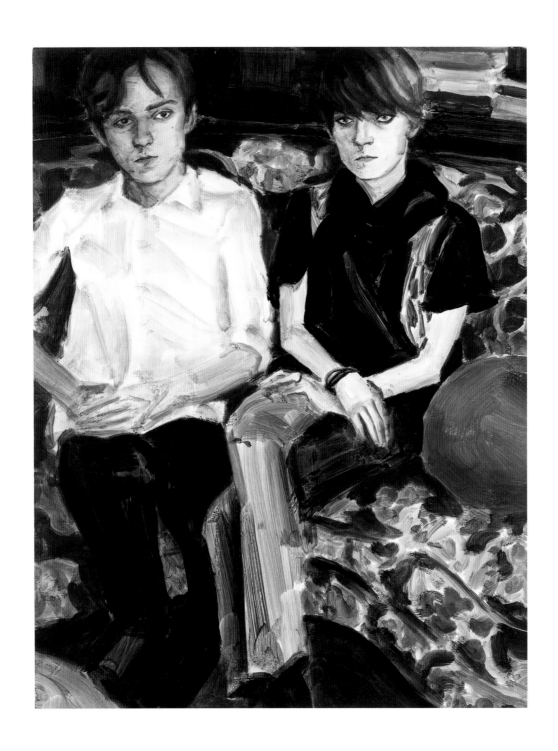

Elizabeth Peyton
Nick and Pati (Nick Mauss and Pati Hertling), 2007
Oil on MDF
33×25.4 cm
cat. 82

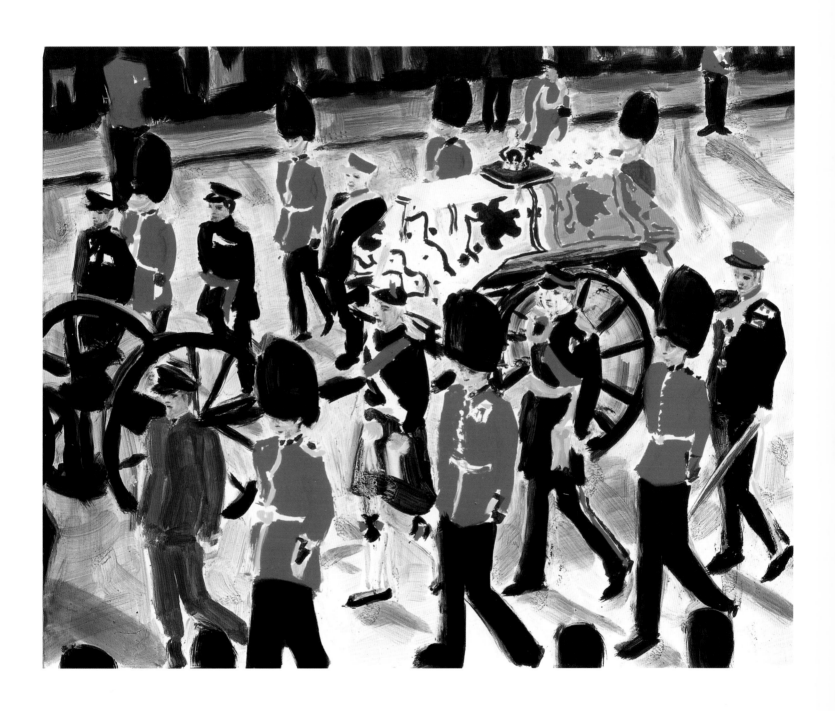

Elizabeth Peyton
Queen Mother's Funeral, 2002
Oil on wood
30.5×38 cm
cat. 80

Elizabeth Peyton
*Klose, Podolski, and Frings (German
Team Stretching), July 8, 2006*, 2006–07
Oil on MDF
23.5×17.8 cm
cat. 81

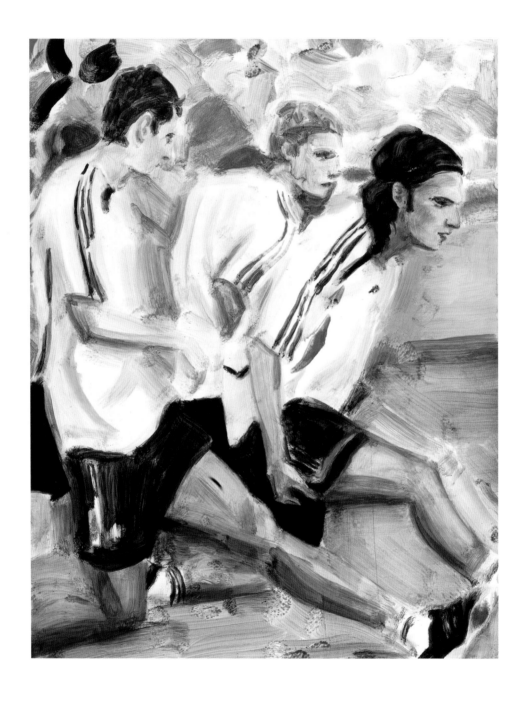

Elizabeth Peyton
Arsenal (Prince Harry), 1997
Oil on board
28.6×36.8 cm
cat. 79

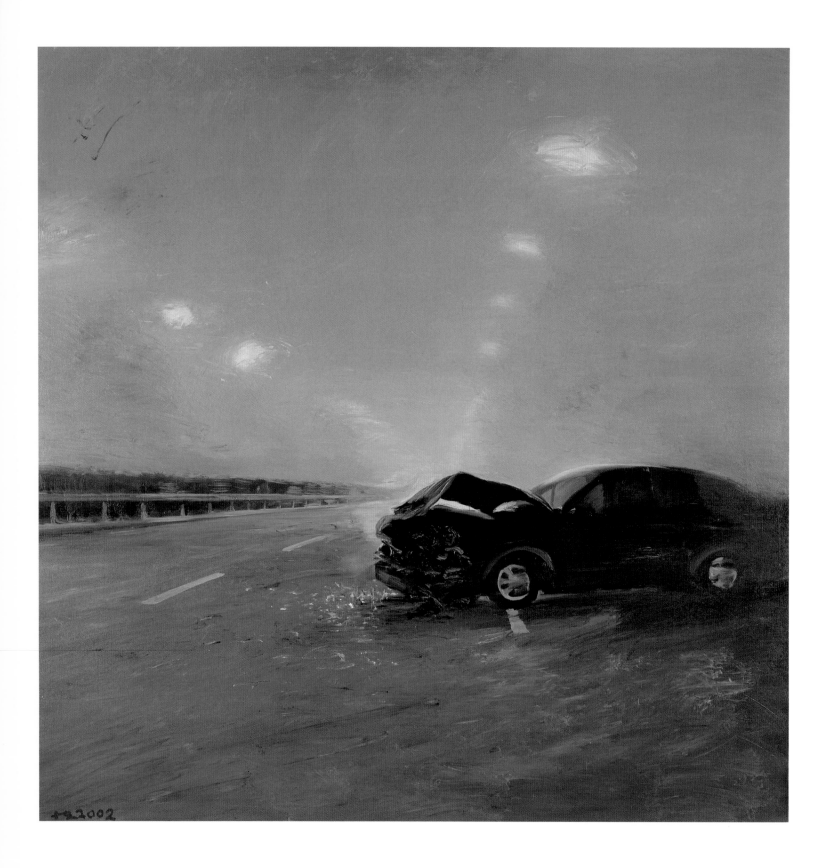

LIU XIAODONG

Born in 1963, Jincheng, China. Lives and works in Beijing, China

Some people have this idea that painting is old-fashioned, that painting is dead. But this is quite wrong. I don't think any medium can be outdated. The medium is not important, it is only a way to express ideas. I think painting is a medium full of charm, it is a charming way to express. I came to painting naturally, it is a convenient way to express and solve questions, it is the art of life. I believe painting as an art is just like eating, like having a meal. As an art of life I believe only painting can solve that problem of being hungry, only painting can satisfy the hunger. **In China, when I was young, there was a period in which the Communist Party** was trying to raise the spirits of people by showing remarkable examples of good citizens, and staging them as heroes. But I believe every single person is important, every person has only one life and the experience of that life, for me, is the most important thing. Humanity has not occupied the centre stage in the recent history of China … grandiosity and heroism have been more important. So in my painting, I try to show more humanity, because that is what has been lacking in China. The people I represent are ordinary people, they are like antiheroes and I am just showing their reality. During our childhood we lived in a certain environment, and then it changed so quickly, there is so much difference between the ideal and the reality. Who can I believe? I cannot believe in any ideal anymore. I just believe in the experience of reality. **Basically in a society art is weak, not strong**. Art cannot change anything. What I am trying to do, and the only thing I can do, is to watch, to witness and to testify.[1] **I judge images instantly, and then very slowly pick an image to fit in my work**. The image is only enjoyable when it is painted slowly. **In actual day-to-day life, I don't enjoy ways of living that are trivial** or banal, but that kind of life-style often attracts my attention. I absorb those images into my paintings so that people will trust my work, and so that they might come under the hypnotic power of my art. For this hypnotic system to work properly, I have to earn the trust of the viewers first. **My photography and my paintings are not mutually replaceable**: whereas in photos there are numerous details of the objective world, in paintings there are more psychological details. There is more desire to go beyond reality in paintings, so they show more subjectivity. Paintings are more like what the human eye perceives. While human eyes cannot take in too many simultaneous details, photographs are capable of showing all the details at the same time – but, as a result, they suffer a loss of airy quality. Paintings possess both this airy quality of the human eye and the sponginess of the plane.[2]

Liu Xiaodong
Traffic Accident, 2002
Oil on canvas
200×200 cm
cat. 72

Liu Xiaodong
Three Girls Watching TV, 2001
Oil on canvas
130×150 cm
cat. 71

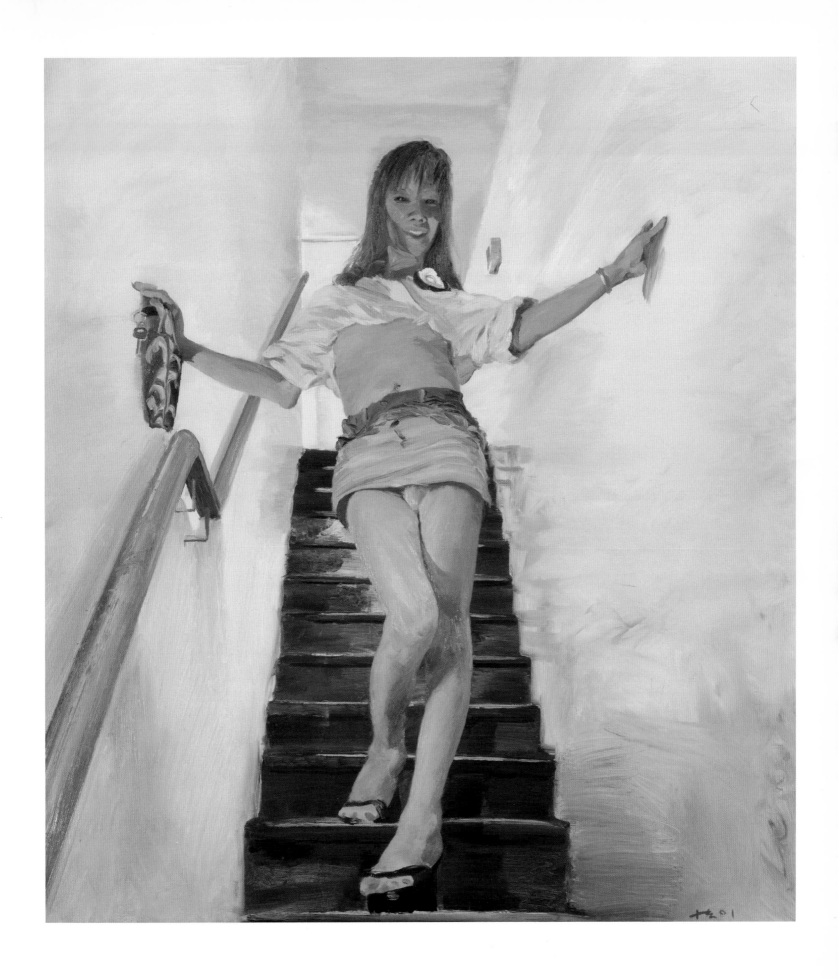

Liu Xiaodong
A Transsexual Getting Down Stairs, 2001
Oil on canvas
152×137 cm
cat. 70

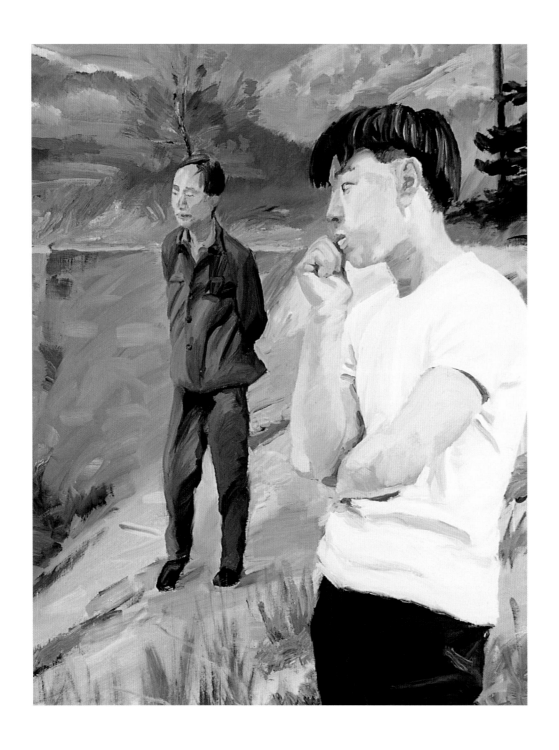

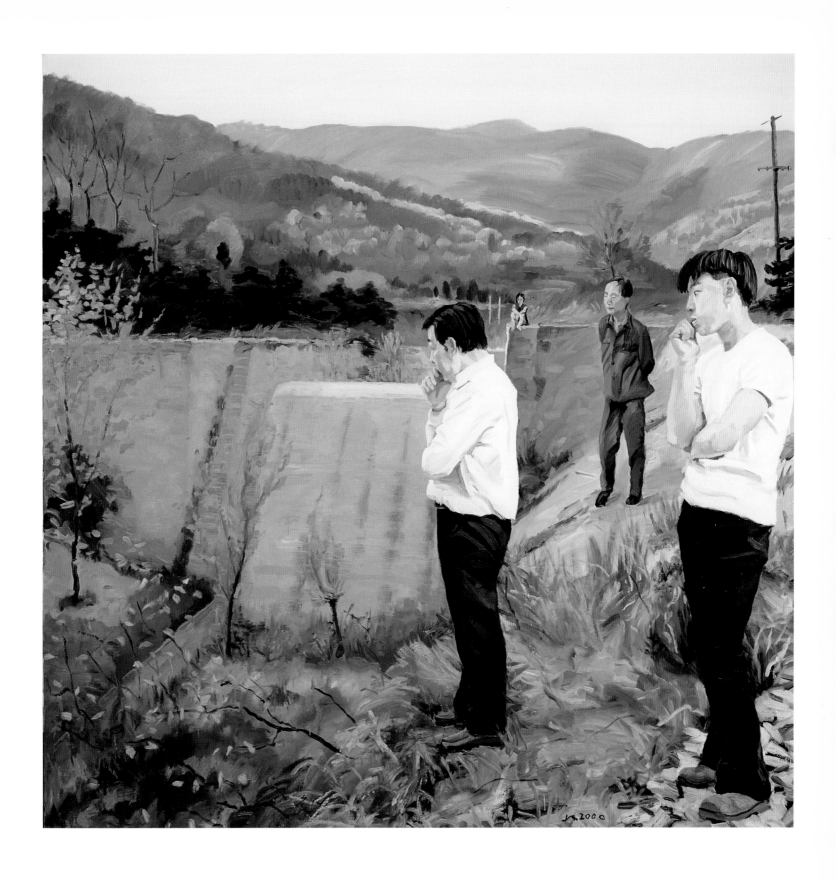

Liu Xiaodong
Watching, 2000 (detail on left)
Oil on canvas
200×200 cm
cat. 69

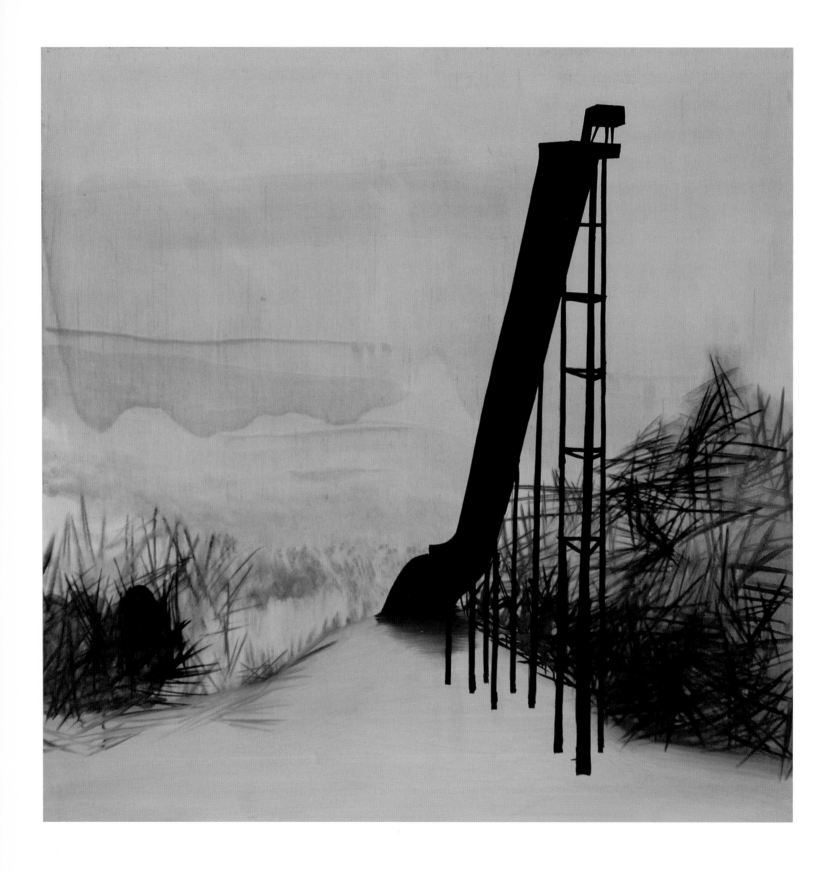

WILHELM SASNAL

Born in 1972, Tarnów, Poland. Lives and works in Krakow, Poland

I tried to make the process of transferring a photographic image onto canvas as emotionless and mechanical as possible. I used to want to transpose as much information as possible and to avoid any possible distortions, but now it's quite different. I think I've come to accept this very basic fact about the way painting works: some things get exaggerated and other things are left out. Sometimes my initial plans slide totally out of control and the painting reclaims its own life. The reworking of a motif provides an arena for interpretation and this is what interests me most. **Over the past five years** I've been trying increasingly to make the original photographic source and the painted image as detached as possible so that the final painting becomes truly autonomous. My practice has also changed accordingly. Earlier I was so afraid of making any strong artistic gesture that I wasn't able to paint anything without relying on the negative, or a slide projection that would enable me to make the initial drawing on canvas. **When it comes to choosing the source image, there really are no strict rules**. In most cases the image finds me, rather then me reaching out and searching for it. I come across most of the photographic sources while browsing through books and surfing the Internet. **It is difficult for me to analyse how a particular image attracts me**. It's a kind of magic, you know … I guess certain images grab my attention because they seem to be meaningful or ambivalent. **There's a lot of nostalgia in my work** – not so much for the communist era; it's more of a quest for something timeless, evergreen. Recently, I've become a real film buff, watching hundreds of old Polish movies. I work quite a lot with this kind of image right now: recording sequences and watching them over and over, still by still. **I'm not interested in conveying historical events to future generations**; I think photography took over this role from painting a long time ago. However, my paintings do record certain histories: ordinary, everyday history as seen thorough my own eyes, and my personal history. Painting is always like writing a diary.[1]

Wilhelm Sasnal
Kielce (Ski Jump), 2003
Oil on canvas
145×145 cm
cat. 92

Wilhelm Sasnal
Untitled (Hunters), 2001
Oil on canvas
150×170 cm
cat. 91

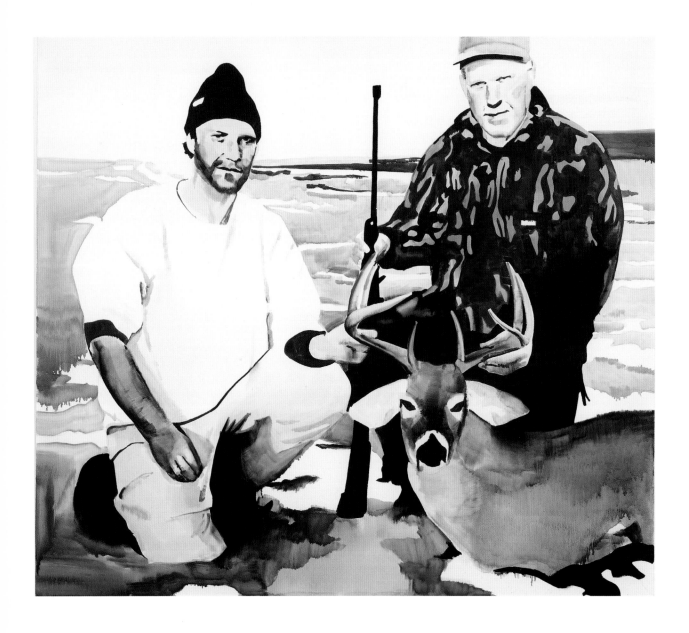

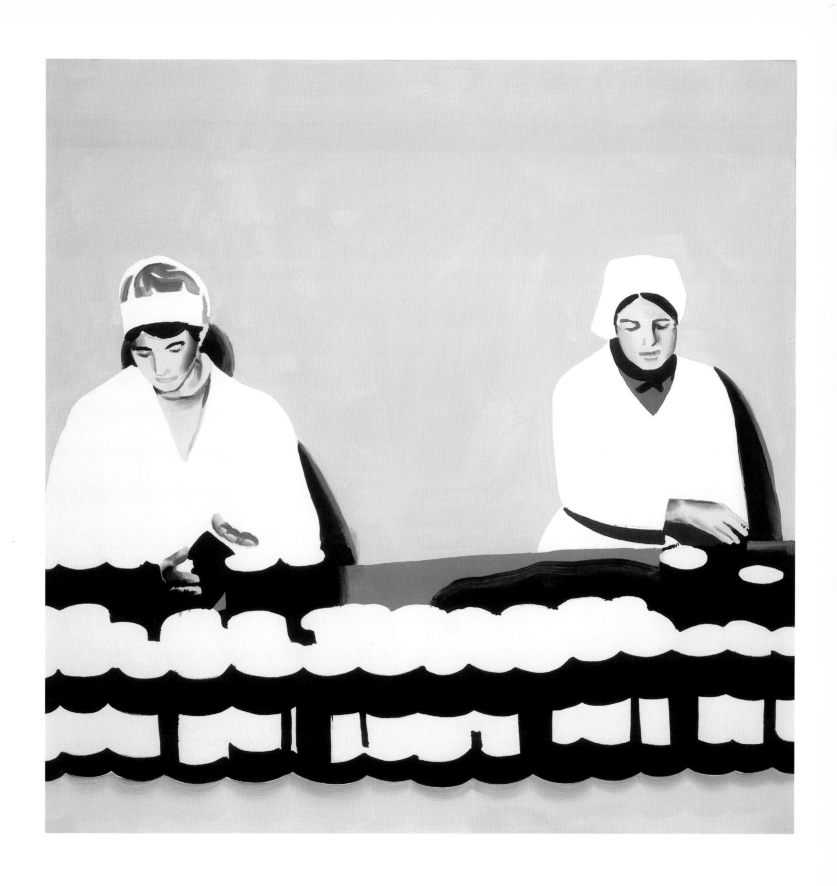

Wilhelm Sasnal
Factory, 2000
Oil on canvas
101×101 cm
cat. 90

Wilhelm Sasnal
Tarnow, Train Station, 2006
Oil on canvas
100×140 cm
cat. 95

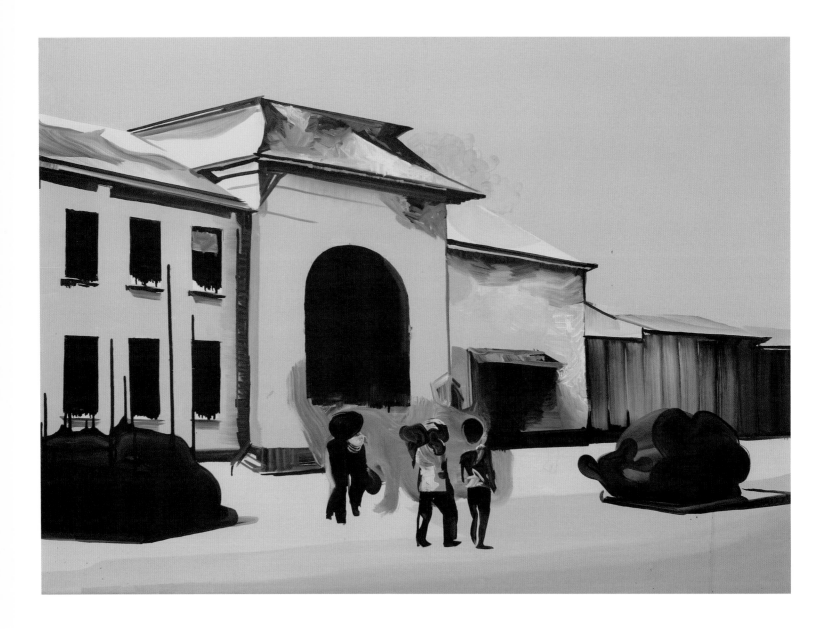

Wilhelm Sasnal
Gas Station 1, 2006
Oil on canvas
40×50 cm
cat. 93

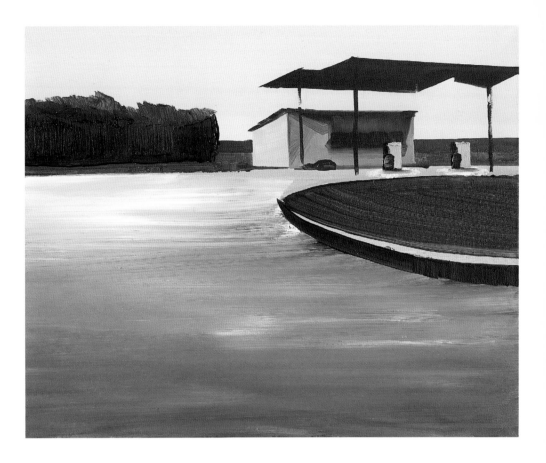

Wilhelm Sasnal
Gas Station 2, 2006
Oil on canvas
40×50 cm
cat. 94

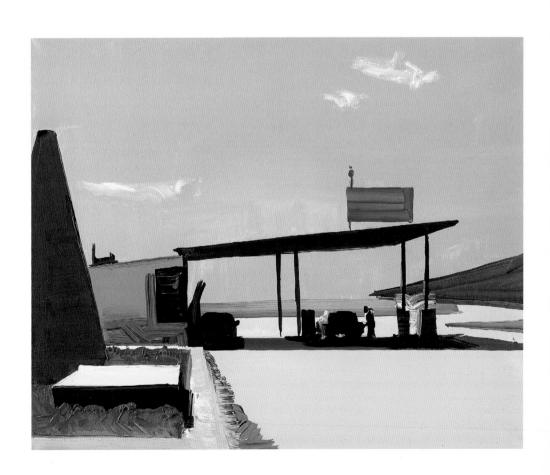

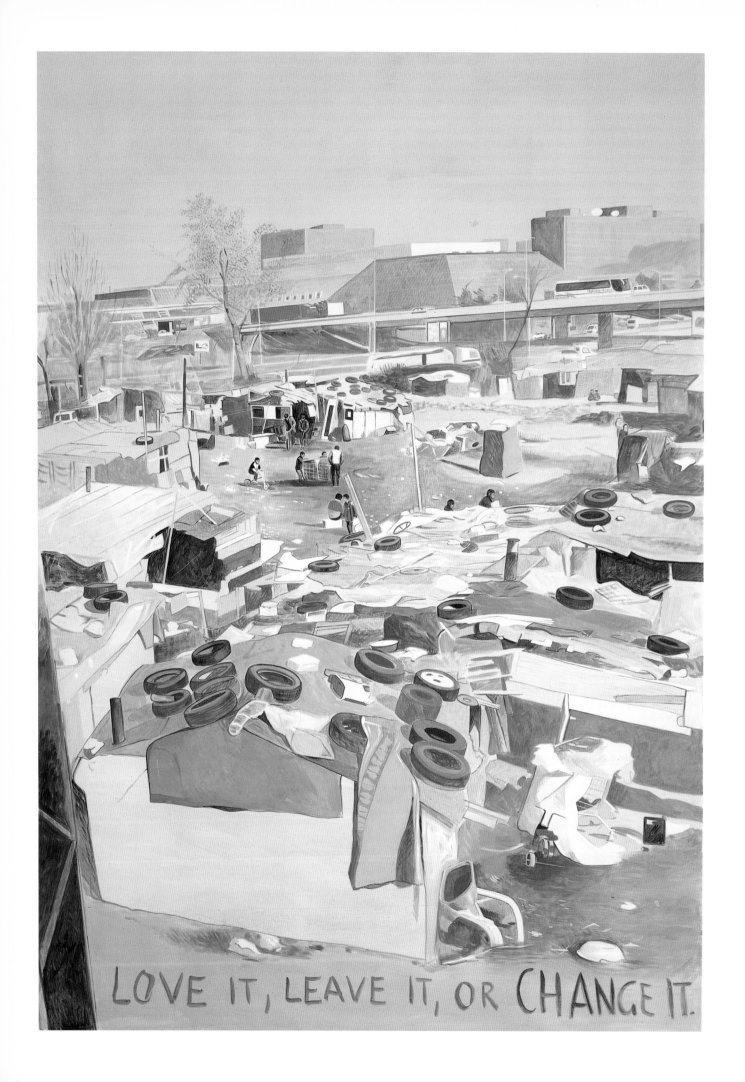

LOVE IT, LEAVE IT, OR CHANGE IT.

JOHANNA KANDL

Born in 1954, Vienna, Austria. Lives and works in Vienna, Austria,
and Berlin, Germany

**My practice as a photographer is linked very closely with my work as
a painter**. My husband Helmut Kandl and I work together as photographers.
We have a gigantic photo archive which I use as sources for my paintings.
Very often my photos are too static, too boring, too 'slow', too unspectacular
to be good as photos – but as raw material for painting they are perfect.
**Strangely, the painting loses the accidental quality of the original
snapshot**. The casual photo, with its technical flaws, gets generalised and
incidental scenes gain relevance … Just as world economy becomes analysed
in the local grocer's shop, I think that these little scenes become 'historic'
and 'monumental'. I try to make the image more 'concentrated' and closer to
what we see in reality than in the photo. I would not call my paintings photo-
realistic, but hyper-realistic – if that word had not already been used in another
way. The images turn into language and into a story. **One of today's greatest
aims is to capture a bit of reality**, of real life. We are all simply longing for
concrete facts, and that is why we like reality shows. I consider it interesting
that paintings contain documentary aspects and, in fact, I try to make the
paintings as concrete and as exact as I can. Tempera painting does not depict
impressions, but a model of the world … The paintings stay grounded and
down to earth, as touchable and concrete, as earthy as my pigments. I grew up
in a paint shop and my first profession was as a restorer. Paint ingredients, such
as Bohemian Green Earth or Burnt Ochre, have a cultural history (of trade,
power, wars and so on) which I want to include in my paintings; I even like
their names. **A painting shows us something of reality in a very special way**.
My paintings often portray scenes in Central and Eastern Europe. For some
people, these paintings seem to recreate lost or damaged memories, like the
fake memories in *Blade Runner*.[1]

Johanna Kandl
Untitled (Love it,…), 2005
Egg tempera on wood
243×170 cm
cat. 53

Johanna Kandl
Untitled (Ein sehr heisser Spätnachmittag…), 1999
Egg tempera on wood
115×150 cm
cat. 50

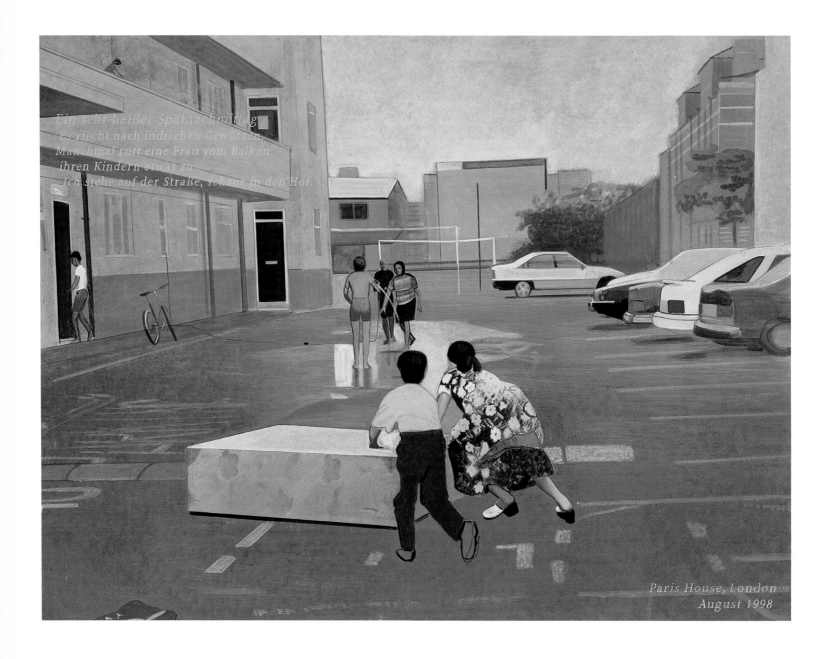

152

Johanna Kandl
Untitled, 2004
Egg tempera on wood
30×40 cm
cat. 51

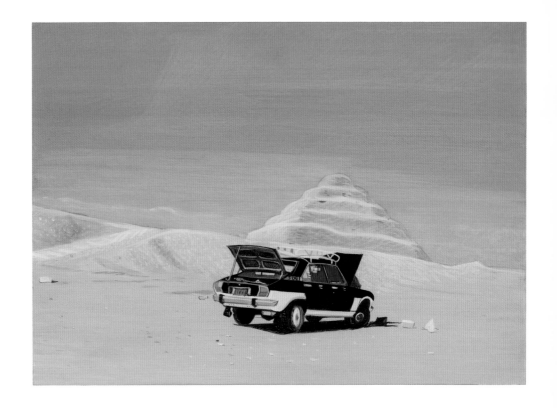

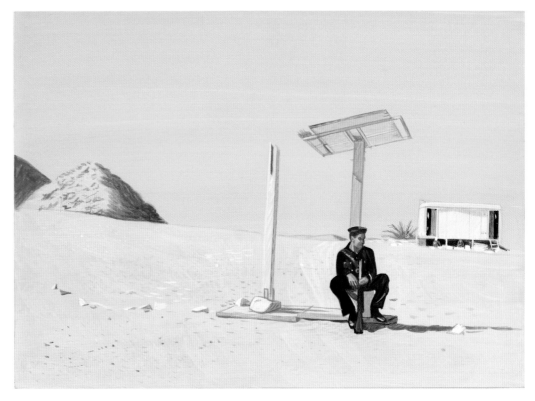

Johanna Kandl
Untitled, 2004
Egg tempera on wood
30×42 cm
cat. 52

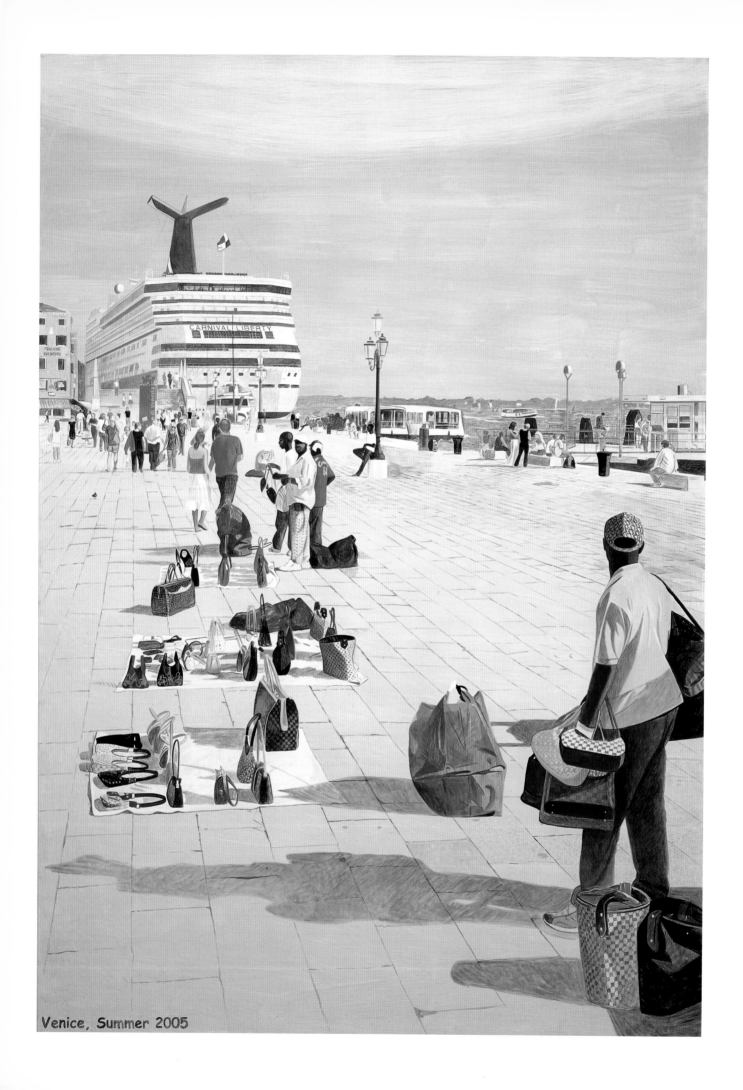

Venice, Summer 2005

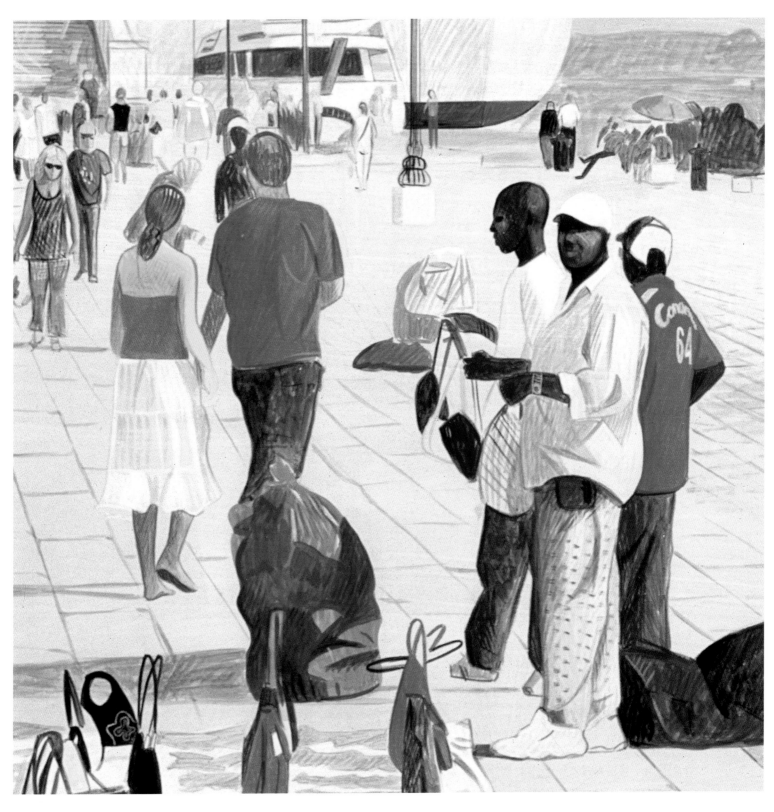

Johanna Kandl
Carnival Liberty, 2006 (detail above)
Egg tempera on wood
241×170 cm
cat. 54

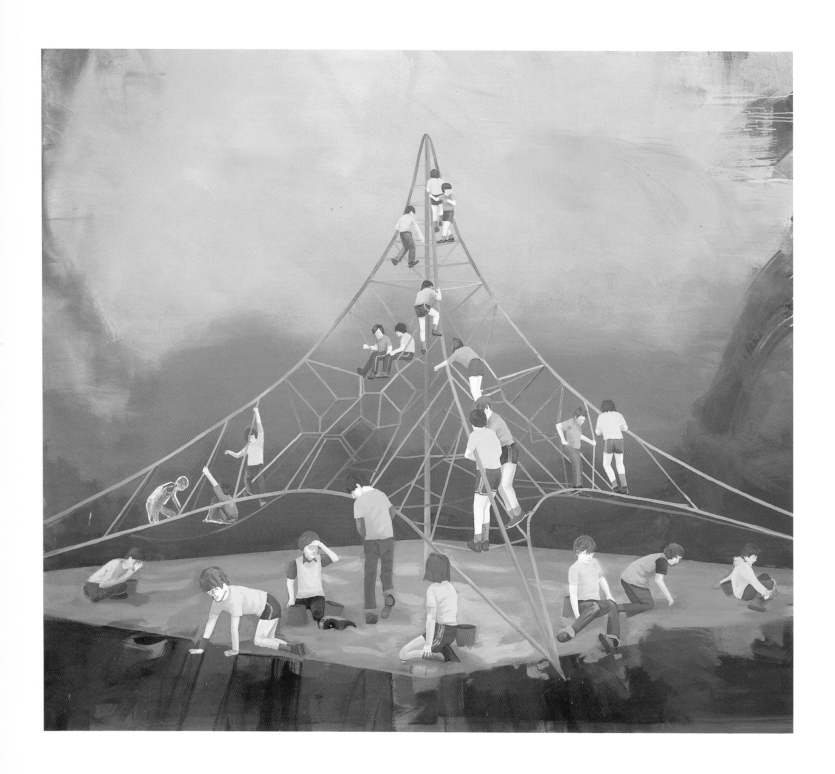

THOMAS EGGERER

Born in 1963, Munich, Germany. Lives and works in New York, NY, USA

Central to my work are paintings of groups of people in defined social situations and spaces. Figures moving in and out of an almost theatrical spatial frame – an artificial negotiation of space almost like in choreography. However, these spaces don't always hold what they seem to promise: they do not exactly offer the kind of linear continuum that the movement of the figures would otherwise suggest. **There is a sense in my work that you are allowed to enter something familiar,** but then you realise that this is not realistic representation. This sense of invitation and frustration is very important to me. **I think it's good one can see my work comes from photography.** What often happens in these group portraits is that the spatial discontinuity deepens an impression of tension and suspended time. Everything seems possible for these groups and individuals. At the same time social control appears to be present and the atmosphere seems to oscillate between two poles: on the one hand euphoric excitement over promised possibilities and, on the other hand, an environment where regulation seems enforced. **For me painterly representation is inconceivable outside the parameters of mass media image production and distribution.** If you look at an earlier issue of *National Geographic* magazine, for instance, it appears obvious that there is an idea of what is the centre and what is the periphery – the centre being, of course, white American post-war culture. Many of these images are almost too graphic in that respect. I am looking for motives that do not offer an obvious line and are generally more ambivalent. **There is another relationship to photography in my work** in that the scenes that I choose to paint are typically rather removed in terms of their point of view. As a viewer one can perceive oneself as an outsider – someone who is not a part of that particular social situation but in the privileged position to observe it. There is a blend of detachment, assumed control and voyeurism in such a position, which I find to be one of the most interesting aspects of mass media imagery. **There is always an authority behind photography** that is somewhat different from the one in painting, and I am interested in that authority. The eye of the camera and the presence of the eye behind it – how does that translate in a painting?[1]

Thomas Eggerer
The Fountain, 2002 (detail on right)
Acrylic on canvas
101.5×161.5 cm
cat. 23

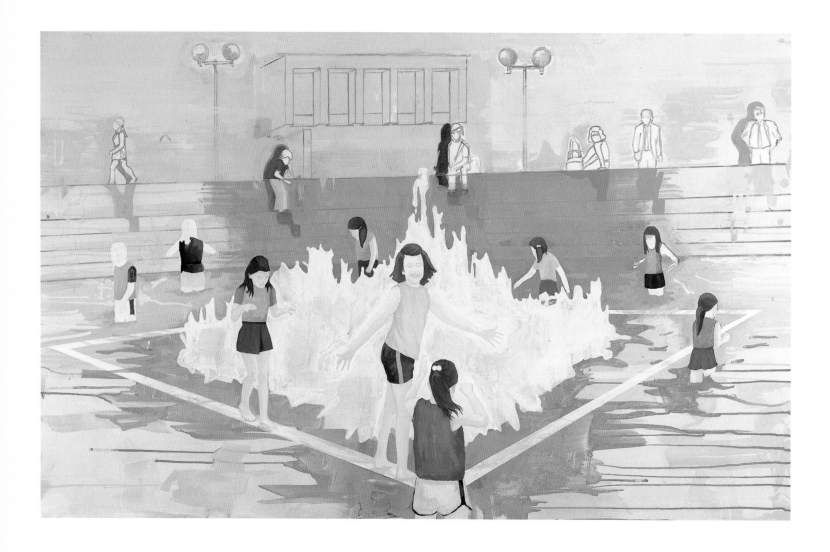

Thomas Eggerer
Sweet Valley High, 1998
Acrylic on canvas
69.9×100 cm
cat. 22

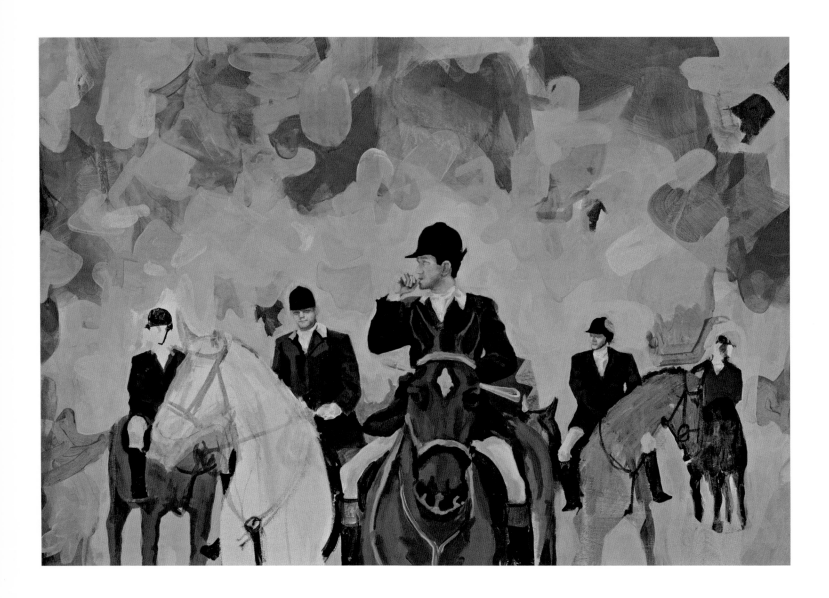

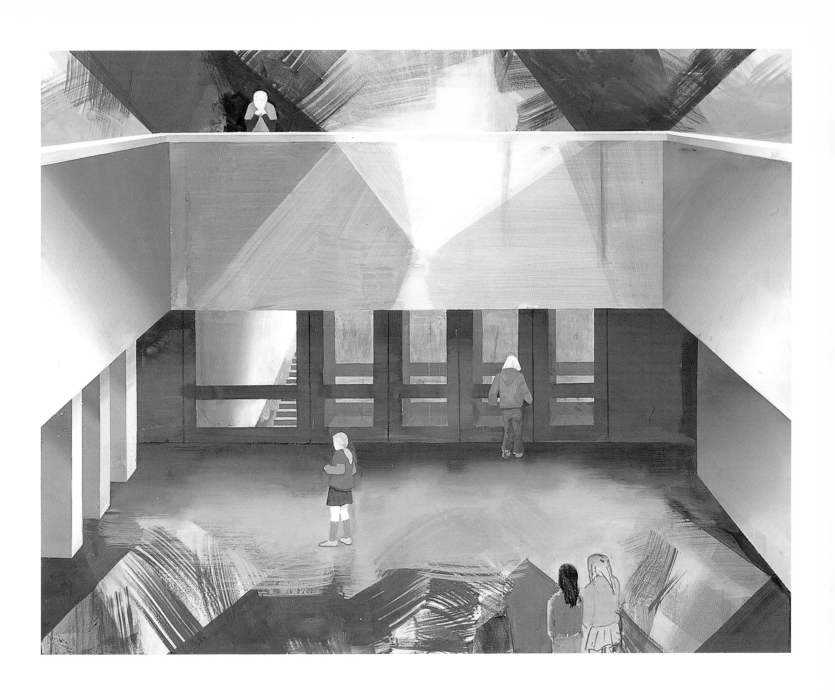

Thomas Eggerer
Mezzanine, 2004
Acrylic on canvas
137.2×175.3 cm
cat. 24

JOHANNES KAHRS

Born in 1965, Bremen, Germany. Lives and works in Berlin, Germany

For me the photographic image becomes more physical, more personal, when it is translated into a painting. It may be more clear in a way as well. But the reality of painting is not the reality of daily life. The presence of painting is about a different reality. Photographs never have this attraction, this fascinating quality, for me. They remain documents of some kind of reality, which I then forget again.[1] **I think of my paintings in reference to sci-fi and horror film atmospheres,** and not only with regard to light but also to space.[2] **When I see a situation in a film that interests me**, I rewind it back and forth and back again and look to see whether something can be isolated from a sequence of images. There has to be something more to the image than just the narration. It has to address something general. This can be a gaze, a movement or a touch. But sometimes I pick up the narrative structure and depict two situations side by side, as in *Révolution Permanente*, in order to suggest movement. The suspense then lies in between the two scenes. **It seems easier to work with photographic images that have an accidental character**. I need to see them as raw material, something I can change or reframe or crop and that can be done with certain types of images. Whereas others, especially artist's photographs, do not work for me as they are in a way already finished.[3] **Composition and style, all these academic things make me nervous** … I don't want to deal with these things because then I have the feeling I control the painting and the image I am looking for. But I don't want control: I want something that I have not yet encountered.[4] **[I reproduce photographic effects in my paintings] perhaps because I see the photograph as an object**. Or it may be because these 'mistakes' make it easier for me to find my own approach towards the photographic image. It may also be because these effects provide a contrast to the narrative aspect of the photograph.[5]

Johannes Kahrs
Figure Turning (large), 2006
Oil on canvas
200×132.3 cm
cat. 49

Johannes Kahrs
La Révolution Permanente, 2000
Oil on canvas, plexiglass, metal, 2 panels
193×269 cm and 193.5×293.5 cm
cat. 47

Johannes Kahrs
93'09", 1997
Oil on canvas, frame with Perspex
196×297 cm
cat. 46

Johannes Kahrs
Fond 2, 2005
Oil on canvas
60.5×81.5 cm
cat. 48

JUDITH EISLER

Born in 1962, New York, NY, USA. Lives and works in New York

I work from images from various films but I avoid specifically recognisable images as this makes the meaning of the work too laboured and determined. The paintings are not meant to reflect on the narratives or structures of the films. I am interested in the new narratives that inevitably emerge within the frame of the painting, and in emotional and psychological states of indeterminate action. The ambiguity allows the viewer to project his or her own prejudices onto this seemingly still image. **My research could be described as forensic** in that I use the camera in a manner that is perhaps similar to a police photographer photographing a crime scene. I sit in front of a television that is playing a video or a DVD of a film and I take photographs. Pausing the fleeting moment allows me to investigate an incident that is otherwise peripheral and not immediately discernable. The relentless flow of images [in a film] may seem quite realistic but in fact what we perceive to be real is actually riddled with distortion. I want to describe the moments of possibility inherent in mediated images. I want to hear the sound of a pause. **As a scavenger of images, I see no mandate for fidelity to an original**. I think of the photographs I use as *objets trouvés*. Beyond the technical armature of the photos, the images function as beginnings of paintings and the paintings take on their own existences in terms of size, colour and proportion. *Smoker (Cruel Story of Youth)* is an instance where I significantly cropped the photo to focus on a detail in the initial image. **While the paintings mimic the immediacy of a photographic image**, they are not read with the same speed used to examine a photograph. The paintings can generate extremely different readings depending on the location of the viewer. The illusionism that is made apparent from afar dissolves into abstract passages of paint when viewed from a closer proximity. **I am not trying to create a distance from the original image so much as to describe a distance** that results from so many layers of technological interference. The films I watch are of great interest to me but their significance is first neutralised by the photograph and then absorbed into the language of the painting. I am interested in the tension that develops from the juxtaposition of the recognisable and the abstract, and how new narratives emerge from the illusory nature of the painted surface. I want to pull a peripheral moment out of the intent and flow of the narrative so that it conveys a presence or implication that vibrates beyond the perceived form. **I need to work with known images and I want them to become something raw**, naked you might say. It's like taking the filter away and taking the image out of its narrative. Therefore, the way I paint is in relationship to images. For me painting is a medium to communicate an idea.[1]

Judith Eisler
Gena (Opening Night), 2003
Oil on canvas
121.9×152.4
cat. 27

Judith Eisler
Delon 2, 2007
Oil on canvas
147.3×193 cm
cat. 29

Judith Eisler
Smoker (Cruel Story of Youth), 2003
Oil on canvas
147×178 cm
cat. 28

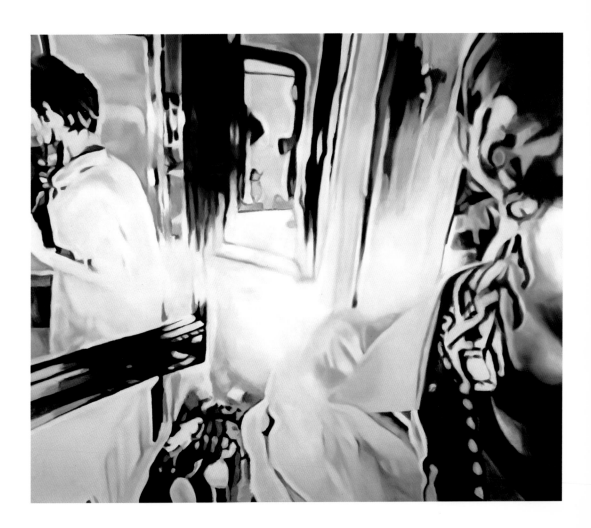

Judith Eisler
Edie (Ciao Manhattan), 2003
Oil on canvas
172.7×203.2 cm
cat. 26

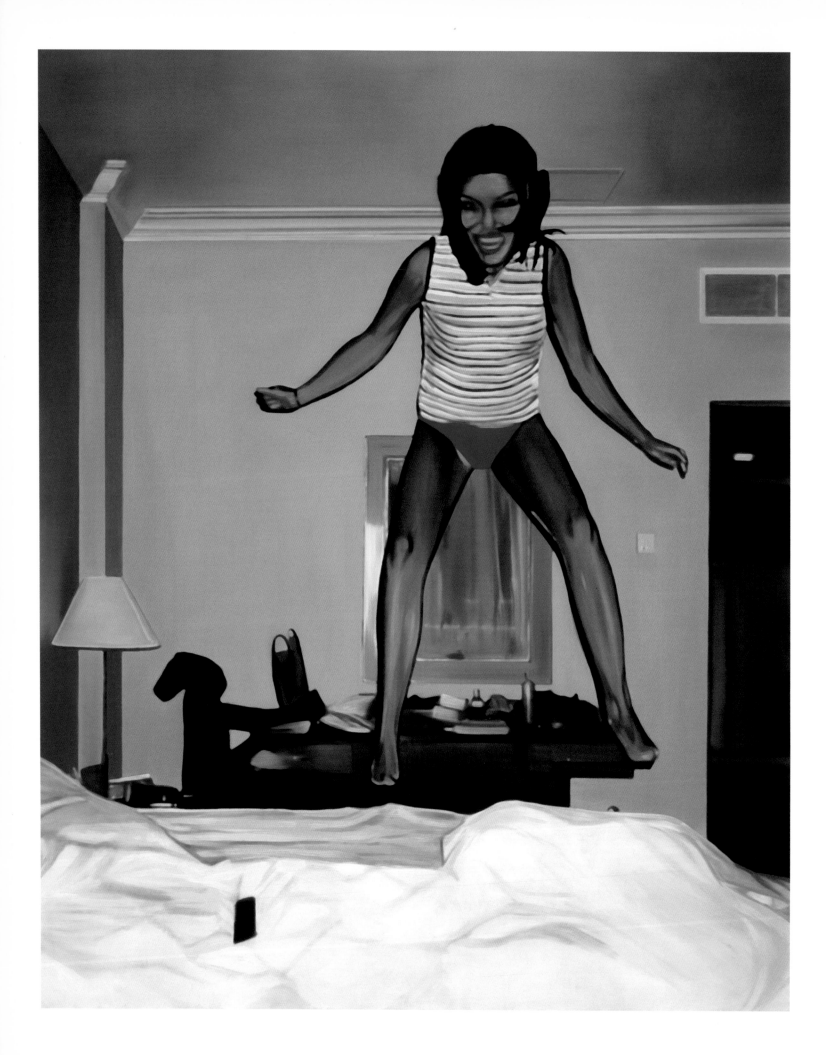

EBERHARD HAVEKOST

Born in 1967, Dresden, Germany. Lives and works in Berlin, Germany

Photography is a medium which restricts reality and it is a 'guest medium' for the image – as is painting. In this respect, I see no difference between photography and painting. And naturally, too, the media also create a reality. That's why we are so sceptical toward photography.[1] **For me, the photographic source is not a document of actual events**, because the ongoing perception of reality overlays the attempt to fix things.[2] **If the brain is a storage system** there has to be an authority that determines what is stored and how. As we know, not everything is stored. And the memories become idealised. Maybe the manipulation starts in the eye. And certainly with the camera. I have probably adapted the view of a camera lens in the meantime.[3] **What I try to do is to break up the photographic effects**. For example, the photographic effect divides up the space into focused and unfocused areas. There is an unfocused area in the background, a focused area in the central area, and sometimes an unfocused area in the foreground. In painting, one can introduce more levels of focusing and non-focusing. **I choose images that have been incorrectly saved**; where one takes the factual element in the image personally and the personal no longer matches the context of the image. At that moment, one has to take the images out of the newspaper and re-evaluate them. The context can have a displacing effect, or can be more than right. **Does a picture lose its status as contemporary** if one uses a three-year-old or six-year-old photo as a model? Everyone flirts with eternity. There is always some disturbing contemporary accessory in a picture. Or a design established for a certain time. The contemporary design leads away from a general human statement in the picture. But it is not possible to have no design, because if one portrayed a human being naked, pornography would immediately come into play. The contemporary pictures contain everything that's going on, or much of what's going on, in the world. **The claim to reality that I have in my photography** is dominated by the claim to reality of the media images. The claim to reality that I have in my painting is dominated by the claim to reality of the photograph. An exhibition, after all, is an offer to create a common reality. It is easier to talk of a common reality if realistic objects are to be seen in the picture.[4]

Eberhard Havekost
Hotelsprung, 2003
Oil on canvas
220×180 cm
cat. 38

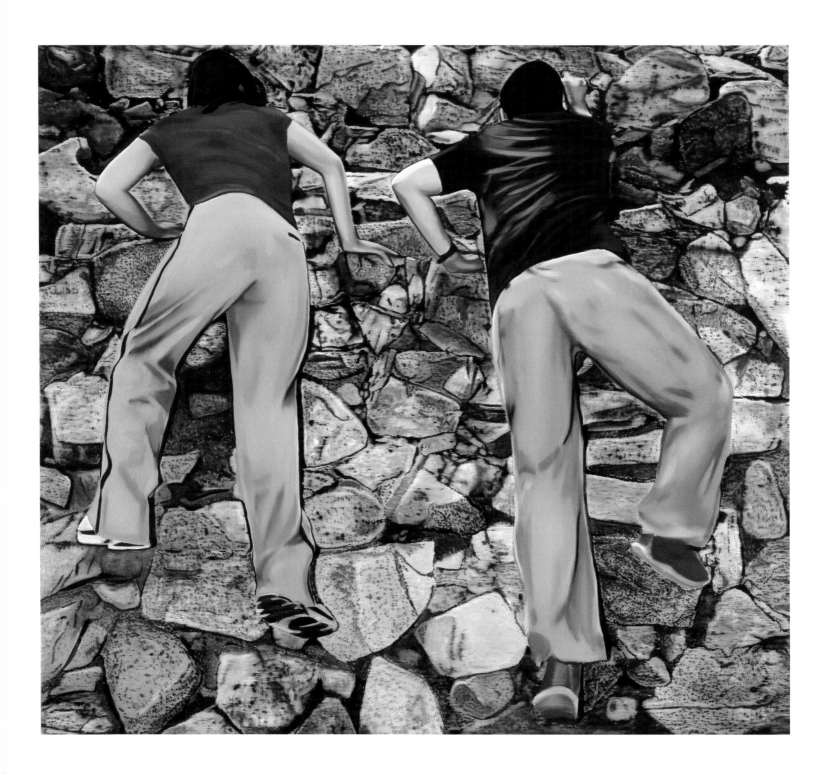

Above
Eberhard Havekost
Beginning A..., 2004
Oil on canvas
180×200 cm
cat. 41

Right
Eberhard Havekost
Luft, 2003
Oil on canvas
90×60 cm
cat. 39

Eberhard Havekost
National Geographic, 2003
Oil on canvas
110×130 cm
cat. 40

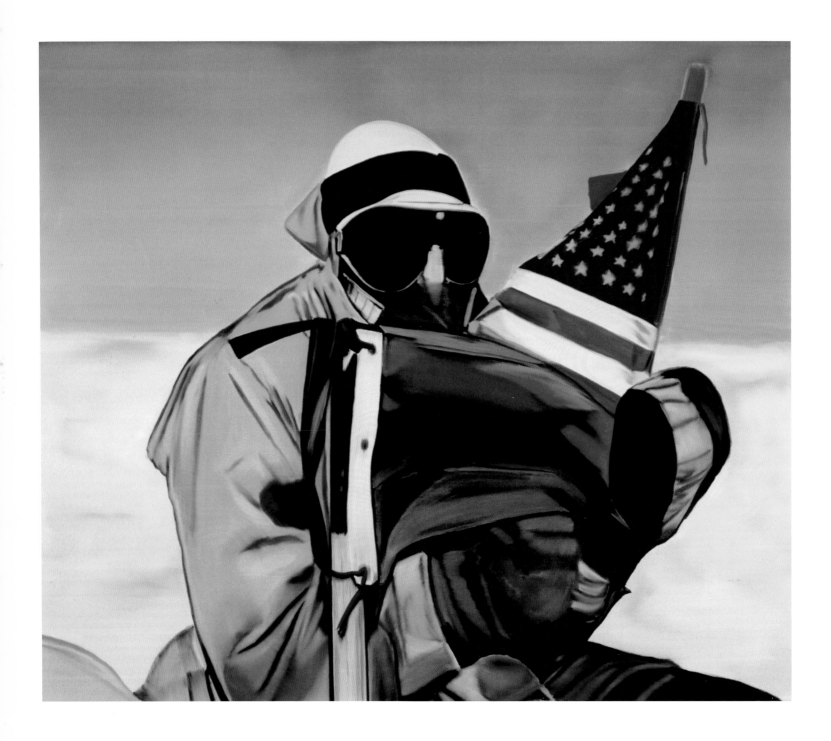

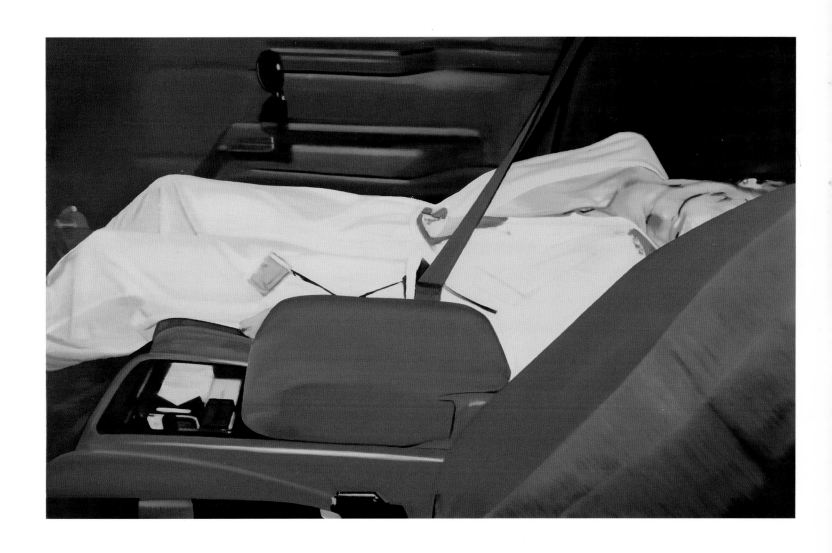

Eberhard Havekost
American Lip Gloss, B06, 2006
Oil on canvas
95×150 cm
cat. 42

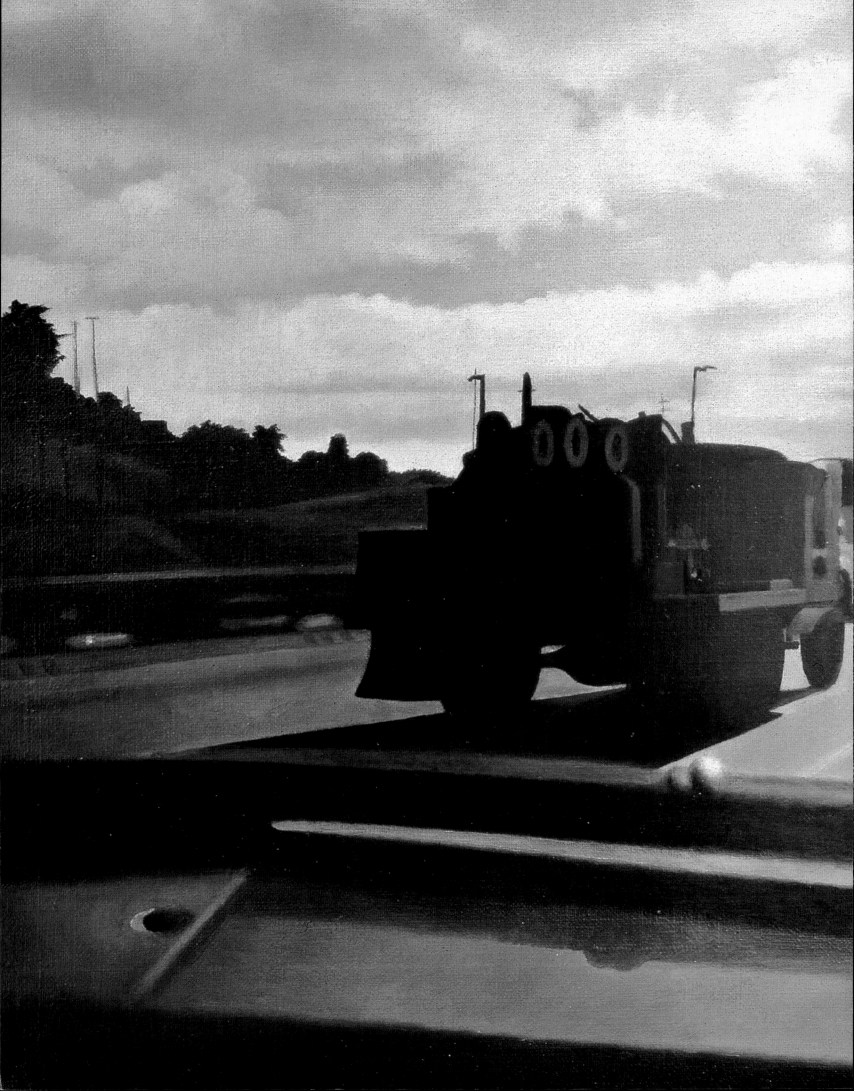

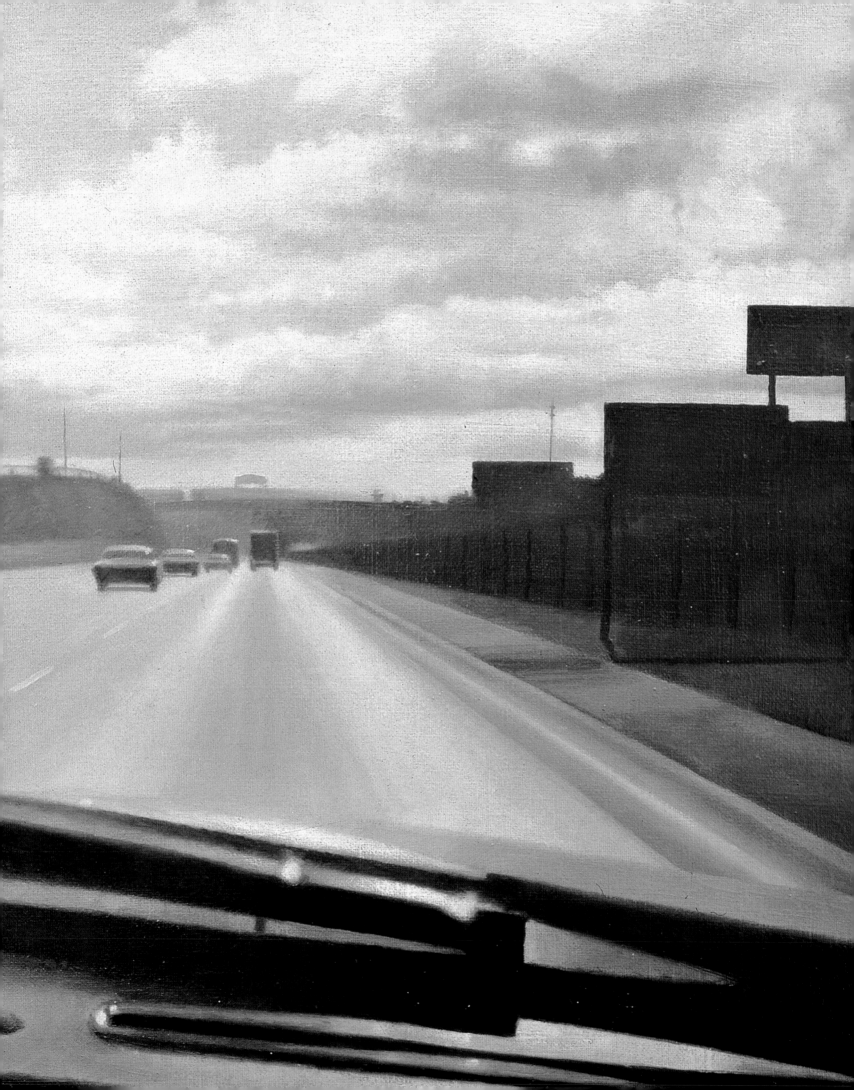

Notes

References are for pages 53 to 173. All texts are by the artists, and are reproduced with kind permission of the artists.

RICHARD ARTSCHWAGER
1 Frédéric Paul, 'Conversation, 14 April, June–July 2003', in *Richard Artschwager*, Domaine de Kerguéhennec, Bignan, 2003.
2 Steve Griffin, 'Interview with Richard Artschwager in "Four Artists"', in *951: An Art Magazine*, November 1975, pp. 16–18. (republished in Dieter Schwarz (ed.), *Richard Artschwager, Texts and Interviews*, Kunstmuseum Winterthur, Richter Verlag, Düsseldorf, 2003.)
3 Paul Cummings, 'Oral History: Interview with Richard Artschwager', in *Smithsonian Archives of American Art*, 3 and 22 March 1978.
4 'Answers to a letter from Coosje van Bruggen, dated 24 May, 1983', in Dieter Schwarz (ed.), op. cit., p. 92.

ROBERT BECHTLE
1 Brian O'Doherty, 'The Photo-Realists: Twelve Interviews', in *Art in America*, 60, no. 6, November–December 1972, pp. 73, 74.
2 Robert Bechtle, September 1973, in Louis K. Meisel, *Photo-Realism*, Harry N. Abrams, New York, 1980, p. 27.

VIJA CELMINS
1 Susan Larson, 'A Conversation with Vija Celmins', in *LAIC Journal*, Los Angeles Institute of Contemporary Art, October–November 1978, p. 38.
2 'Vija Celmins Interviewed by Chuck Close at her New York Loft on September 26 and 27, 1991', in *Vija Celmins*, A.R.T. Press, New York, 1992, p. 12.
3 Sarah Pierce, 'Space and Time: An Interview with Vija Celmins', in *Q / A Journal of Art*, Spring 1993.
4 'Vija Celmins Interviewed by Chuck Close', op. cit.

PETER DOIG
1 'Peter Doig: Twenty Questions (extract)', 2001, in *Peter Doig*, Phaidon Press, London, 2007, pp. 124–140.
2 Peter Doig interviewed by Adrian Searle, London, April 1995, 'I've never been canoeing on a toxic swamp', in *Peter Doig: Blotter*, Contemporary Fine Art, Berlin and Victoria Miro Gallery, London, 1995.
3 Peter Doig in conversation with The Hayward, 2007.

MARLENE DUMAS
1 'Marlene Dumas in conversation with Gavin Jantjes, Amsterdam, 15 December 1996', in *A Fruitful Incoherence: Dialogues with Artists on Internationalism*, inIVA, London, 1998, pp. 50–63.
2 Marlene Dumas interviewed by Gioni Massimiliano, 'Marlene Dumas, ton visage demain / Your Face Tomorrow', Jacques Demarcq (trans.), in *Art Press*, no. 317, November, pp. 32–38.
3 Marlene Dumas in conversation with The Hayward, 2007.
4 'Marlene Dumas in conversation with Gavin Jantjes', op. cit., pp. 50–63.
5 Marlene Dumas in conversation with The Hayward, 2007.

THOMAS EGGERER
1 Thomas Eggerer in conversation with The Hayward, 2007.

JUDITH EISLER
1 Judith Eisler in conversation with The Hayward, 2007.

FRANZ GERTSCH
1 Franz Gertsch interviewed by Michael S. Cullen, in *Hyperréalistes américains – réalistes européens*, Centre national d'Art Contemporain, Paris, 1974, p. 94.
2 Franz Gertsch interviewed by Jırgen Glaesemer, in *Franz Gertsch*, Kunsthaus Zürich, Bern, 1980, p. 10.
3 Franz Gertsch, 'Meine Strategie des Malens', ('My Strategy as a Painter'), in *Franz Gertsch*, Akademie der Künste, Berlin, 1975, unpaginated.

RICHARD HAMILTON
1 Richard Hamilton, 'Photography and Painting', in *Studio International*, March 1969, pp. 120–125. See *Collected Words*, Thames & Hudson, London, 1982.

EBERHARD HAVEKOST
1 Eberhard Havekost interviewed by Mark Coetzee, November 2006, in *Eberhard Havekost*, Rubell Family Collection, Miami, 2006.
2 Eberhard Havekost in conversation with The Hayward, 2007. Translated by Richard Humphrey.
3 Eberhard Havekost interviewed by Mark Coetzee, op. cit.
4 Eberhard Havekost in conversation with The Hayward, 2007. Translated by Richard Humphrey.

DAVID HOCKNEY
1 Nikos Stangos (ed.), *David Hockney – My Early Years*, Thames & Hudson, London, 1976, p. 130.
2 *David Hockney. Photographs*, Petersburg Press, London and New York, 1982, pp. 9, 13, 24.

JOHANNES KAHRS
1 Johannes Kahrs in conversation with The Hayward, 2007.
2 *Johannes Kahrs. Men with Music*, GAMeC, Bergamo, Italy, 2007, p. 88.
3 Johannes Kahrs in conversation with The Hayward, 2007.
4 *Johannes Kahrs. Men with Music*, op. cit., p. 91.
5 Johannes Kahrs in conversation with The Hayward, 2007.

JOHANNA KANDL
1 Johanna Kandl in conversation with The Hayward, 2007.

MARTIN KIPPENBERGER
1 Gisela Stelly, *Ihr Kippy-Kippenberger. Letters-Paintings-Photos-Film 1976–1978. By and With Martin Kippenberger*, Galerie Bärbel Grässlin, Frankfurt am Main, 2006, p. 25.
2 Description of making of *Uno di voi*, Daniel Baumann, 'Interview with Martin Kippenberger', Geneva, 1997, Fiona Elliot (trans.), in Doris Krystof and Jessica Morgan (eds), *Martin Kippenberger*, Tate Publishing, London, 2006, p. 60.
3 Martin Kippenberger interviewed by Jutta Koether, in 'Martin Kippenberger: An artist doesn't have to be new, an artist has to be good', 1991, in *FlashArt*, March–April 2006, pp. 94, 95.
4 Angelika Taschen and Burkhard Riemschneider (eds), *Kippenberger*, Taschen Books, Cologne, 1997, pp. 49, 54.

LIU XIAODONG
1 'Interview with Liu Xiaodong', in *Liu Xiaodong*, Red Flag Collection, Map Book Publishers, Hong Kong, 2006, pp. 12, 15, 22.
2 Liu Xiaodong in conversation with The Hayward, 2007.

MALCOLM MORLEY
1 Malcolm Morley in conversation with The Hayward, 2007.

ELIZABETH PEYTON

1 Elizabeth Peyton in conversation with
The Hayward, 2007.
2 Francesco Bonami, 'Elizabeth Peyton: We've been
looking at images for so long that we've forgotten
who we are', in *Flash Art*, March–April 1996, p. 84.
3 'Elizabeth Peyton in conversation with Rob Pruitt and
Steve Lafreniere', in *index magazine*, June–July 2002.

MICHELANGELO PISTOLETTO

1 Michelangelo Pistoletto, 'Division and Multiplication
of the Mirror', 1978, in *Michelangelo Pistoletto*,
Museu d'Art Contemporani de Barcelona, Barcelona,
2000, p. 122.
2 Michelangelo Pistoletto, 'The Mirror', 1982, ibid,
p. 120.
3 Michelangelo Pistoletto in conversation with Gilbert
Perlein, Pierre Padovani and Michèle Brun, 19 February
2007, in www.cittadellarte.it/citta2005/pdf.
4 Michelangelo Pistoletto, 'The Last Famous Words',
1976, in *Michelangelo Pistoletto: Zeit-Räume*,
Museum moderner Kunst Stiftung Ludwig Wien,
Vienna, 1995, p. 154.

GERHARD RICHTER

1 'Interview with Peter Sager', in Gerhard Richter,
The Daily Practice of Painting: Writings 1962–1993,
Hans-Ulrich Obrist (ed.), Thames & Hudson, London,
1995, p. 66.
2 'Notes, 1964–1965', ibid, pp. 33–34.
3 'Interview with Benjamin H.D. Buchloh, 1986',
in *The Daily Practice of Painting*, op. cit., p. 145.
4 'Notes, 1964–1965', op. cit., p. 31.
5 'Interview with Rolf Schön', 1972, in *The Daily Practice
of Painting*, op. cit., p. 73.
6 'Notes, 1964–1965', op. cit., pp. 22–23.

WILHELM SASNAL

1 Wilhelm Sasnal in conversation with The Hayward,
2007. Translated by Rafal Niemojewski.

LUC TUYMANS

1 'Luc Tuymans interviewed by Martin Gayford',
in *Modern Painters*, Autumn 1999, p. 11.
2 John Tusa, *The John Tusa Interview – Luc Tuymans*,
BBC Radio 3, 28 July, http://www.bbc.co.uk/radio3/
johntusainterview/pip/epjva/.
3 Daniel Birnbaum, 'A thousand words: Luc Tuymans',
in *ArtForum*, October 1998, p. 107.

4 Juan Vicente Aliaga in conversation with Luc Tuymans,
in *Luc Tuymans*, Phaidon, London, 2003, p. 12.
5 Narcisse Tordoir and Luc Tuymans (eds), *Trouble Spot.
Painting at the NICC and MUHKA*, NICC and MUHKA,
Antwerp, 1999.
6 CNN interview, 18 October 2006,
http://edition.cnn.com/2006/TRAVEL/02/17/
antwerp.qa/.
7 Juan Vicente Aliaga in conversation with Luc Tuymans,
op. cit., p. 12.

ANDY WARHOL

1 Gerard Malanga, 'A Conversation with Andy Warhol',
in *The Print Collector's Newsletter*, January–February 1971
(published in Kenneth Goldsmith (ed.), *I'll be Your Mirror:
The Selected Andy Warhol Interviews*, Carroll & Graf,
New York, 2004, pp. 194–196).
2 Glenn O'Brien, 'Interview: Andy Warhol', June 1977,
in *High Times*, 24 August 1977 (published in Kenneth
Goldsmith (ed.), ibid, p. 7).
3 'Warhol interviews Bourdon', unpublished manuscript
from the Andy Warhol Archives, Pittsburgh (published
in Kenneth Goldsmith (ed.), op. cit., pp. 8–9).
4 Gretchen Berg, 'Andy Warhol: My True Story',
Summer 1966, in *The East Village Other*, 1 November
1966 (published in Kenneth Goldsmith (ed.),
op. cit., p. 95).
5 'Warhol interviews Bourdon', op.cit., p. 7.
6 Gretchen Berg, op. cit.

Selected Exhibitions and Bibliographies

RICHARD ARTSCHWAGER

Solo exhibitions

Richard Artschwager: 'Painting' Then and Now, Museum of Contemporary Art, Miami (2003); *Richard Artschwager*, Kunstmuseum Winterthur; and tour (2003); *Richard Artschwager*, Domaine de Kerguéhennec, France; and tour (2003); *Richard Artschwager*, MAK, Vienna (2002); *Richard Artschwager: Up and Across*, Neues Museum, Nüremberg; Serpentine Gallery, London (2001); *Richard Artschwager*, Fondation Cartier pour l'art contemporain, Paris (1995); *Connections: Richard Artschwager*, Museum of Fine Arts, Boston (1992); *Richard Artschwager*, Whitney Museum of American Art, New York; and tour (1988); *Richard Artschwager*, Kunsthalle Basel; and tour (1985); *Richard Artschwager's Theme(s)*, Albright-Knox Gallery, Buffalo, New York; and tour (1979); *Artschwager*, Leo Castelli Gallery, New York (1965)

Group exhibitions

Hyperréalismes USA, 1965–75, Musée d'Art moderne et contemporain de Strasbourg (2003); *The Photogenic: Photography Through its Metaphors in Contemporary Art*, Institute of Contemporary Art, Philadelphia (2002); *Birth of the Cool: American Painting*, Deichtorhallen, Hamburg; and tour (1997); *Documenta 9*, Kassel (1992); *Pop Art: An International Perspective*, Royal Academy of Arts, London (1991); *Documenta 8*, Kassel (1987); *Skulptur Projekte*, Münster (1987); *The Painter-Sculptor in the Twentieth Century*, Whitechapel Art Gallery, London (1986); *Documenta 7*, Kassel (1982); Venice Biennale (1980 and 1976); *American Pop Art*, Whitney Museum of American Art (1974); *Contemporary American Painting*, Whitney Museum of American Art (1972); *Documenta 5*, Kassel (1972); *Live in Your Head, When Attitudes Become Form: Works-Concepts-Processes-Situations-Information*, Kunsthalle Bern (1969); *Pop Art*, Hayward Gallery (1969); *Documenta 4*, Kassel (1968); *Primary Structures*, Jewish Museum, New York (1966); *The Photographic Image*, The Solomon R. Guggenheim Museum, New York (1966); *Light and Lively*, Albright-Knox Gallery, Buffalo, New York (1964)

Bibliography

Richard Artschwager, Domaine de Kerguéhennec, France, 2003.

Dieter Schwarz (ed.), *Richard Artschwager, Texts and Interviews*, Kunstmuseum Winterthur, Richter Verlag, Düsseldorf, 2003.

Richard Artschwager. Up and Across, Neues Museum in Nüremberg and Verlag für Modern Kunst, Nüremberg, 2001.

Ingrid Schaffner, Kurt W. Forsterm, Vik Muniz and Richard Armstrong, on 'Richard Artschwager', in *Parkett*, no. 46, Zürich, 1996.

Richard Armstrong, *Richard Artschwager*, Whitney Museum of American Art, New York, 1988.

Richard Artschwager, Kunsthalle Basel, Basel, 1985.

Richard Artschwager's Theme(s), Albright-Knox Gallery, Buffalo, 1979.

Paul Cummings, 'Oral History Interview with Richard Artschwager', in *Smithsonian Archives of American Art*, 3 and 22 March 1978.

Brian O'Doherty, 'The Photo-Realists: Twelve interviews', in *Art in America*, 60, no. 6, November–December 1972.

ROBERT BECHTLE

Solo exhibitions

Robert Bechtle: A Retrospective, San Francisco Museum of Modern Art; and tour (2005–06); *Robert Bechtle: New Work*, San Francisco Museum of Modern Art (1991); *Robert Bechtle: Matrix/Berkeley 33*, Berkeley Art Museum, University of California (1980); *Robert Bechtle: A Retrospective Exhibition*, E.B. Crocker Art Gallery, Sacramento; and tour (1973); O.K. Harris Works of Art, New York (1971); *Robert Bechtle*, San Francisco Museum of Modern Art (1967)

Group exhibitions

Hyperréalismes USA, 1965–75, Musée d'Art moderne et contemporain de Strasbourg, France (2003); *Les années pop*, Centre Pompidou, Paris (2001); *Made in California: Art, Image and Identity, 1900–2000*, Los Angeles County Museum of Art (2000); *Made in USA: An Americanization in Modern Art: The 50's and 60's*, Berkeley Art Museum; and tour (1987); *American Super Realism from the Morton G. Neumann Family Collection*, Terra Museum of American Art, Evanston, Illinois (1983); *Contemporary American Realism Since 1960*, Pennsylvania Academy of Fine Arts, Philadelphia; and tour (1981); *Seven Photorealists from New York Collections*, The Solomon R. Guggenheim Museum, New York (1981); *Super Realism*, Baltimore Museum of Art, Maryland (1975); *Photo Realism*, Serpentine Gallery, London (1973); *Documenta 5*, Kassel (1972); *Twenty-Two Realists*, Whitney Museum of American Art, New York (1970); *Directions 2: Aspects of a New Realism*, Milwaukee Art Center, Wisconsin (1969); *East Bay Realists*, San Francisco Art Institute (1966)

Bibliography

Michael Auping, Janet Bishop, Charles Ray, Jonathan Weinberg, *Robert Bechtle: A Retrospective*, San Francisco Museum of Modern Art, San Francisco, 2005.

Robert Bechtle, Paul J. Karlstrom, 'An Interview with Robert Bechtle', in *Archives of American Art Journal*, vol. 20, no. 2, 1980.

Louis K. Meisel, *Photo-Realism*, Harry N Abrams, New York, 1980.

Udo Kultermann, *The New Painting*, Wesley V. Blomster (trans.), Westview Press, Boulder, Colorado, 1976.

Ivan C. Karp, Susan Regan McKillop, *Robert Bechtle: A Retrospective Exhibition*, E.B. Crocker Art Gallery, Sacramento, 1973.

Brian O'Doherty, interview with Robert Bechtle, 'The Photo-Realists: Twelve Interviews', in *Art in America*, 60, no. 6, November–December 1972.

VIJA CELMINS

Solo exhibitions

Vija Celmins: A Drawing Retrospective, Hammer Museum, UCLA, Los Angeles (2007) and Centre Pompidou, Paris (2006); *Vija Celmins: Works from The Edward R. Broida Collection*, The Museum of Fine Arts, Houston, Texas (2002–03); *The Prints of Vija Celmins*, Metropolitan Museum of Art, New York (2002); *Vija Celmins Drawings*, Museum für Gegenwartskunst, Basel (2001); *Vija Celmins. Works 1964–1996*, Institute of Contemporary Arts, London; and tour (1996–07); *Vija Celmins*, Fondation Cartier pour l'art contemporain, Paris (1995); *Vija Celmins Retrospective*, Institute of Contemporary Art, Philadelphia; and tour (1992–94); *Vija Celmins: A Survey Exhibition*, Newport Harbor Art Museum, Newport Beach, California; and tour (1980); *Vija Celmins*, Whitney Museum of American Art, New York (1973); Dickson Art Center, UCLA (1965)

Group exhibitions

Magritte and Contemporary Art: The Treachery of Image, Los Angeles County Museum of Art (2006–07); *The Undiscovered Country*, Hammer Museum (2004); *Hyperréalismes USA, 1965–75*, Musée d'Art moderne et contemporain de Strasbourg, France (2003); Venice Biennale (2003); *Whitney Biennial*, Whitney Museum of American Art (2002); *Examining Pictures: Exhibiting Paintings*, Whitechapel Art Gallery, London; and tour (1999); *Whitney Biennial*, New York (1997); *Sunshine & Noir: Art in LA 1960–1997*, Louisiana Museum of Modern Art, Denmark; Castello di Rivoli, Turin, Italy; and tour (1997); *Birth of the Cool: American Painting,*

Deichtorhallen, Hamburg, Germany; and tour (1997); *About Place: Recent Art of the Americas*, Art Institute of Chicago (1995) *Institute of Contemporary Anxiety*, Institute of Contemporary Arts, London (1995); *Contemporary American Realism*, Pennsylvania Academy of the Fine Arts, Philadelphia (1981); *American Drawings 1963–1973*, Whitney Museum of American Art (1973); *Continuing Surrealism*, La Jolla Museum of Contemporary Art, California (1971); *24 Young Los Angeles Artists*, Los Angeles County Museum of Art (1971); *Annual of Contemporary American Sculpture*, Whitney Museum of American Art (1970)

Bibliography
Simon Grant, 'Thinking Drawing. Interview: Vija Celmins', in *Tate etc.*, issue 9, Spring 2007.
Louise Gray, 'Out of reach', in *Art Review*, vol. 56, February 2006.
Briony Fer, Robert Gober, Lane Relyea, *Vija Celmins (Contemporary Artists series)*, Phaidon Press, London, 2004.
Robert Enright, 'Tender Touches: An Interview with Vija Celmins', in *Border Crossings*, vol. 22, no. 3, August 2003.
James Lingwood, Stuart Morgan, Richard Rhodes, Neville Wakefield, *Vija Celmins*, Institute of Contemporary Arts, London; Museo Nacional Centro de Arte Reina Sofia, Madrid, 1996.
Vija Celmins, Fondation Cartier pour l'art contemporain, Paris, 1995. Essay by Robert Storr.
Nancy Princenthal, Jim Lewis, Jeanne Silverthorne, Richard Shiff, 'Vija Celmins', in *Parkett*, no. 44, Zürich, 1995.
Vija Celmins. Museum of Contemporary Art, Los Angeles, 1994.
Sarah Pierce, 'Space and Time: An Interview with Vija Celmins', in *Q/A Journal of Art*, Spring 1993.
Sheena Wagstaff, 'Vija Celmins', in *Parkett*, no. 32, Zürich, 1992.
'Vija Celmins Interviewed by Chuck Close at her New York Loft on September 26 and 27, 1991', in *Vija Celmins*, A.R.T. Press, New York, 1992.
Susan Larsen, 'A Conversation with Vija Celmins', in *LAICA Journal*, Los Angeles Institute of Contemporary Art, October–November 1978.

PETER DOIG

Solo exhibitions
Peter Doig, Tate Britain, London (2008); *Go West Young Man*, Museum der Bildenden Künste Leipzig (2006); *Studiofilmclub*, Museum Ludwig, Cologne; and tour (2005); *Metropolitain*, Pinakothek der Moderne, Munich; and tour (2004); *Charley's Space*, Bonnefanten Museum, Maastricht; and tour (2003); *Peter Doig*, The Arts Club of Chicago (2003); *Blizzard Seventy-Seven,* Kunsthalle Nüremberg; and tour including Whitechapel Art Gallery, London (1998); *Peter Doig and Udomsak Krisanamis*, Arnolfini, Bristol; and tour (1998); *Homely*, Gesellschaft für Aktuelle Kunst, Bremen (1996); *Blotter*, Contemporary Fine Art, Berlin, Victoria Miro Gallery, London (1995); *Urban Mayhem*, Metropolitan Gallery, London (1983)

Group exhibitions
Whitney Biennial, Whitney Museum of American Art, New York (2006); *Imagination Becomes Reality – Part III: Talking Pictures*, Sammlung Goetz, Munich (2006); *The Triumph of Painting*, The Saatchi Gallery, London (2005); *The Undiscovered Country*, Hammer Museum, UCLA, Los Angeles (2004); *Pittura/Painting. From Rauschenberg to Murakami 1964–2003*, Venice Biennale (2003); *Cavepainting: Peter Doig, Chris Ofili & Laura Owens*, Santa Monica Museum of Art (2002); *Dear painter, paint me...: painting the figure since late Picabia*, Centre Pompidou, Paris; and tour (2002); *Twisted: Urban and Visionary Landscapes in Contemporary Painting*, Stedelijk van Abbemuseum, Eindhoven (2000); *Examining Pictures*, Whitechapel Art Gallery; and tour (1999); *About Vision: New British Painting in the 1990s*, Fruitmarket Gallery, Edinburgh; and tour (1996); *Turner Prize*, Tate Gallery, London (1994); *Unbound: Possibilities in Painting*, Hayward Gallery (1994); *John Moores Exhibition 18*, Liverpool (1993); *Project Unité Firminy*, Ferminy Vert, France (1993); *Whitechapel Artist Award*, Whitechapel Art Gallery (1991); *Things as They Are*, Riverside Studios, London (1985); *New Contemporaries*, Institute of Contemporary Arts, London (1982)

Bibliography
Catherine Grenier, Kitty Scott, Adrian Searle, *Peter Doig (Contemporary Artists series)*, Phaidon Press, London, 2007.
Robert Enright, 'The Eye of Painting: An Interview with Peter Doig', in *Border Crossings*, vol. 25, no. 2, June 2006.
Charlotte Mullins, *Painting People. The State of the Art*, Thames & Hudson, London, 2006.
Karen Wright, 'Keeping it Real', in *Modern Painters*, March 2006.
Paul Bonaventura, Rudi Fuchs, Beatrix Ruf, 'Peter Doig', in *Parkett*, no. 67, , Zürich, 2003.
Catherine Grenier, Paula van den Bosch, *Charley's Space*, Hatje Cantz, Ostfildern-Ruit, 2003.
Matthew Higgs, 'Peter Doig at Arts Club of Chicago', in *Artforum*, October 2003.
Leo Edelstein, 'Peter Doig. Losing Oneself in the Looking', in *Flash Art*, May–June 1998.
Terry R. Myers, et al, *Peter Doig. Blizzard Seventy-Seven*, Kunsthalle zu Kiel, Kiel and Whitechapel Art Gallery, London, 1998.
Adrian Searle, *Peter Doig: Blotter*, Contemporary Fine Art, Berlin, Victoria Miro Gallery, London, 1995.

MARLENE DUMAS

Solo exhibitions
Marlene Dumas, Museum of Contemporary Art, Los Angeles; Museum of Modern Art, New York (2008); *Marlene Dumas*, National Gallery, Cape Town, South Africa (2007); *Marlene Dumas: Broken White*, Metropolitan Museum of Contemporary Art, Tokyo (2007); *Time and Again*, Art Institute of Chicago (2004); *Name No Names*, Centre Pompidou, Paris; and tour (2001–02); *100 Models and Endless Rejects*, Institute of Contemporary Art, Boston (2001); *Marlene Dumas*, Camden Arts Centre, London (2000); *Marlene Dumas*, Museum voor Hedendaagse Kunst Antwerpen, Antwerp (1999); *Marlene Dumas*, Tate Gallery, London (1996); *Marlene Dumas*, Bonner Kunstverein, Bonn and Institute of Contemporary Art, London (1993); *Miss Interpreted*, Stedelijk van Abbemuseum, Eindhoven and tour (1992); *The Question of Human Pink*, Kunsthalle Bern (1989); *Waiting (for meaning)*, Kunsthalle zu Kiel, Amsterdam (1988); *The Eyes of the Night Creatures*, Galerie Paul Andriesse, Amsterdam (1985)

Group exhibitions
EROS in Modern Art, Fondation Beyeler, Basel (2007); *The Eighties*, Museu Serralves, Porto, Portugal (2007); *Back to the Figure – Contemporary Painting*, Kunsthalle der Hypo-Kulturstiftung, Munich (2006); *Infinite Painting: Contemporary Painting and Global Realism*, Villa Manin Centro d'Art Contemporanea, Udine, Italy (2006); *The Triumph of Painting*, The Saatchi Gallery, London (2005); *Getting Emotional*, Institute of Contemporary Art, Boston (2005); Venice Biennale (2005 and 2002); *From the Low Countries. Reality and Art from 1960–2001*, Charlottenborg Udstillingsbygning, Copenhagen; and tour (2001–02); *Painting at the Edge of the World*, Walker Art Center, Minneapolis (2001); *Strippinggirls, Marlene Dumas and Anton Corbijn*, SMAK, Ghent (2000); *Trouble Spot. Painting at the NICC and MUHKA*, Museum voor Hedendaagse Kunst Antwerpen, Antwerp (1999); *Identity and alterity: figures of the body*

1895/1995, Venice Biennale (1995); *The Particularity of Being Human*, Malmö Konsthall; and tour (1995); *Art des Pays Bas au XXeme Siècle, Du Concept à l'Image*, Musée d'art moderne de la Ville de Paris (1994); *The Broken Mirror*, Kunsthalle Wien, Vienna; and tour (1993–04); *Documenta 9*, Kassel (1992); and tour (1986); *Documenta 7*, Kassel (1982); *Atelier 15 (10 young artists)*, Stedelijk Museum, Amsterdam (1978)

Bibliography

Marlene Dumas: Broken White, Metropolitan Museum of Contemporary Art, Tokyo, 2007. Includes essay and interview with the artist by Yuko Hasegawa.
Marlene Dumas, Mankind, Paul Andriesse, Amsterdam, 2006.
Ilaria Bonacossa, *Marlene Dumas. supercontemporanea*, Mondadori Electa, Milan, 2006.
'The Fearless Body. An Interview with Marlene Dumas', in *Border Crossings*, 91, 2004.
Barbara Bloom, Mariuccia Casadio, Dominic van den Boogerd, *Marlene Dumas (Contemporary Artists series)*, Phaidon Press, London, 1999.
Gavin Jantjes in conversation with Marlene Dumas in *A Fruitful Incoherence: Dialogues with Artists on Internationalism*, inIVA, London, 1998.
Mariska van den Berg (ed.), *Marlene Dumas. Sweet Nothings. Notes and Texts*, Galerie Paul Andriesse, Amsterdam, 1998.
Marlene Dumas, Tate Publishing, London, 1996. Text by Catherine Kinley.
Marlene Dumas, Bonner Kunstverein, Bonn, 1993. Texts by Marlene Dumas and Annelie Pohlen.
Ulrich Loock, Ingrid Schaffner, Anna Tilroe, Marina Warner, 'Marlene Dumas', in *Parkett*, no. 38, Zürich, 1993.
Marlene Dumas, Miss Interpreted, Stedelijk van Abbemuseum, Eindhoven, 1993.

THOMAS EGGERER

Solo exhibitions

Oh Pioneers!, Galerie Daniel Buchholz, Cologne (2006); Friedrich Petzel Gallery, New York (2004); *Atrium*, Kunstverein Braunschweig, Germany (2003); Richard Telles Gallery, Los Angeles (2003); *Matrix 148*, Wadsworth Atheneum Museum of Art, Hartford, Connecticut (2002); Galerie Daniel Buchholz (2002); Richard Telles Gallery (2001); Galerie Daniel Buchholz (1999)

Group exhibitions

Das Achte Feld, Museum Ludwig, Cologne (2006); *The Undiscovered Country*, Hammer Museum, UCLA, Los Angeles (2004); *Baja to Vancouver. The West Coast and Contemporary Art*, Seattle Art Museum, and tour (2003–04); *deutschemalereizweitausenddrei*, Frankfurter Kunstverein, Frankfurt (2003); *Painting on the Move / Nach der Wirklichkeit*, Kunsthalle Basel (2002); *Snapshot. New Art from Los Angeles*, Hammer Museum, UCLA; and tour (2001); *Malerei*, INIT Kunsthalle, Berlin (1999); *Market*, Kunstverein Munich (1995); *Oh Boy, It's a Girl – Feminismen in der Kunst* (with Jochen Klein), Kunstverein Munich and Vienna (1994); *Die Utopie des Designs*, Kunstverein Munich (1994)

Bibliography

Helmut Draxler, 'Experiences Facing Groups – Medial and the Social Constellations in the Work of Thomas Eggerer', in *Thomas Eggerer. 'O Pioneers'*, Galerie Daniel Buchholz, Cologne, 2007.
Charlotte Mullins, *Painting People. The State of the Art*, Thames & Hudson, London, 2006.
Russell Ferguson, 'Lost in Space', in *Artnews*, January 2005.
David Joselit, 'Terror and Form', in *Artforum*, January 2005.
P.C. Smith, 'Thomas Eggerer at Friedrich Petzel', in *Art in America*, November 2004.
Matthew Higgs on Thomas Eggerer, in *Baja to Vancouver. The West Coast and Contemporary Art*, Seattle Art Museum, 2003.
David Joselit, 'Thomas Eggerer's Antigravitational Painting', in *Thomas Eggerer. Atrium*, Kunstverein Braunschweig, 2003.
Nicholas Baume, *Matrix 148: Anxious Pleasures*, Wadsworth Atheneum Museum of Art, Hartford, 2002.
Ali Subotnick, 'Snapshots: New Art from Los Angeles', in *Frieze*, no. 62, October 2001.
Thomas Eggerer and Jochen Klein, 'Virtually Queer – Gay Politics in Der Clinton Ara', in *text zur Kunst*, no. 22, May 1996.

JUDITH EISLER

Solo exhibitions

Anhauchen, Galerie Krobath Wimmer, Vienna (2006); *Rapt*, Cohan and Leslie, New York (2006); *Drive, he said*, Grimm Rosenfeld, Munich (2005); *Room Tone*, Cohan and Leslie (2004); *The Unconscious Has a Reputation*, Galerie Krobath Wimmer (2003); *Interiors*, Galerie Krobath Wimmer (2001); Tate Gallery, London (1999)

Group exhibitions

Counterparts, Contemporary Arts Center of Virginia, Virginia Beach (2007); *Lazarus Effect. New Painting Today*, Prague Biennale (2003); *Girls on Film*, Penrose Gallery, Tyler School of Art, Philadelphia (2003); *Painting as Paradox*, Artists Space, New York (2002); *Wild/Life or the Impossibility of Mistaking Nature for Culture*, Weatherspoon Art Gallery, Greensboro, North Carolina (1998); *Judith Eisler & Shop @ Supastore*, Up&Co, New York (1998); *Don't Postpone Joy or Collecting can be Fun*, Austrian Cultural Institute, New York; Neue Galerie, Graz (1994)

Bibliography

Christopher Bollen, 'New Art', in *V Magazine*, Spring Preview, 2006.
Judith Eisler, 'Freeze Frame', in *V Magazine*, 31 January 2004.
Jeffrey Kastner, 'First to Take – 12 New Artists', in *Artforum*, January 2004.
Jenn Joy, 'Focus Painting Part One: Contemporary Painting Today', in *Flash Art*, October 2002.
Karen Pinkus, *Judith Eisler. Interiors*, Krobath Wimmer, Vienna, 2001.
Friedrich Tietjen, 'Judith Eisler', in *Flash Art*, October 2001.
Michael Wilson, 'New York Roundup', in *Art Monthly*, June 2001.
Wild/Life or the Impossibility of Mistaking Nature for Culture, Weatherspoon Art Gallery, Greensboro, 1998.

FRANZ GERTSCH

Solo exhibitions

Franz Gertsch, Albertina Museum and Museum Moderner Kunst Stiftung Ludwig Wien, Vienna (2006); *Franz Gertsch – die Retrospektive*, museum franz gertsch, Burgdorf, Switzerland; and tour (2005); *Patti Smith*, Museum Folkwang, Essen; Pinakothek der Moderne, Munich; Gagosian Gallery, New York (2003); Centre Culturel Suisse, Paris (2001); *Franz Gertsch*, Kunstmuseum Bern (1994); *Franz Gertsch, Large Scale Woodcuts*, Museum of Modern Art, New York; and tour (1990); *Johanna II*, Kunsthalle Bern; and tour (1986) *Franz Gertsch. Major Works*, Louis K. Meisel Gallery, New York (1981–82); *Franz Gertsch*, Kunsthaus, Zürich; and tour (1980); *Franz Gertsch*, Kunsthalle Düsseldorf; and tour (1975); *Franz Gertsch*, Kunstmuseum Luzern (1972); *Franz Gertsch*, Anlikerkeller, Bern (1955); *Franz Gertsch*, Galerie Simmen, Bern (1951)

Group exhibitions

Pittura/Painting. From Rauschenberg to Murakami 1964–2003, Venice Biennale (2003); *Hyperréalismes USA, 1965–75*, Musée d'Art moderne et contemporain de Strasbourg (2003); *Urgent Painting*, Musée d'art moderne de la Ville de Paris (2002); Venice Biennale (2003); *Das Gedächtnis der Malerei*, Aargauer Kunsthaus, Aarau (2000); *Face to Face to Cyberspace*, Fondation Beyeler, Riehen/Basel (1999); *D'APPERTutto*, Venice Biennale (1999); Lyon Biennale (1997); *Printed Art. A View of Two Decades*, Museum of Modern Art, New York (1980); Venice Biennale (1978); *Dalla natura all'arte, dall'arte alla natura Realismus und Realität*, (Patti Smith series), Kunsthalle Recklinghausen, Germany (1975); *Hyperréalistes américains – réalistes européens*, Centre national d'art contemporain, Paris (1974); *Art conceptuel et hypperréaliste. Collection Ludwig*, Musée d'art moderne de la Ville de Paris (1974); *New Photo Realism*, Wadsworth Atheneum Museum of Art, Hartford, Connecticut (1974); *Mit Kamera, Pinsel und Spritzpistole. Realistische Kunst in unserer Zeit*, Kunsthalle Recklinghausen (1973); *Questioning Reality: Iconographies Today*, Documenta 5, Kassel (1972); *Berner Maler und Bildauer*, Kunstmuseum Bern (1965)

Bibliography

Reinhard Spieler, Samuel Vitali (eds), *Franz Gertsch, Die Retrospektive*, museum franz gertsch, Burgdorf, 2005.
Angelika Affentranger-Kirchrath, *Franz Gertsch: Die Magie der Realen*, Wabern-Bern, 2004.
Michele Robecchi, 'Franz Gertsch', in *Flash Art International*, vol. 36, March/April 2003.
Alexander Braun, 'Franz Gertsch: "Ich bin ein ungeduldiger Mensch, der sich diszipliniert"', in *Kunstforum International*, no. 148, December/January 1999–2000.
Michael Danoff, Helmut Friedel, Ulrich Loock, Reiner Michael Mason, Amei Wallach, 'Franz Gertsch', in *Parkett*, no. 28, Zürich, 1991.
Dieter Ronte, *Franz Gertsch*, Bern, 1986. With an essay by Jean-Christophe Ammann.
Erika Billeter (ed.), *Franz Gertsch*, Kunsthaus Zürich, Bern, 1980. Including an essay by Jean-Christophe Ammann.
Jean-Christophe Ammann, Karl Ruhrberg, Harald Szeemann, *Franz Gertsch*, Akademie der Künste, Berlin, 1975.
Jean-Christophe Ammann, Timothy O'Leary, Harald Szeemann, *Franz Gertsch*, Kunstmuseum Luzern, Lucerne, 1972.

RICHARD HAMILTON

Solo exhibitions

A Host of Angels, Fondazione Bevilacqua la Masa, Palazzetto Tito, Venice (2007); *Retrospective*, Museu d'Art Contemporani, Barcelona; and tour (2002); *Imaging Ulysses*, British Council tour including The British Museum, London (2002); *Richard Hamilton: subject to an impression*, Kunsthalle Bremen (1998); *Richard Hamilton*, San Francisco Museum of Modern Art (1996); *Richard Hamilton*, Tate Gallery, London; and tour (1992–93); *Exteriors, Interiors, Objects, People*, Kunstmuseum Winterthur (1990); *Richard Hamilton*, Fruitmarket Gallery, Edinburgh (1988); *Richard Hamilton, Image and Process*, Tate Gallery, London (1983–84); *Richard Hamilton*, The Solomon R. Guggenheim Museum, New York; and tour (1973–74); *Richard Hamilton*, Tate Gallery, London; and tour (1970); *Richard Hamilton: Swingeing London '67, People, Graphics 1963–1968*, Robert Fraser Gallery, London (1969); *Man, Machine & Motion*, University of Durham, Newcastle-upon-Tyne (1955); *Growth and Form*, Institute of Contemporary Arts, London (1951)

Group exhibitions

Art & the 60s: this was tomorrow, Tate Britain (2004); *The Undiscovered Country*, Hammer Museum, UCLA, Los Angeles (2004); *Faces in the Crowd, Picturing Modern Life from Manet to Today*, Whitechapel Art Gallery, London; Castello di Rivoli, Turin (2004); *Dieter Roth: Richard Hamilton: Collaborations. Relations – confrontations*, Museu Serralves, Porto (2002); *Les années Pop*, Centre Pompidou, Paris (2001); *Protest & survive*, Whitechapel Art Gallery (2000); *Documenta 10*, Kassel (1997); British Pavilion, Venice Biennale (1993); *Pop Art: An International Perspective*, Royal Academy of Arts, London (1991); *High and Low: Modern Art and Popular Culture*, Museum of Modern Art, New York (1990); *A Cellular Maze*, with Rita Donagh, Orchard Gallery, Londonderry (1983); *Aspects of Postwar Painting*, The Solomon R. Guggenheim Museum, New York (1983); *Instantanés*, Centre Pompidou (1980); *Documenta 6*, Kassel (1977); *The Human Clay*, Hayward Gallery (1976); *Combattimento per Un'Immagine: Fotografi e Pittori*, Il Museo Civico di Torino, Turin (1973); *Pop Art*, Hayward Gallery (1969); *Art by Telephone*, Art Institute of Chicago (1969); *Documenta 4*, Kassel (1968); *This is Tomorrow*, Whitechapel Art Gallery (1956)

Bibliography

Richard Hamilton: painting by numbers, Edition Hansjörg Mayer, Stuttgart, 2006.
Dieter Roth: Richard Hamilton: Collaborations. Relations – confrontations, Edition Hansjörg Mayer, Stuttgart, 2003. With an introduction by Vicente Todolí and texts by Etienne Lullin and Emmett Williams.
Stephen Coppel, Richard Hamilton, Etienne Lullin, *Richard Hamilton: prints and multiples 1939–2002: catalogue raisonné*, Richter Verlag, Düsseldorf, 2002.
Richard Hamilton: subject to an impression, Kunsthalle Bremen, 1998. Including texts by Dieter Schwarz.
Sarat Maharaj, *Richard Hamilton: XLV Biennale di Venezia: British Pavillion 1993*, The British Council, London, 1993.
Richard Hamilton, Tate Publishing, London, 1992. With essays by Richard Morphet, David Mellor, Sarat Maharaj and Stephen Snoddy.
Mark Francis, *Richard Hamilton*, Fruitmarket Gallery, Edinburgh, 1988.
Richard Hamilton: Collected Words. 1953–1982, Thames & Hudson, London, 1983.
John Russell, *Richard Hamilton*, The Solomon R. Guggenheim Foundation, New York, 1973.
Richard Hamilton, 'Photography and Painting', in *Studio International*, March 1969.

EBERHARD HAVEKOST

Solo exhibitions

Eberhard Havekost. Harmony. Paintings 1997–2005, Kunstmuseum Wolfsburg; and tour (2006); Staatliche Kunstsammlungen Dresden (2004); *Graphik 1999–2004*, Kupferstich-Kabinett, Dresden (2004); *Eberhard Havekost, Lieu d'Art Contemporain*, Sigean, France (2003); *Eberhard Havekost*, Centre d'art contemporain, Cajarc, France (2003); *DRIVER*, Museu Serralves, Porto (2001); *Druck Druck*, Galerie für Zeitgenössische Kunst, Leipzig (1999); *Fenster-Fenster*, Kunstmuseum Luzern (1998); Kulturwissenschaftliches Institut, Essen (1998); *WÄRME* (with Thomas Scheibitz), Galerie Gebr. Lehmann, Dresden (1995)

Group exhibitions

Painting Now!, Kunsthal Rotterdam (2007); *Images in Painting. Johannes Kahrs, Magnus von Plessen, Eberhard Havekost and Wilhem Sasnal*, Museu Serralves, Porto (2006); *Imagination Becomes Reality – Painting, Surface, Space*, Sammlung Goetz, Munich (2005); *The Triumph of Painting*, The Saatchi Gallery, London (2005); *La nouvelle peinture allemande*, Carré d'Art, Nîmes (2005); *Generation X*, Kunstmuseum, Wolfsburg (2005);

Lazarus Effect. New Painting Today, Prague Biennale (2003); *Painting Pictures*, Kunstmuseum Wolfsburg (2003); *deutschemalereizweitausenddrei*, Frankfurter Kunstverein, Frankfurt am Main (2003); *Painting at the Edge of the World*, Walker Art Center, Minneapolis (2001); *Malerei*, INIT Kunsthalle, Berlin (1999); *Pictures of Pictures*, Norwich Gallery, Norwich (1999); *Vier/VI*, Leonhardi-Museum, Dresden (1997); *Fantastic-Elastic*, Kunst-Konsum, Dresden (1995)

Bibliography
Martin Herbert, 'In Memory of my Feelings', in *Eberhard Havekost. BACKGROUND*, White Cube, London, 2007.
Images in Painting, Museu Serralves, Porto, 2006. With a text on Eberhard Havekost by Ulrich Loock and Hans Rudolf Reust.
Christoph Tannert (ed.), *New German Painting: Remix*, Prestel, Munich, 2006.
Eberhard Havekost, Annelie Lütgens (eds), *Eberhard Havekost: Harmonie: Bilder / paintings 1998–2005*, Kunstmuseum Wolfsburg, 2005.
Jordan Kantor, 'The Tuymans Effect. Eberhard Havekost, Magnus von Plessen, Wilhelm Sasnal, Luc Tuymans', in *Artforum*, November 2004.
Valérie Breuvart (ed.), *Vitamin P. New Perspectives in Painting*, Phaidon Press, London, 2002. Text by Meghan Dailey.
Sandra Guimarães, *DRIVER*, Museu Serralves, Porto, 2001.
Ulrich Loock, *Eberhard Havekost. Windows – Windows*, Kunstmuseum Luzern, Lucerne, 1998.

DAVID HOCKNEY

Solo exhibitions
David Hockney. Portraits, Museum of Fine Arts Boston and National Portrait Gallery, London; and tour (2006–07); *Five Double Portraits*, National Portrait Gallery, London (2003); *David Hockney: Painting 1960–2000*, Louisiana Museum, Humlebaek (2002); *David Hockney*, Kunst und Austellunghalle Bonn, Germany (2000); *David Hockney. Photoworks – Rétrospective*, Musée de l'Elysée, Lausanne; and tour (1999); *Espace/Paysage*, Centre Pompidou, Paris (1999); *A Drawing Retrospective*, Kunsthalle Hamburg; and tour (1995); *David Hockney: paintings and photographs of paintings*, Museum Boymans-van Beuningen, Rotterdam (1995); *A Retrospective*, Los Angeles County Museum of Art; and tour (1988); *Hockney Paints the Stage*, Walker Art Center, Minneapolis (1983); *Hockney's Photographs*, Hayward Gallery; and tour (1983); *David

Hockney photographe*, Centre Pompidou (1982); *David Hockney. Retrospective*, Musée des Arts Décoratifs, Paris (1973–75); *Paintings, Prints, Drawings 1960–1970*, Whitechapel Art Gallery, London; and tour (1970); *Paintings and Drawings*, Stedelijk Museum, Amsterdam (1966); *David Hockney: Pictures with People In*, Kasmin Gallery, London (1963)

Group exhibitions
Los Angeles 1955–1985: birth of an art capital, Centre Pompidou (2006); *Whitney Biennial*, Whitney Museum of American Art, New York (2004); *Les années Pop*, Centre Pompidou (2001); *Encounters: New Art from Old*, National Gallery, London (2000); *Sunshine & Noir: Art in LA 1960–1997*, Louisiana Museum of Modern Art; and tour including Castello di Rivoli, Turin (1997); *Identity and Alterity*, Palazzo Grassi, Venice Biennale (1995); *The Sixties art scene in London*, Barbican Art Gallery, London (1993); *Painter as photographer*, ACGB (Arts Council of Great Britain), London (1982); *A New Spirit in Painting*, Royal Academy of Arts, London (1981); *Documenta 6*, Kassel (1977); *Pop Art in England: Beginnings of a New Figuration 1947–1963*, Kunstverein Hamburg (1976); *The Human Clay*, Hayward Gallery (1976); *Pop Art*, Hayward Gallery (1969); *Documenta 4*, Kassel (1968); Venice Biennale (1968); *London: The New Scene*, Walker Art Gallery (1965); *The New Generation*, Whitechapel Art Gallery (1964); Biennale de Paris (1963); *Young Contemporaries*, R.B.A. Galleries, London (1962); *John Moores Liverpool Exhibition*, Walker Art Gallery, Liverpool (1961)

Bibliography
Sarah Howgate, Barbara Stern Shapiro (eds), *David Hockney. Portraits*, National Portrait Gallery Publications, London, 2006.
Kay Heymer, Marco Livingstone, Paul Melia, Didier Ottinger, et al, *David Hockney: exciting times are ahead*, Kunst-und Ausstellungshalle der Bundesrepublik, Bonn, 2001.
David Hockney, *Secret knowledge: rediscovering the lost techniques of the old masters*, Viking Studio, New York, 2001.
Paul Melia, *David Hockney*, (Critical Introductions to Art), Manchester University Press, Manchester, 1995.
Penelope Curtis, *David Hockney*, Tate Gallery Publishing, London, 1993.
Nikos Stangos (ed.), *That's the Way I See It*, Thames & Hudson, London, 1993.
Hockney on Photography: Conversations with Paul Joyce, Jonathan Cape, London, 1988.

Henry Geldzahler, Christopher Knight, Kenneth E. Silver, Lawrence Weschler, et al, *David Hockney: a retrospective*, Los Angeles County Museum of Art, 1988.
Marco Livingstone, *David Hockney*, Thames & Hudson, London, 1987.
David Hockney. Photographs, Petersburg Press, London and New York, 1982.
David Hockney by David Hockney – My Early Years, Nikos Stangos (ed.), Thames & Hudson, London, 1976.

JOHANNES KAHRS

Solo exhibitions
Johannes Kahrs. Men with Music, GAMeC, Bergamo (2007); *Ein ganz fremder Nackter*, Zeno X Gallery, Antwerp (2006); *Lonely Long Meaningless Way Home*, Parasol Unit Foundation for Contemporary Art, London (2006); *Dunkles Zimmer*, Zeno X Gallery (2004); *A-h*, Kunstverein Munich; and tour (2001); *Why don't you paint my portrait*, Gesellschaft für Aktuelle Kunst, Bremen (1998); *Schlag doch*, DAAD Galerie, Berlin (1993)

Group exhibitions
Constructing Reality: New Berlin, Phoenix Art Museum, Arizona; and tour (2006); *Images in Painting. Johannes Kahrs, Magnus von Plessen, Eberhard Havekost and Wilhem Sasnal*, Museu Serralves, Porto (2006); *Le Mouvement des images*, Centre Pompidou, Paris (2006); *Zur Vorstellung de Terrors: Die RAF – Ausstellung*, Kunst-Werke, Berlin (2005); *Was Malerei heute ist*, Stiftung Opelvillen, Rüsselheim (2004); *Manifesta 5, European Biennale of Contemporary Art*, San Sebastian (2004); *Contre-Images*, Carré d'Art, Nîmes (2004); *deutschemalereizweitausenddrei*, Frankfurter Kunstverein, Frankfurt (2003); *Warum! Bilder diesseits und jenseits des Menschen*, Martin-Gropius-Bau, Berlin (2003); *Great Theater of the World*, Taipei Biennal (2002); *Squatters*, Museu Serralves (2001); *Club Berlin*, Venice Biennale (1995)

Bibliography
Alessandro Rabottini, *Johannes Kahrs. Men with Music*, GAMeC, Bergamo, Italy, 2007.
Images in Painting, Museu Serralves, Porto, 2006. With a text on Johannes Kahrs by Jordan Kantor and Ulrich Loock.
Lonely Long Meaningless Way Home, Parasol Unit Foundation for Contemporary Art, London, 2006. Text by Nicola Suthor.
Isabel Stevens, 'Johannes Kahrs', in *contemporary 88*, 2006.

Christoph Tannert (ed.), *New German Painting: Remix*, Prestel, Munich, 2006. Text by Gerrit Vermeiren.
deutschemalereizweitausenddrei, Frankfurter Kunstverein, Frankfurt, 2003. Text by Nicolaus Schafhausen.
Valérie Breuvart (ed.), *Vitamin P. New Perspectives in Painting*, Phaidon Press, London, 2002. Text by Bartolomeu Marí.
Joao Fernandes, 'Johannes Kahrs', in *Flash Art*, no. 224, 2002.
Harald Fricke, 'Strange Intimacy', in *Johannes Kahrs. A-h*, Kunstverein Munich, 2001.
Johannes Kahrs. Why Don't You Paint my Portrait, Gesellschaft für Aktuelle Kunst, Bremen, 1999.

JOHANNA KANDL

Solo exhibitions
Geography is Dead (with Helmut Kandl), Dortmunder Kunstverein, Dortmund (2007); *Kämpfer, Träumer & Co.* (with Helmut Kandl), Lentos Kunstmuseum Linz (2006); *Kämpfer fürs Glück,* Kunstverein Ulm (2003); *Sightseeing*, Fototriennale Graz (2003); *From Bagdad to Babylon* (with Helmut Kandl), ACF, London (2003); *Speaking in Public, 9th International Cairo Biennale,* Cairo (2003); *Johanna Kandl*, Galerie für zeitgenössische Kunst, Leipzig (2002); *Johanna Kandl*, Secession, Vienna (1999); *Geschlossene Gesellschaft*, Salzburger Kunstverein; and tour (1996)

Group exhibitions
Volksgarten. Politics of Belonging (with Helmut Kandl), Steirischer Herbst und Kunsthaus Graz (2007); *Academy. Learning from Art,* Museum voor Hedendaagse Kunst Antwerpen, Antwerp (2006); *Postmedial Kondition*, Medialab Centre, Madrid (2006); *Geschichte(n) vor Ort* (with Helmut Kandl), Project in Public Space, Vienna (2006); *Zurück zur Figur – Malerei der Gegenwart,* Kunsthalle der Hypo-Kulturstiftung, Munich (2006); Centro Cultural Conde Duque Madrid (2006); *Postmediale Kondition*, Neue Galerie Graz (2005); *Urbane Malerei*, GfZK, Leipzig (2005); *Talking Pieces*, Museum Morsbroich, Leverkusen (2003); *Painting on the move,* Kunsthalle Basel (2002); *Touristic Gazes* (with Helmut Kandl), Kunstverein Wolfsburg (2002); *Uncommon Denominator*, MassMOCA, North Adams, Massachusetts (2002); *Ungemalt = unpainted*, Sammlung Essl, Vienna (2002); *Die Arena des Privaten*, Kunstverein Munich (1993); *In Situ*, Secession, Vienna (1988)

Bibliography
Stella Rollig (ed.), *Kämpfer, Träumer & Co.*, Lentos Kunstmuseum Linz, 2006. Essay by Walter Seidl.
Helmut and Johanna Kandl, Business or Pleasure, Photos & Stories, Fotohof Editions, Salzburg, 2005.
Johanna Kandl. Kämpfer für's Glück, Kunstverein Ulm, 2003. Texts by Brigitte Hausmann, Barbara Steiner.
Ursula Maria Probst, 'Johanna Kandl. Eine Kämpferin für's Glück', in *Kunstforum*, March–May 2003.
Christa Steinle, *Johanna Kandl – Speaking in Public*, 9th International Cairo Biennale, 2003.
Johanna Kandl, Secession, Vienna, 1999. Texts by Hans-Christian Dany and Andreas Spiegl.
Johanna Hofleitner, 'Feind-Bilder, Tabu-Akkumulation', in *Camera Austria International*, no. 53, 1995.
Das Geschlossene System, Kunsthalle Krems, 1993.
Johanna Kandl, *Portraits*, Knoll Galerie, Vienna and Budapest, 1990.

MARTIN KIPPENBERGER

Solo exhibitions
Modell Martin Kippenberger, Utopien für alle, Kunsthaus Graz (2007); *Martin Kippenberger*, Tate Modern, London and K21, Düsseldorf (2006); *Selfportraits*, Kunsthalle Basel (1998); *Respektive 1997–1976*, Musée d'art moderne et contemporain, Geneva; Castello di Rivoli, Turin (1997); *Der Eiermann und seine Ausleger*, Städtisches Museum Abteiberg, Mönchengladbach, Germany (1997); *The Happy End of Franz Kafka's 'Amerika'*, Museum Boijmans Van Beuningen, Rotterdam (1994); *Candidature à une rétrospective*, Centre Pompidou, Paris (1993); *Metro-Net, Entrance To The Subway Station Lord Jim*, Kthma Canné Hrousa, Syros, Greece (1993); *Martin Kippenberger: New Work*, San Francisco Museum of Modern Art (1991); *Heavy Burschi*, Kölnischer Kunstverein, Cologne (1991); *Tiefes Kehlchen*, Wiener Festwochen, Vienna (1991); *Nochmal Petra*, Kunsthalle Winterthur (1988); *Miete Strom Gas*, Hessisches Landesmuseum, Darmstadt (1986); *Fiffen, Faufen, Ferfaufen*, Studio F, Ulm (1982); *Lieber Maler, male mir*, Neue Gesellschaft für bildende Kunst, Berlin (1981); *2. außerordentliche Veranstaltung in Bild und Ton: Aktion Pißkrücke, Geheimdienst am Nächsten*, Künstlerhaus, Hamburg (1980); *1. außerordentliche Veranstaltung in Bild und Klang zum Thema der Zeit: ELEND*, Kippenbergers Büro, Berlin (1979)

Group exhibitions
La nouvelle peinture allemande, Carré d'Art, Nîmes (2005); *Obsessive Malerei – Ein Rückblick auf die neuen Wilden*, ZKM, Karlsruhe (2004); German Pavilion (with Candida Höfer), Venice Biennale (2003); *Painting on the Move*, Kunstmuseum Basel; and tour (2002); *Dear painter, paint me...: painting the figure since late Picabia*, Centre Pompidou; and tour (2002); *Zero Gravity*, Kunstverein für die Rheinlande und Westfalen, Düsseldorf (2001); *Painting at the Edge of the World*, Walker Art Centre, Minneapolis (2001); *Apertutto*, Venice Biennale (1999); *Skulptur–Projekte*, Münster (1997); *Metro-Net*, Documenta 10, Kassel (1997); *Ars Pro Domo*, Museum Ludwig, Cologne (1992); *Refigured Painting: The German Image 1960–1988*, The Solomon R. Guggenheim Museum, New York (1989); *Laterne an Betrunkene and Hühnerdisco Aperto*, Venice Biennale (1987); *Geoma-Plan. Neurologisches Experiment mit der Macht* (with Georg Herold), Hamburger Kunstverein (1983); *Photocollage*, Neue Gesellschaft für Bildende Kunst, Realismusstudio 24, Berlin (1983); *Die junge Malerei in Deutschland*, Galleria d'Arte Moderna, Bologna (1982); *O sole mio*, Künstlerhaus Hamburg (1980)

Bibliography
Gisela Stelly, *Ihr Kippy-Kippenberger. Letters-Paintings-Photos-Film 1976–1978. By and with Martin Kippenberger*, Galerie Bärbel Grässlin, Frankfurt am Main, 2006.
'Martin Kippenberger: An artist doesn't have to be new, an artist has to be good', interview with Jutta Koether, 1991, in *FlashArt*, March–April 2006.
Doris Krystof, Jessica Morgan (eds), *Martin Kippenberger*, Tate Publishing, London, 2006.
Martin Kippenberger, Lieber Maler, male mir, Gagosian Gallery, New York, 2005.
Martin Kippenberger. Das 2. Sein, Dumont Verlag, Cologne, in association with Museums fur Neue Kunst/ZKM, Karlsruhe, 2003.
Angelika Taschen, Burkhard Riemschneider (eds), *Kippenberger*, Taschen Books, Cologne, 1997.
Marius Babias, 'Clean Thoughts', Interview with Martin Kippenberger, in *Artscribe*, 90, Feb/March 1992.
Martin Kippenberger. I Had A Vision, San Francisco Museum of Art, 1991.
Martin Kippenberger, *Ten years after*, Taschen Books, Cologne, 1991.

LIU XIAODONG

Solo exhibitions
Liu Xiaodong: Painting from Life, Art Museum of Guangdong, China (2006); *The Three Gorges Project – Painting by Liu Xiaodong*, Asian Art Museum of San Francisco (2006); *Childhood Friends Getting Fat*,

Galerie Loft, Paris (2005); *Eighteen Solo Exhibitions*, Bunker Museum of Contemporary Art (BMOCA), Kinmen, Taiwan (2004); *Prostitutes, Transvestites and Nothing to do Men*, Galerie Loft (2001); *Liu Xiaodong 1990–2000*, Museum of Central Institute of Fine Arts, Beijing (2000); *Liu Xiaodong and His Time*, LIMN Gallery, San Francisco (2000); *Liu Xiaodong*, Gallery of Central Institute of Fine Arts, Beijing (1990)

Group exhibitions

Made in China, The Louisiana Museum of Modern Art, Humlebæk (2007); *Zones of contact*, Biennale of Sydney (2006); *The Blossoming of Realism – The Oil Painting of Mainland China since 1978*, Taipei Fine Arts Museum, Taiwan (2006); *Dreaming of the Dragon's Nation – Contemporary Art Exhibition from China*, Irish Museum of Modern Art, Dublin (2004); *Alors, La Chine?*, Centre Pompidou, Paris (2003); *A Decade of Experimental Chinese Art – Guangzhou Triennial*, Art Museum of Guangdong, Guangzhou, China (2002); *Towards a New Image, 1981–2001. Twenty Years of Contemporary Chinese Painting*, China Art Museum, Beijing; and tour (2001); *China Art in the 20th Century*, Art Museum of China, Beijing (2000); *Shanghai Overseas*, Shanghai Biennial Art Exhibition, China (2000); Venice Biennale (1997); *Contemporary Chinese Oil Painting from Realism to Post Modernism*, Theoremes Gallery, Brussels (1995); *Liu Xiaodong and Yu Hong's works*, OIPCA East Village, New York (1994); *Art Today in China*, California Art Institute, Valencia, California (1992); *Chinese Avant Garde Art Exhibition*, Beijing (1989)

Bibliography

Mahjong: contemporary Chinese art from the Sigg Collection, Hatje Cantz Verlag, Ostfildern-Ruit, 2007.
Ai Weiwei, Britta Erickson, Charles Merewether, *The Richness of Life: Personal Photographs of Contemporary Chinese Artist Liu Xiaodong*, Timezone 8, Beijing, 2007.
Zones of contact: 2006 Biennale of Sydney (15th), 2006.
Jean Marc Decrop (ed.), *Liu Xiaodong*, Red Flag Collection, Map Book Publishers, Hong Kong, 2006. Essays by Charles Merewether and Ou Ning.
Bill Fox, Jeff Kelley, *The Three Gorges Project – Painting by Liu Xiaodong*, Asian Art Museum of San Francisco, 2006.
Liu Xiaodong, *Painting from Life*, Guangdong Museum, Lingnan Fine Art Press, Guangdong, December 2006.
Liu Xiaodong and His Time, LIMN Gallery, San Francisco, 2000.
Liu Xiaodong, Guangxi Art Publishing House, China, 1993.

MALCOLM MORLEY

Solo exhibitions

Malcolm Morley: The Art of Painting, Museum of Contemporary Art, Miami (2006); *Malcolm Morley in Full Colour*, Hayward Gallery (2001); *Malcolm Morley*, Fundació 'la Caixa', Barcelona ; and tour (1995); *Malcolm Morley*, Centre Pompidou, Paris; and tour (1993); *Malcolm Morley. Watercolours*, Bonnefanten Museum, Maastricht; and tour (1991–92); *Malcolm Morley. Sculpture*, Bonnefanten Museum (1991); *Malcolm Morley: Paintings 1965–82*, Kunsthalle Basel; and tour (1983–84); *Malcolm Morley*, The Clocktower, Institute for Art and Urban Resources, New York (1976); *Malcolm Morley*, Time Magazine Building, New York (1972–73); *Malcolm Morley*, Kornblee Gallery, New York (1964)

Group exhibitions

Hyperréalismes USA, 1965–75, Musée d'Art moderne et contemporain de Strasbourg (2003); *Reality and Desire*, Fundació Joan Miró, Barcelona (1999); *Birth of the Cool: American Painting*, Deichtorhallen, Hamburg; and tour (1997); *Recognizable Images, 1969–1986*, Museum of Contemporary Art, Los Angeles (1988); *Turner Prize*, Tate Gallery, London (1984); *Issues: New Allegory 1*, Institute of Contemporary Art, Boston (1982); *Super Realism from the Morton G. Neumann Family Collection*, Kalamazoo Institute of Art, Missouri; and tour (1981–82); *A New Spirit in Painting*, Royal Academy of Arts, London (1981); *Documenta 6*, Kassel (1977); *Hyperréalistes américains, réalistes européens*, Centre national d'Art Contemporain, Paris; and tour (1974); *Documenta 5*, Kassel (1972); *Radical Realism*, Museum of Contemporary Art, Chicago (1971); *Painting from the Photo*, Riverside Museum, New York (1970); *22 Realists*, Whitney Museum of American Art, New York (1970); *Pop Art*, Hayward Gallery (1969); *Directions 2: Aspects of a New Realism*, Milwaukee Art Centre, Wisconsin (1968); *The Photographic Image*, The Solomon R. Guggenheim Museum, New York (1966)

Bibliography

Bonnie Clearwater, *Malcolm Morley. The Art of Painting*, Museum of Contemporary Art, North Miami, 2006.
Jean-Claude Lebensztejn, *Malcolm Morley: Itineraries*, Reaktion Books, London, 2002.
Malcolm Morley: In Full Colour, Hayward Gallery Publishing, London, 2001.
Richard Milazzo, *Malcolm Morley: the art of the superreal, the rough, the Neo-Classical and the incommensurable 1958–1998*, Editions d'Afrique du Nord, Tangier, 2000.
Catherine Grenier, Klaus Kertess, Les Levine, David Sylvester, *Malcolm Morley*, Centre Pompidou, Paris, 1993.
Robert Storr, 'Let's Get Lost: Interview with Malcolm Morley', in *Art Press*, no. 180, May 1993.
Michael Compton, *Malcolm Morley: Paintings 1965–82*, Whitechapel Art Gallery, London, 1983.
Klaus Kertess, 'Malcolm Morley: Talking about Seeing', in *Artforum*, vol. 18, no. 10, June 1980.
Lawrence Alloway, 'Morley Paints a Picture', in *Art News*, vol. 67, no. 4, Summer 1968.
Lawrence Alloway, 'The Paintings of Malcolm Morley', in *Art and Artists*, vol. 1, no. 11, February 1967.

ELIZABETH PEYTON

Solo exhibitions

Elizabeth Peyton, Salzburger Kunstverein, Salzburg (2003); *Elizabeth Peyton*, Royal Academy of Arts, London (2002); *Elizabeth Peyton*, Deichtorhallen, Hamburg (2001); *Elizabeth Peyton*, Aspen Art Museum, Aspen, Colorado (2000); *Elizabeth Peyton*, Westfälischer Kunstverein, Münster (2000); *Elizabeth Peyton*, Museum of Contemporary Art, Castello di Rivoli, Turin (1999); *Elizabeth Peyton*, Kunstmuseum, Wolfsburg; and tour (1998); *Elizabeth Peyton*, St Louis Art Museum, St Louis, Missouri (1997); Gavin Brown's enterprise at Hotel Chelsea, Rm 828, New York (1993)

Group exhibitions

Likeness: Portraits of Artists by Other Artists, CCA Wattis Institute, San Francisco; and tour (2006); *Superstars: from Warhol to Madonna*, Vienna Kunstforum/Vienna Kusthalle (2005); *Getting Emotional*, Institute of Contemporary Art, Boston (2005); *Whitney Biennial*, Whitney Museum of American Art, New York (2004); *Dear painter, paint me...: painting the figure since late Picabia*, Centre Pompidou, Paris; and tour (2002); *Malerei*, INIT Kunsthalle, Berlin (1999); *Examining Pictures*, Whitechapel Art Gallery, London; and tour (1999); *Young Americans II*, The Saatchi Gallery, London (1998); *Truce: Echoes of Art in an Age of Endless Conclusions*, Site Santa Fe, New Mexico (1997); *John Currin / Elizabeth Peyton / Luc Tuymans*, Museum of Modern Art, New York (1997); *Heaven*, P.S.1, New York (1997); *Longing and Memory*, Los Angeles County Museum of Art (1997); *Campo*, Venice Biennale (1995); *Little Thing*, Randolph St Gallery, Chicago; and tour (1993)

Bibliography

Charlotte Mullins, *Painting People. The State of the Art*, Thames & Hudson, London, 2006.
Matthew Higgs, Steve Lafreniere, *Elizabeth Peyton*, Rizzoli, New York, 2005.
'Blithe Spirit: A conversation with Elizabeth Peyton and Cheryl Kaplan', in *Deutsche Bank magazine*, 2003–04.
'Elizabeth Peyton in conversation with Rob Pruitt and Steve Lafreniere', in *index magazine*, June–July 2002.
Valérie Breuvart (ed.), *Vitamin P. New Perspectives in Painting*, Phaidon Press, London, 2002. Text by Alison M. Gingeras.
Elizabeth Peyton, Museum für Gegenwartskunst Basel, 1998.
Elizabeth Peyton: Craig, Verlag der Buchhandlung Walther König, Cologne, 1998.
Lisa Liebmann, Linda Pilgrim, David Rimanelli, Philip Ursprung, 'Elizabeth Peyton', in *Parkett*, no. 53, Zürich, 1998.
Francesco Bonami, 'Elizabeth Peyton: We've been looking at images for so long that we've forgotten who we are', in *Flash Art*, March–April 1996.

MICHELANGELO PISTOLETTO

Solo exhibitions

Michelangelo Pistoletto, Museum of Modern and Contemporary Art, Nice (2007); *Michelangelo Pistoletto & Cittadellarte*, Museum voor Hedendaagse Kunst Antwerpen, Antwerp (2003); *Michelangelo Pistoletto*, Galleria Civica d'Arte Moderna e Contemporanea, Turin; and tour (2000); *Michelangelo Pistoletto, I sono l'altro*, Castello di Rivoli, Turin (2000); *In primo luogo*, Castello di Rivoli (1999); *Michelangelo Pistoletto*, Museum 20er Haus, Vienna (1995); *Michelangelo Pistoletto*, Deichtorhallen, Hamburg (1993); *Michelangelo Pistoletto e la fotografia*, Museu Serralves, Porto; and tour (1993); *Oggetti in meno 1965–1966*, Camden Arts Centre, London (1991); *Michelangelo Pistoletto*, Galleria Nazionale d'Arte Moderna, Rome (1990); *Michelangelo Pistoletto*, Kunsthalle Bern; and tour (1989); *Michelangelo Pistoletto*, P.S.1, New York (1988); *Michelangelo Pistoletto*, Palacio de Cristal, Madrid (1983); *Michelangelo Pistoletto*, Nationalgalerie Berlin (1978); *Michelangelo Pistoletto*, Palazzo Grassi, Venice (1978); *Michelangelo Pistoletto*, Boymans van Beuningen Museum, Rotterdam (1969); *Michelangelo Pistoletto*, Palais des Beaux-Arts, Brussels (1967); *Michelangelo Pistoletto*, Walker Arts Center, Minneapolis (1966); *Michelangelo Pistoletto*, Palazzo della Promotrice delle Belle Arti, Turin (1962)

Group exhibitions

Views from the Bosphorus, Istanbul Modern, Turkey (2007); Venice Biennale (2003); *Arte Povera – From 0 to infinity*, Tate Modern, London; and tour (2001–02); *Quotidiana*, Castello di Rivoli, Turin (2000); *Trouble Spot. Painting at the NICC and MUHKA*, Museum voor Hedendaagse Kunst Antwerpen, Antwerp (1999); *Documenta 10*, Kassel (1997); *Face à l'Histoire*, Centre Pompidou, Paris (1996); Venice Biennale (1995 and 1993); *Gravity and Grace. The Changing Condition of Sculpture 1965–1975*, Hayward Gallery (1993); *L'arte povera*, Centre Pompidou (1992); *Documenta 9*, Kassel (1992); Venice Biennale (1986 1984,1982); *Documenta 7*, Kassel (1982); Venice Biennale (1978 and 1976); *Malerei und Photographie im Dialog*, Kunsthaus Zürich (1977); *Information*, Museum of Modern Art, New York (1970); *Processi di Pensiero visualizzati*, Kunstmuseum Luzern (1970); *When Attitudes Become Form*, Kunsthalle Bern (1969); *The obsessive image*, Institute of Contemporary Art, London (1968); *Arte Povera + Azioni Povere*, Arsenali, Amalfi, Italy (1968); Venice Biennale (1968); *Documenta 4*, Kassel (1968); Venice Biennale (1966); *Mythologies quotidiennes*, Musée d'art moderne de la Ville de Paris (1964); *New Realism and Pop Art*, Museum des XX. Jahrhunderts, Vienna (1964)

Bibliography

Marco Farano, Gilbert Perlein, *Michelangelo Pistoletto*, Museum of Modern and Contemporary Art, Nice, 2007.
Michelangelo Pistoletto & Cittadellarte &., Snoeck, Ghent, 2003.
Michelangelo Pistoletto, Museu d'Art Contemporani de Barcelona, Barcelona, 2000.
Michael Tarantino, Robert Hopper, *Michelangelo Pistoletto: shifting perspective ('I am the Other'): commentaries on the exhibitions: Mirror work 1962–1992; New work*, Modern Art Oxford, 1999.
Michelangelo Pistoletto: Zeit-Räume, Museum moderner Kunst Stiftung Ludwig Wien, Vienna, 1995.
Jean-François Chevrier, Chris Dercon, Jorge Molder, *Michelangelo e la fotografia*, Museu Serralves, Porto, 1993.
Oggetti in meno 1965–1966, Camden Arts Centre, London, 1991. With an interview with the artist by Michael Craig-Martin.
Germano Celant, *Pistoletto*, Rizzoli, New York, 1989.
Bruno Corà, *Lo Spazio della riflessione nell'arte*, Edizioni Essegi, Ravenna, 1986.
Michelangelo Pistoletto, Palazzo Grassi, Venice, 1976.
Germano Celant, *Art Povera: conceptual, actual or impossible art?*, Edizioni Mazzotta, Milan, 1969.

GERHARD RICHTER

Solo exhibitions

Painting as a Mirror, 21st Century Museum of Contemporary Art, Kanazawa; and tour (2005); *Gerhard Richter*, K 20, Kunstsammlung Nordrhein-Westfalen, Düsseldorf; and tour (2005); *Image After Image*, Louisiana Museum, Humlebaek, Denmark (2005); *Six Gray Mirrors*, Dia:Beacon, New York (2003); *Gerhard Richter: 40 Years of Painting*, Museum of Modern Art, New York; and tour (2002); *Gerhard Richter. The Art of the Impossible – Paintings 1964–1998*, Astrup Fearnley Museet, Oslo (1999); *Gerhard Richter*, ARC/Musée d'art moderne de la Ville de Paris; and tour (1993); *Gerhard Richter*, Tate Gallery, London (1991); *18. Oktober 1977*, Museum Haus Esters, Krefeld; and tour (1989); *Gerhard Richter. Bilder 1962–1985*, Städtische Kunsthalle Düsseldorf; and tour (1986); *Gerhard Richter*, Stedelijk van Abbemuseum, Eindhoven; and tour, including Whitechapel Art Gallery, London (1978–79); *Gerhard Richter*, Centre Pompidou, Paris (1977); *Gerhard Richter*, Städtische Galerie im Lenbachhaus, Munich (1973); *Gerhard Richter*, Kunstverein für die Rheinlande und Westfalen, Düsseldorf (1971); *Gerhard Richter*, Palais des Beaux-Arts, Brussels (1970); *Volker Bradke*, Galerie Alfred Schmela, Düsseldorf (1966); *Gerhard Richter. Fotobilder, Porträts und Familien*, Galerie Friedrich und Dahlem, Munich (1964); *Gerhard Richter/Konrad Lueg. Leben mit Pop. Eine Demonstration für den Kapitalistischen Realismus*, Möbelhaus Berges, Düsseldorf (1963)

Group exhibitions

Venice Biennale (2007); *Faces in the Crowd, Picturing Modern Life from Manet to Today*, Whitechapel Art Gallery, London; Castello di Rivoli, Turin, Italy (2004); *As Painting: Division and Displacement*, Wexner Center for the Arts, Columbus, Ohio (2001); *Documenta 10*, Kassel (1997); Venice Biennale (1997); *Desire, Disaster, Document*, San Francisco Museum of Modern Art (1995); *Documenta 9*, Kassel (1992); German Pavilion, Venice Biennale (1972); *Refigured Painting: The German Image 1960–1988*, The Solomon R. Guggenheim Museum, New York (1989); *Documenta 8*, Kassel (1987); *German Art in the 20th Century*, Royal Academy of Arts, London; and tour (1985); *Art in the Mirror*, Venice Biennale (1984); *'60 80' Attitudes/Concepts/Images*, Stedelijk Museum, Amsterdam (1982); *Documenta 7*, Kassel (1982); *A New Spirit in Painting*, Royal Academy of Arts, London (1981); *Pier + Ocean: Construction of Art in the Seventies*, Hayward Gallery; and tour (1980); Venice Biennale (1980); *Documenta 5*, Kassel (1972); *Painting from Photography*,

Stadtmuseum, Munich (1970); *The Düsseldorf Scene*, Kunstmuseum Luzern (1969); *14 Aspects of Modern Painting*, Haus der Kunst, Munich (1965); *Neue Realisten. Konrad Lueg, Sigmar Polke, Gerhard Richter*, Galerie Parnass, Wuppertal (1964)

Bibliography
Helmut Friedel (ed.), *Gerhard Richter: Atlas*, Thames & Hudson, London, 2006.
Stefan Gronert, *Gerhard Richter. Portraits*, Hatje Cantz Verlag, Ostfildern-Ruit, 2006.
Hans-Ulrich Obrist (ed.), *The Daily Practice of Painting: Writings 1962–1993*, Thames & Hudson, London, 2005.
Robert Storr, *Gerhard Richter. Forty Years of Painting*, The Museum of Modern Art, New York, 2002.
Benjamin H.D. Buchloh, Jean-François Chevrier, Armin Zweite, Rainer Rochlitz, *Photography and Painting in the Work of Gerhard Richter, Four essays on Atlas*, Museu d'Art Contemporani de Barcelona, 2000.
Robert Storr, *Gerhard Richter: October 18, 1977*, Museum of Modern Art, New York, 2000.
Gerhard Richter: Landscapes, Hatje Cantz Verlag, Ostfildern-Ruit, 1998.
Gerhard Richter (volume 1 , volume 2: Texte, volume 3: Werkübersicht / catalogue raisonné 1962–1993), Kunst-und Ausstellungshalle der Bundesrepublik Deutschland, Bonn, 1993.
'Gerhard Richter Collaboration', *Parkett*, no. 35, Zürich, 1993. Texts by Jean-Pierre Criqui, Peter Gidal, Dave Hickey, Gertrude Koch, Birgit Pelzer.
Neal Ascherson, Stefan Germer, Sean Rainbird, *Gerhard Richter*, Tate Gallery Publishing, London, 1991.
Jürgen Harten, *Gerhard Richter: Bilder – paintings 1962–1985*, DuMont Buchverlag, Cologne, 1986 / Kunsthalle, Düsseldorf, 1986.
Gerhard Richter: Graue Bilder, Städtisches Museum Mönchengladbach, 1975.
Gerhard Richter, Städtische Galerie im Lenbachhaus, Munich, 1973.
Gerhard Richter – Bilder des Kapitalistischen Realismus, Galerie René Block, Berlin, 1964.

WILHELM SASNAL

Solo exhibitions
Pintures, Fundació 'la Caixa', Espai Montcada, Caixa Forum, Barcelona (2007); *Wilhelm Sasnal*, Douglas Hyde Gallery, Dublin (2006); *Wilhelm Sasnal*, Frankfurter Kunstverein, Frankfurt am Main (2006); *Wzorzec kilograma*, Foksal Gallery Foundation, Warsaw (2006); *Wilhelm Sasnal*, Stedelijk van Abbemuseum, Eindhoven (2006); *Matrix 219*, Berkeley Art Museum, University of California (2005); *Map Trap*, Swietlica Sztuki Raster, Warsaw (2004); *Wilhelm Sasnal*, Camden Arts Centre, London (2004); *Wilhelm Sasnal*, Rüdiger Schöttle Gallery, Munich (2004); *Wilhelm Sasnal*, Johnen & Schöttle Gallery, Cologne (2004); *Wilhelm Sasnal*, Westfälischer Kunstverein, Muenster (2003); *Wilhelm Sasnal*, Kunsthalle Zürich (2003)

Group exhibitions
Airs de Paris, Centre Pompidou, Paris (2007); *The Vincent 2006*, Stedelijk van Abbemuseum, Eindhoven (2006); *Images in Painting. Johannes Kahrs, Magnus von Plessen, Eberhard Havekost and Wilhem Sasnal*, Museu Serralves, Porto (2006); *Grey Flags*, Sculpture Center, Long Island City, New York (2006); *The Triumph of Painting – Part 2*, The Saatchi Gallery, London (2005); *26. Bienal de Sao Paulo*, Brazil (2004); *Who if not we ...? episode 2: Time and Again*, Stedelijk Museum, Amsterdam (2004); *Crawling Revolution 2*, Rooseum, Centre for Contemporary Art, Malmö (2003); *Nach der Wirklichkeit III – Painting on the move*, Kunsthalle Basel (2002); *Pause, 4th Gwangju Biennial*, South Korea (2002); *Urgent Painting*, Musée d'art moderne de la Ville de Paris (2002)

Bibliography
Images in Painting, Museu Serralves, Porto, 2006. With a text on Wilhelm Sasnal by Ulrich Loock and Adam Szymczyk.
Sebastian Cichocki, Charles Esche, *Wilhelm Sasnal, Paintings & Films*, Van Abbemuseum, Eindhoven, 2006.
Charlotte Mullins, *Painting People. The State of the Art*, Thames & Hudson, London, 2006.
'Wilhelm Sasnal', interview by Craig Garrett, in *Purple Magazine*, issue 4, Fall–Winter, 2005–06.
Andrea Bellini, 'There Are No Rules: An Interview with Wilhelm Sasnal', in *Flash Art International*, vol. 38, July–September 2005.
Alison M. Gingeras, 'Photography, Painting and the Fear of Forgetting', in *Wilhelm Sasnal. File Note #08*, Camden Arts Centre, London, 2004.
Jordan Kantor, 'The Tuymans Effect. Eberhard Havekost, Magnus von Plessen, Wilhelm Sasnal, Luc Tuymans', in *Artforum*, November 2004.
Ulrich Loock, Carina Plath, Andrzej Przywara, Beatrix Ruf, *Wilhelm Sasnal. Night Day Night*, Hantje Cantz Verlag, Ostfildern-Ruit, 2003.
Valérie Breuvart (ed.), *Vitamin P. New Perspectives in Painting*, Phaidon, London, 2002. Text by Igor Zabel.
Wilhelm Sasnal, *Everyday Life in Poland 1999–2001*, Warschau and Krakow, 2002.

LUC TUYMANS

Solo exhibitions
Luc Tuymans, San Francisco Museum of Modern Art (2008); *Luc Tuymans*, Haus der Kunst, Munich (2008); *I don't get it*, Museum voor Hedendaagse Kunst Antwerpen, Antwerp (2007); *Dusk*, Museu Serralves, Porto (2006); *Portraits: 1975–2003*, Musée d'art moderne et contemporain, Geneva (2006); Tate Modern, London (2004); *The Arena*, Kunstverein Hannover; and tour (2002–03); *Mwana Kitoko – Beautiful White Man*, Belgian Pavilion, Venice Biennale (2001); *The Purge, Paintings 1991–1998*, Bonnefantenmuseum, Maastricht; and tour (1999); *Blow Up. Luc Tuymans. Schilderijen/Paintings 1985–1995*, De Pont, Tilburg (1995); *Superstition*, Institute of Contemporary Arts, London; and tour (1994–95); *Luc Tuymans*, Kunsthalle Bern (1992); *Luc Tuymans*, Provinciaal Museum voor Moderne Kunst, Ostend (1990)

Group exhibitions
The Eighties, Museu Serralves (2007); *Street: Behind the Cliché*, Witte de With Center for Contemporary Art, Rotterdam (2006); *Out of Time: A Contemporary View*, Museum of Modern Art, New York (2006); *The Triumph of Painting*, The Saatchi Gallery, London (2005); *The Undiscovered Country*, Hammer Museum, UCLA, Los Angeles (2004); *After Images*, Neues Museum Weserburg, Bremen (2004); *Dear painter, paint me...: painting the figure since late Picabia*, Centre Pompidou, Paris; and tour (2002); *Documenta 11*, Kassel (2002); *Painting on the Move*, Museum für Gegenwartskunst, Basel (2002); *Examining Pictures: Exhibiting Paintings*, Whitechapel Art Gallery, London; and tour (1999–2000); *Trouble Spot. Painting at the NICC and MUHKA*, co-curated by Luc Tuymans, Museum voor Hedendaagse Kunst Antwerpen, Antwerp (1999); *John Currin / Elizabeth Peyton / Luc Tuymans*, Museum of Modern Art, New York (1997); *Future, Present, Past*, Venice Biennale (1997); *Painting the Extended Field*, Magasin 3 Konsthall, Stockholm; and tour (1996–97); *Face à l'Histoire*, Centre Pompidou, Paris (1996); *Unbound. Possibilities in Painting*, Hayward Gallery (1994); *The Broken Mirror*, Kunsthalle Wien, Vienna; and tour (1993–94); *Documenta 9*, Kassel (1992)

Bibliography
Gerrit Vermeiren, *LUC TUYMANS: I Don't Get It*, Ludion, Ghent, 2007.
Hand Rudolf Reust, Luc Tuymans (eds), *Luc Tuymans. Dusk*, Museu Serralves, Porto 2006.

Emma Dexter, Jésus Fuenmayor, Julian Heynen, *Luc Tuymans*, Tate Publishing, London, 2004.
Jordan Kantor, 'The Tuymans Effect. Eberhard Havekost, Magnus von Plessen, Wilhelm Sasnal, Luc Tuymans', in *Artforum*, November 2004.
Juan Vicente Aliaga, Ulrich Loock, Nancy Spector, *Luc Tuymans*, Phaidon Press, London, 2003.
Laura Hoptman, Gerardo Mosquera, Hans Rudolf Reust, 'Luc Tuymans', in *Parkett*, no. 60, Zürich, 2000.
Narcisse Tordoir, Luc Tuymans (eds.), *Trouble Spot. Painting at the NICC and MUHKA*, NICC and MUHKA, Antwerp, 1999.
'Luc Tuymans interviewed by Martin Gayford', in *Modern Painters*, Autumn 1999.
Daniel Birnbaum, 'A thousand words: Luc Tuymans', in *Artforum*, October 1998.
Julian Heynen, *Luc Tuymans*, Museum Haus Lange, Krefeld, 1993.
Ulrich Loock, *Luc Tuymans*, Kunsthalle Bern, 1992.
Robert Van Ruyssevelt, Marc Schepers, *Luc Tuymans*, Provinciaal Museum voor Moderne Kunst, Ostend, 1990.

ANDY WARHOL

Solo exhibitions

Artist of Modern Life, The Andy Warhol Museum, Pittsburgh (2006); *Supernova, Stars, Deaths, and Disasters. 1962–1964*, Walker Art Center, Minneapolis; and tour (2005–06); *Andy Warhol: Social Observer*, Pennsylvania Academy of the Fine Arts, Philadelphia (2001); *Andy Warhol: Photography*, Kunsthalle, Hamburg; and tour (1999); *Andy Warhol: A Retrospective*, Museum of Modern Art, New York; and tour (1989); *Death and Disasters*, The Menil Collection, Houston (1988); *Andy Warhol* (showing *Disaster Paintings 1963*), Dia Art Foundation, New York (1986); *Andy Warhol*, Kunsthaus Zürich (1978); *Warhol*, Tate Gallery, London (1971); *Andy Warhol*, Pasadena Art Museum, California; and tour (1970); *Andy Warhol*, Moderna Museet, Stockholm (1968); *Andy Warhol. Holy Cow! Silver Clouds!! Holy Cow!*, Contemporary Arts Center, Cincinnati (1966); *Andy Warhol*, Institute of Contemporary Art, Philadelphia (1965); *Andy Warhol*, Leo Castelli Gallery, New York (1964); Galerie Ileana Sonnabend (showing *Death and Disaster* paintings), New York (1964)

Group exhibitions

The Last Picture Show: Artists Using Photography, 1960–1982, Walker Art Center, Minneapolis (2005); *Ungemalt = unpainted*, Sammlung Essl, Vienna (2002); *Deep Storage*, Haus der Kunst, Munich (1999); *Examining Pictures: Exhibiting Paintings*, Whitechapel Art Gallery, London; and tour (1999); *Birth of the Cool: American Painting*, Deichtorhallen, Hamburg; and tour (1997); *Police pictures: the photograph as evidence*, San Francisco Museum of Modern Art (1997); *L'informe: mode d'emploi*, Centre Pompidou, Paris (1996); Venice Biennale (1995); *Zeitgeist: Internationale Kunstaussstellung*, Martin-Gropius-Bau, Berlin (1982); *Documenta 7*, Kassel (1982); *Realität Realismus Realität*, Von der Heyt-Museum, Wuppertal (1972); *Pop Art*, Hayward Gallery (1969); *Documenta 4*, Kassel (1968); *The photographic image*, The Solomon R. Guggenheim Museum, New York (1966); *New Painting of Common Objects*, Pasadena Art Museum (1962); *New Realists*, Sidney Janis Gallery, New York (1962)

Bibliography

Francesco Bonami, Douglas Fogle, David Moos, *Supernova, Stars, Deaths, and Disasters. 1962–1964*, Walker Art Center, Minneapolis, 2005.
I'll be Your Mirror: The Selected Andy Warhol Interviews, Carroll & Graf, New York, 2004.
George Frei, Neil Printz, Sally King Nero (eds), *The Andy Warhol Catalogue Raisonné. Paintings and Sculpture, 1964–69*, volume 2, Phaidon, London, 2004.
Heiner Bastian, Kirk Varnedoe, Donna De Salvo, et al, *Andy Warhol: retrospective*, Tate Gallery Publishing, London, 2002.
George Frei, Neil Printz, Sally King Nero (eds), *The Andy Warhol Catalogue Raisonné. Paintings and Sculpture, 1961–63*, volume 1, Phaidon, London, 2002.
Andy Warhol, Pat Hackett, *The Andy Warhol Diaries*, Warner Books, New York, 1989.
Christoph Heinrich (ed.), *Andy Warhol: photography*, Hamburger Kunsthalle, Hamburg and Andy Warhol Museum, Pittsburg, 1999.
Walter Hopps, Neil Printz, Remo Guidieri, *Andy Warhol: death and disasters*, The Menil Foundation, Houston, Houston Fine Art Press, 1988.
Carter Ratcliff, *Andy Warhol*, Abbeville Press, New York, 1983.
Rainer Crone, *Andy Warhol*, Verlag Gert Hatje, Stuttgart, 1970.
Samuel Gerard Green, *Andy Warhol*, Institute of Contemporary Art, Philadelphia, 1965.
Gene Swensen, 'What is Pop Art?, Answers from 8 Painters, Part I', in *Art News*, November 1963.

List of Works

All measurements are in centimetres, height×width×depth. This list was accurate at the time of publication. There may have been subsequent changes to works in the exhibition.

RICHARD ARTSCHWAGER

1 (p. 66)
Office Scene, 1966
Acrylic on Celotex with metal frame
106.5×109
Froehlich Collection, Stuttgart
© The artist 2007, ARS, NY and DACS, London 2007

2 (p. 67)
Dormitory, 1968
Liquitex on Celotex with metal frame
84×69
Private collection, Paris
© The artist 2007, ARS, NY and DACS, London 2007
Photo: Marc Domage

3 (p. 64)
Fabrikhalle, 1969
Factory
Liquitex on Celotex with Formica on chipboard
57.5×76.5
Ulmer Museum, Ulm, Donation Kurt Fried
© The artist 2007, ARS, NY and DACS, London 2007
Photo: © Photodesign Armin Buhl

4 (pp. 68–69)
Destruction III, 1972
Acrylic on Celotex, 2 panels
188×223.5
Stefan T. Edlis Collection
© The artist 2007, ARS, NY and DACS, London 2007

ROBERT BECHTLE

5 (p. 96)
'61 Pontiac, 1968–69
Oil on canvas
153.7×215.9
Whitney Museum of American Art, New York Purchase, with funds from the Richard and Dorothy Rodgers Fund
© Robert Bechtle
Photo: Geoffrey Clements, Courtesy Whitney Museum of American Art, New York. Digital image courtesy the San Francisco Museum of Modern Art

6 (p. 98)
'67 Chrysler, 1973
Oil on canvas
121.9×175.3
Helen van der Mey-Tcheng
© Robert Bechtle
Photo: David Clarke. Digital image courtesy the San Francisco Museum of Modern Art

7 (p. 99)
Alameda Chrysler, 1981
Oil on canvas
121.9×175.3
Collection Meisel Family
© Robert Bechtle
Photo: D. James Dee, courtesy the artist. Digital image courtesy the San Francisco Museum of Modern Art

VIJA CELMINS

8 (p. 70)
Time Magazine Cover,1965
Oil on canvas
56×40.6
Private collection
© Vija Celmins
Photo: Ch.Schwager Winterthur

9 (p. 72)
Explosion at Sea, 1966
Oil on canvas
34.3×59.7
The Art Institute of Chicago, Gift of Lannan Foundation
© Vija Celmins. Courtesy the artist and McKee Gallery, New York
Photo: Sarah Wells, New York

10 (p. 73)
Flying Fortress, 1966
Oil on canvas
40.6×66
The Museum of Modern Art, New York. Gift of Edward R. Broida, 2005
© Vija Celmins. Courtesy the artist and McKee Gallery, New York

11 (p. 74)
Freeway, 1966
Oil on canvas
43.8×66.7
Harold Cook, PhD.
© Vija Celmins. Courtesy the artist and McKee Gallery, New York

12 (p. 75)
Tulip Car #1, 1966
Oil on canvas
40.6×68.5
National Gallery of Art, Washington, Gift of Edward R. Broida 2005.142.12
© Vija Celmins. Courtesy the artist and McKee Gallery, New York
Photo: Courtesy McKee Gallery, New York

PETER DOIG

13 (p. 130)
Concrete Cabin II, 1992
Oil on canvas
200×275
Private collection
© the artist. Courtesy Victoria Miro Gallery

14 (p. 129)
Lump (Olin MK IV Part II), 1995–96
Oil on canvas
295×200
Collection Glenn Scott Wright. Courtesy Victoria Miro Gallery
© the artist. Courtesy Victoria Miro Gallery

15 (p. 128)
Buffalo Station I, 1997–98
Oil on canvas
175.3×269.2
Collection David Teiger. Courtesy Victoria Miro Gallery, London
© the artist. Courtesy Victoria Miro Gallery

16 (p. 131)
Untitled, 2001–02
Oil on canvas
186×199
Private collection
© the artist. Courtesy Victoria Miro Gallery

17 (p. 126)
Lapeyrouse Wall, 2004
Oil on canvas
200×250
Private collection; fractional and promised gift to The Museum of Modern Art, New York in honor of Kynaston McShine
© the artist. Courtesy Victoria Miro Gallery

MARLENE DUMAS

18 (p. 122)
The Teacher (sub a), 1987
Oil on canvas
160×200
Private collection
Photo: Peter Schälchli, Zürich

19 (p. 123)
The Visitor, 1995
Oil on canvas
180×300
Private collection – on long term loan to L.A.C. Lieu d'Art Contemporain, Sigean, France

20 (pp. 124–125)
The Blindfolded, 2002
Oil on canvas, 3 panels
130×110 each
Hauser & Wirth Collection, Switzerland

21 (p. 120)
Frisked, 2006
Oil on canvas
200×100
Collection of the artist

THOMAS EGGERER

22 (p. 160)
Sweet Valley High, 1998
Acrylic on canvas
69.9×100
Courtesy of Friedrich Petzel, New York
© the artist 2007. Courtesy Galerie Daniel Buchholz, Cologne
Photo: Lothar Schnepf

23 (pp. 158–159)
The Fountain, 2002
Acrylic on canvas
101.5×161.5
Thomas Borgmann, Cologne
© the artist 2007. Courtesy Galerie Daniel Buchholz, Cologne
Photo: Lothar Schnepf

24 (p. 161)
Mezzanine, 2004
Acrylic on canvas
137.2×175.3
Thomas Borgmann, Cologne
© the artist 2007. Courtesy Galerie Daniel Buchholz, Cologne
Photo © the artist. Courtesy of the artist and Friedrich Petzel Gallery, New York

25 (p. 156)
Into Thin Air, 2005
Acrylic on canvas
194.9×220.5
Collection David Teiger. Courtesy Galerie Daniel Buchholz, Cologne
© the artist 2007. Courtesy Galerie Daniel Buchholz, Cologne
Photo: Jürgen Schmidt, Cologne

JUDITH EISLER

26 (p. 171)
Edie (Ciao Manhattan), 2003
Oil on canvas
172.7×203.2
Collection of Stanley & Nancy Singer

27 (p. 168)
Gena (Opening Night), 2003
Oil on canvas
121.9×152.4
Courtesy of Cohan and Leslie, New York

28 (p. 171)
Smoker (Cruel Story of Youth), 2003
Oil on canvas
147×178
Collection of Ninah and Michael Lynne

29 (p. 170)
Delon 2, 2007
Oil on canvas
147.3×193
Courtesy of Cohan and Leslie, New York

FRANZ GERTSCH

30 (p. 102)
Kranenburg, 1970
Dispersion on unprimed half-linen
200×300
Aargauer Kunsthaus Aarau
© Franz Gertsch
Photo: Jorg Müller, Aarau

31 (p. 103)
Aelggi Alp, 1971
Dispersion on unprimed half-linen
350×525
Kunstmuseum Bern, on permanent loan from private collection, Switzerland
© Franz Gertsch
Photo: Peter Lauri, Bern

32 (p. 100)
At Luciano's House, 1973
Acrylic on unprimed cotton
243×355
Sander Collection
© Franz Gertsch

RICHARD HAMILTON

33 (p. 86)
Swingeing London 67 (f), 1968–69
Acrylic, collage and aluminium on canvas
67.3×85.1
Tate Purchased 1969
© Richard Hamilton. All Rights Reserved, DACS 2007
Photo: John Webb © Tate, London 2007

34 (p. 90)
Chicago Project I, 1969
Acrylic on photograph on board
81×122
British Council Collection
© Richard Hamilton. All Rights Reserved, DACS 2007

35 (p. 90)
Chicago Project II, 1969
Acrylic on photograph
on board
81×122
British Council Collection
© Richard Hamilton. All
Rights Reserved, DACS 2007

36 (pp. 88–89)
The citizen, 1981–83
Oil on canvas, 2 panels
200×100 each
Tate Purchased 1985
© Richard Hamilton. All
Rights Reserved, DACS 2007
Photo: © Tate, London 2007

37 (p. 91)
Mother and Child, 1984–85
Oil on canvas
150×150
Kathy & Keith Sachs
© Richard Hamilton. All
Rights Reserved, DACS 2007

EBERHARD HAVEKOST

38 (p. 172)
Hotelsprung, 2003
Hotel Jump
Oil on canvas
220×180
Sammlung Rheingold
© the artist 2007, and Galerie
Gebr. Lehmann, Dresden
Photo: Werner Lieberknecht,
Dresden

39 (p. 175)
Luft, 2003
Air
Oil on canvas
90×60
Private collection. Courtesy
White Cube, London
© the artist 2007, and Galerie
Gebr. Lehmann, Dresden
Photo: Werner Lieberknecht,
Dresden

40 (p. 176)
National Geographic, 2003
Oil on canvas
110×130
Courtesy of Locksley Shea
Gallery
© the artist 2007, and Galerie
Gebr. Lehmann, Dresden
Photo: Werner Lieberknecht,
Dresden

41 (p. 174)
Beginning A..., 2004
Oil on canvas
180×200
Hort Family Collection
© the artist 2007, and Galerie
Gebr. Lehmann, Dresden
Photo: Werner Lieberknecht,
Dresden

42 (p. 177)
American Lip Gloss, B06, 2006
Oil on canvas
95×150
David Roberts Collection
© the artist 2007, and Galerie
Gebr. Lehmann, Dresden
Photo: Werner Lieberknecht,
Dresden

DAVID HOCKNEY

43 (p. 92)
Boy About to Take a Shower,
1964
Acrylic on canvas
91×91
Private collection.
Courtesy of Ivor Braka Ltd
© David Hockney

44 (p. 94)
*Le Parc des Sources,
Vichy*, 1970
Acrylic on canvas
213.5×305
Devonshire Collection,
Chatsworth
© David Hockney
Photo: The Devonshire
Collection, Chatsworth

45 (p. 95)
Mr and Mrs Clark and Percy,
1970–71
Acrylic on canvas
213.4×304.8
Tate Presented by the Friends
of the Tate Gallery 1971
© David Hockney
Photo: © Tate, London 2007

JOHANNES KAHRS

46 (p. 166)
93'09", 1997
Oil on canvas, frame with
Perspex
196×297
Collection S.M.A.K, Gent
© DACS 2007

47 (pp. 164–165)
La Révolution Permanente,
2000
Oil on canvas, plexiglass,
metal, 2 panels
193×269; 193.5×293.5
The Saatchi Gallery, London
© DACS 2007/Courtesy the
artist and Zeno X Gallery
Antwerp

48 (p. 167)
Fond 2, 2005
Back of a Car
Oil on canvas
60.5×81.5
Courtesy Zeno X Gallery
© DACS 2007

49 (p. 162)
Figure Turning (large), 2006
Oil on canvas
200×132.3
Chadha Art Collection,
The Netherlands
© DACS 2007

JOHANNA KANDL

50 (p. 152)
*Untitled (Ein sehr heisser
Spätnachmittag...)*, 1999
Untitled (A very hot late
afternoon...)
Egg tempera on wood
115×150
Courtesy Christine König
Galerie, Vienna
© Johanna Kandl. Courtesy
Christine König Galerie,
Vienna

51 (p. 153)
Untitled, 2004
Egg tempera on wood
30×40
Heide Giesing-Grübl,
Hamburg
Photo: Manfred Wigger

52 (p. 153)
Untitled, 2004
Egg tempera on wood
30×42
Heinz G. Lück, Hamburg
Photo: Manfred Wigger

53 (p. 150)
Untitled (Love it,...), 2005
Egg tempera on wood
243×170
Arbeiterkammer Wien
(Chamber of Labour, Vienna)
Photo: Courtesy Christine
König Galerie, Vienna

54 (pp. 154–155)
Carnival Liberty, 2006
Egg tempera on wood
241×170
The Essl Collection
Klosterneuburg/Vienna
Photo: Marcus Schneider

MARTIN KIPPENBERGER

55–66
*Uno di voi, un Tedesco in
Firenze*, 1977
One of You, A German in
Florence
Oil on canvas
© Estate Martin
Kippenberger, Galerie Gisela
Capitain, Cologne

55 (p. 108)
60×50
Collection Stolitzka, Graz
Photo: Max Wedscheidler

56 (p. 107)
60×50
Collection Stolitzka, Graz
Photo: Max Wedscheidler

57 (p. 104)
60×50
Collection Stolitzka, Graz
Photo: Max Wedscheidler

58 (p. 107)
60×50
Private collection, Berlin
Photo: Jan Windszus

59 (p. 109)
60×50
Private collection, Berlin
Photo: Jan Windszus

60 (p. 109)
50×60
Private collection

61 (p. 108)
50×60
Galerie Bärbel Grässlin,
Frankfurt a.M.

62 (p. 108)
50×60
Galerie Bärbel Grässlin,
Frankfurt a.M.

63 (p. 109)
50×60
Galerie Bärbel Grässlin,
Frankfurt a.M.

64 (p. 108)
60×50
Galerie Bärbel Grässlin,
Frankfurt a.M.

65 (p. 106)
50×60
Private collection, Germany

66 (p. 109)
60×50
Private collection, Athens

67 (p. 110)
Ohne Titel, from the series
'Lieber Maler, male mir', 1981
Untitled, from the series
'Dear Painter, Paint For Me'
Acrylic on canvas
300×200
Estate Martin Kippenberger,
Galerie Gisela Capitain,
Cologne
© Estate Martin
Kippenberger, Galerie Gisela
Capitain, Cologne

68 (p. 111)
Ohne Titel, from the series
'Lieber Maler, male mir', 1981
Untitled, from the series
'Dear Painter, Paint For Me'
Acrylic on canvas
300×200
Sender Collection
© Estate Martin
Kippenberger, Galerie Gisela
Capitain, Cologne

LIU XIAODONG

69 (pp. 142–143)
Watching, 2000
Oil on canvas
200×200
Collection Jean-Marc Decrop.
Courtesy Galerie Loft
© the artist 2007. Courtesy
Guy and Myriam Ullens
Foundation, Switzerland

70 (p. 141)
*A Transsexual Getting Down
Stairs*, 2001
Oil on canvas
152×137
Collection Guy & Myriam
Ullens Foundation,
Switzerland
© the artist 2007. Courtesy
Guy and Myriam Ullens
Foundation, Switzerland

71 (p. 140)
Three Girls Watching TV, 2001
Oil on canvas
130×150
Collection Jean-Marc Decrop.
Courtesy Galerie Loft

72 (p. 138)
Traffic Accident, 2002
Oil on canvas
200×200
Collection Guy & Myriam
Ullens Foundation,
Switzerland
© the artist 2007. Courtesy
Guy and Myriam Ullens
Foundation, Switzerland

MALCOLM MORLEY

73 (p. 82)
Cristoforo Colombo, 1966
Liquitex on canvas
35.6×50.8
Collection Jean-Christophe
Castelli
© Malcolm Morley 2007

74 (p. 80)
On Deck, 1966
Magna on canvas
212.5×162.3
Lent by The Metropolitan
Museum of Art, Gift of Mr.
and Mrs. S. Brooks Barron,
1980 (1980.289)
© Malcolm Morley 2007
Photo: © 1980 The
Metropolitan Museum of Art

75 (p. 83)
Family Portrait, 1968
Acrylic and oil on canvas
172.7×172.7
The Detroit Institute of Arts,
Gift of Judge and Mrs.
Peter B. Spivak
© Malcolm Morley 2007
Photo: © 2007 The Detroit
Institute of Arts

76 (p. 84)
Wall Jumpers, 2002
Oil on canvas
228.6×175.3
Musée d'Art moderne et
contemporain de Strasbourg
© Malcolm Morley 2007
Photo: M. Bertola

77 (p. 85)
Military Object #1, 2006
Acrylic paint, lettering
enamel on paper, oil on linen,
magnets
147.3×47.6×38
Courtesy the artist and
Sperone Westwater,
New York
© Malcolm Morley 2007

ELIZABETH PEYTON

78 (p. 132)
Mendips, 1963, 1996
Oil on canvas
81.2×71
Mima and César Reyes
Collection, San Juan,
Puerto Rico
Photo: Courtesy Gavin
Brown's enterprise

79 (p. 137)
Arsenal (Prince Harry), 1997
Oil on board
28.6×36.8
Private collection, London
and Sadie Coles HQ, London
© the artist 2007; courtesy
Sadie Coles HQ, London

80 (p. 135)
Queen Mother's Funeral, 2002
Oil on wood
30.5×38
Private collection, Berlin.
Courtesy
neugerriemschneider, Berlin

81 (p. 136)
*Klose, Podolski, and Frings
(German Team Stretching),
July 8, 2006*, 2006–07
Oil on MDF
23.5×17.8
Courtesy The Stephanie and
Peter Brant Foundation,
Greenwich, CT, USA

82 (p. 134)
*Nick and Pati (Nick Mauss
and Pati Hertling)*, 2007
Oil on MDF
33×25.4
François Pinault Collection
Photo: Paolo Pellion.
Courtesy Gavin Brown's
enterprise

MICHELANGELO PISTOLETTO

83 (pp. 78–79)
Ragazza che cammina, c.1960
Girl Walking
Painted tissue paper on steel
230×120
Castello di Rivoli Museo
d'Arte Contemporanea,
Rivoli-Torino Permmanent
loan – Fondazione CRT
Progetto Arte Moderna e
Contemporanea

84 (p. 76)
Attesa n.5 – 25 in più,
1962–75
Waiting n.5 + 25
Silkscreen on stainless steel
250×125
Collection Pistoletto
Foundation

GERHARD RICHTER

85 (p. 60)
Faltbarer Trockner, 1962
Folding Dryer
Oil on canvas
99.3×78.6
Froehlich Collection,
Stuttgart
© Gerhard Richter
Photo: Uli Zeller, Stuttgart

86 (p. 58)
Frau mit Schirm, 1964
Woman with Umbrella
Oil on canvas
160×95
Daros Collection, Switzerland
© Gerhard Richter

87 (p. 61)
Renate und Marianne, 1964
Renate and Marianne
Oil on canvas on board
135×170
Private collection, London
© Gerhard Richter

88 (p. 62)
Krankenschwestern, 1965
Nurses
Oil on canvas
48×60
Kunstmuseen Krefeld
© Gerhard Richter
Photo: V.Döhne Krefelder
Kunstmuseum

89 (p. 63)
Volker Bradke, 1966
Oil on canvas
148.7×199.2
The Cranford Collection,
London
© Gerhard Richter

WILHELM SASNAL

90 (p. 147)
Factory, 2000
Oil on canvas
101×101
The Saatchi Gallery, London

91 (p. 146)
Untitled (Hunters), 2001
Oil on canvas
150×170
Rubell Family Collection,
Miami

92 (p. 144)
Kielce (Ski Jump), 2003
Oil on canvas
145×145
Collection of the artist

93 (p. 149)
Gas Station 1, 2006
Oil on canvas
40×50
Courtesy Private Collection,
Genoa, and Sadie Coles HQ,
London
© the artist 2007; courtesy
Sadie Coles HQ, London

94 (p. 149)
Gas Station 2, 2006
Oil on canvas
40×50
Courtesy Private Collection,
London, and Sadie Coles HQ,
London
© the artist 2007; courtesy
Sadie Coles HQ, London

95 (p. 148)
Tarnow, Train Station, 2006
Oil on canvas
100×140
Collection of the artist

LUC TUYMANS

96 (p. 112)
De Wandeling, 1991
The Walk
Oil on canvas
37×48
Private collection, Tervuren,
Belgium
© the artist 2007, and
courtesy Zeno X Gallery

97 (p. 117)
G.I. Joe, 1996
Oil on canvas
68.5×62
Centre Pompidou, Paris.
Musée national d'art
moderne / Centre de création
industrielle
© the artist 2007, and
courtesy Zeno X Gallery
Photo: © Photo CNAC/MNAM
dist.RMN/© Jacques Faujor

98 (p. 116)
Passenger, 2001
Oil on canvas
90.2×60
Sender Collection
© the artist 2007, and
courtesy Zeno X Gallery

99 (p. 119)
Prisoners of war, 2001
Oil on canvas
124.5×117.5
Private collection, Belgium
© the artist 2007, and
courtesy Zeno X Gallery

100 (p. 118)
Altar, 2002
Oil on canvas
232×313
Property of Sir Evelyn and
Lynn Forester de Rothschild
© the artist 2007, and
courtesy Zeno X Gallery

101 (pp. 114–115)
Imperméable, 2006
Raincoat
Oil on canvas
224×94
Private collection
© the artist 2007, and
courtesy Zeno X Gallery
Photo: Marc Domage

ANDY WARHOL

102 (pp. 56–57)
*Orange Car Crash (Orange
Disaster) (5 Deaths 11 Times in
Orange)*, 1963
Acrylic and silkscreen ink on
linen
220×210
GAM - Galleria Civica d'Arte
Moderna e Contemporanea,
Turin
© Licensed by the Andy
Warhol Foundation for the
Visual Arts, Inc/ARS, New
York and DACS London 2007

103 (pp. 54–55)
Race Riot, 1963
Silkscreen ink on linen
307×210
Daros Collection, Switzerland
© Licensed by the Andy
Warhol Foundation for the
Visual Arts, Inc/ARS, New
York and DACS London 2007

104 (p. 52)
Big Electric Chair, 1967
Silkscreen and acrylic on
primed canvas
137.2×185.5
Froehlich Collection,
Stuttgart
© Licensed by the Andy
Warhol Foundation for the
Visual Arts, Inc/ARS, New
York and DACS London 2007
Photo: Uwe H.Seyl, Stuttgart

List of Comparative Illustrations

All measurements are in centimetres, height×width.

Painting Modern Life

Photo source for Richard Hamilton, *Swingeing London 67 (f)*, 1968–69 (cat. 33)
Detail from Richard Hamilton's photo collage, *Swingeing London 67*, 1967–68
Lithograph on paper
71.1×49.8
© Richard Hamilton.
All rights reserved, DACS
Photo © Tate, London 2007

David Hockney
The Room, Manchester Street
Acrylic on canvas
304.8×213.4
© David Hockney 2007

Franz Gertsch
Vietnam, 1970
Dispersion on unprimed half-linen
205×290
Hess Collection, Bern, Switzerland

Jasper Johns
Flag, 1954–55
Encaustic oil and collage on fabric mounted on plywood (3 panels)
107.3×153.8
© Jasper Johns/VAGA, New York/DACS, London 2007
Photo: © 2007, The Museum of Modern Art/Scala, Florence

Gerhard Richter
Verwaltungsgebäude (no. 39), 1964
Administrative Building
Oil on canvas
90×150
Private collection, San Francisco
© Gerhard Richter, Cologne 2007

Malcolm Morley
HMS Hood (Friend), 1965
Liquitex and ink on canvas
106×106
Courtesy Sperone Westwater, New York
© Malcolm Morley 2007

Richard Hamilton
Whitely Bay, 1965
Oil on photograph laid on panel
81×122
© Richard Hamilton.
All rights reserved, DACS

Photography by Other Means

Gerhard Richter
Motorboot (1. Fassung) (no. 79a), 1965
Motorboat, 1. version
Oil on canvas
170×170
Galerie Neue Meister, Staatliche Kunstsammlungen Dresden, on loan from a private collection
© Gerhard Richter, Cologne 2007

Photo source for Gerhard Richter, *Folding Dryer*, 1962 (cat. 85)
From Gerhard Richter's *Atlas*
Photo: Courtesy Städtische Galerie im Lenbachhaus, Munich

Photo source for Gerhard Richter, *Nurses*, 1965 (cat. 88)
From Gerhard Richter's *Atlas*
Photo: Courtesy Städtische Galerie im Lenbachhaus, Munich

Vija Celmins
Suspended Plane, 1966
Oil on canvas
60.3×88.3
San Francisco Museum of Modern Art
Purchase, by exchange, through bequest of Elise S. Haas
© Vija Celmins

Photo source for Andy Warhol, 'Electric Chair' series, c.1963 (see *Big Electric Chair*, 1967, cat. 104)
Mechanical ('Sing Sing's Death Chamber'). 'Sing Sing prison, Ossining, NY; chair in which Julius and Ethel Rosenberg were executed', Wide World Photos, 13 January 1953
Gelatin silver print on Manila file folder, with felt-tip ink inscriptions
52.4×30
Founding Collection, The Andy Warhol Museum, Pittsburgh

Sheer Sensation: Photographically-Based Painting and Modernism

Robert Rauschenberg
Almanac, 1962
Oil, acrylic and silkscreen on canvas
245×153.5
© DACS, London/VAGA, New York 2007
Photo: © Tate, London 2007

Jackson Pollock
Cathedral, 1947
Enamel and aluminium paint on canvas
181.6×89.1
Dallas Museum of Modern Art, gift of Mr. and Mrs. Bernard J. Reiss
© Jackson Pollock. All rights reserved, DACS

Richard Artschwager
Lefrak City, 1962
Acrylic on Celotex with Formica
113×247.7
Collection of Irma and Norman Braman USA
Richard Artschwager © ARS, NY and DACS, London 2007

Photo source for Andy Warhol, *Orange Car Crash (Orange Disaster) (11 Deaths 11 Times in Orange)*, 1963 (cat. 102)
'Two Die in Collision', United Press International Inc., 17 June 1959
Gelatin silver print, coloured acetate and ballpoint ink inscriptions
15.9×22.9
The Andy Warhol Museum, Pittsburgh
Founding Collection, Contribution The Andy Warhol Foundation for the Visual Arts, Inc.

Luc Tuymans
Cargo, 2004
Oil on canvas
150×196.5
© Luc Tuymans 2007, and courtesy Zeno X Gallery
Photographer: Felix Tirry

A Strange Alliance: The Painter and the Subject

Édouard Manet
Masked Ball at the Opera, 1873
Oil on canvas
591×725
Gift of Mrs Horace Havemeyer in memory of her mother-in-law, Louisine W. Havemeyer
Photo: © 2007 Board of Trustees, National Gallery of Art, Washington

Arshile Gorky
The Artist and His Mother, c.1926–36
Oil on canvas
152.4×127
Whitney Museum of American Art, New York
© ADAGP, Paris and DACS, London 2007

Photo source for Elizabeth Peyton, *Arsenal (Prince Harry)*, 1997 (cat. 79)
From *The Daily Telegraph*, Monday 1 December 1997

Photo source for Martin Kippenberger, *Uno di voi, un Tedesco in Firenze*, 1977 (cat. 56)
One of You, A German in Florence
Artist's photograph
© Martin Kippenberger 2007

Photo source for Marlene Dumas, *The Blindfolded*, 2002 (cat. 20)
'Palestinians are blindfolded after several hundred surrendered to the Israeli army outside a refugee camp in the West Bank City of Tulkarm', 8 March 2002
Photograph reproduced in *NRC Handelsblad*, 14 January 2006. Reuters/Nir Elias

Jean-Auguste-Dominique Ingres
Baigneuse de Valpinçon, 1808
The Bather of Valpinçon
Oil on canvas
146×97.5
Louvre Museum, Paris
© photo RMN/©Gérard Blot

René Magritte
La réproduction interdite, 1937
Not to be reproduced
Oil on canvas
81×65
Collection Museum Boijmans van Beuningen, Rotterdam
© ADAGP, Paris and DACS

Elizabeth Peyton
Julian with a broken leg, 2004
Oil on board
35.6×27.9
Photo: Courtesy Gavin Brown's enterprise

Wilhelm Sasnal
Girl Smoking (Anka), 2001
Oil on canvas
45×50
Courtesy of The Saatchi Gallery, London
© Wilhelm Sasnal 2007

Rehearsing Doubt: Recent Developments in Painting-after-Photography

Luc Tuymans
Gas Chamber, 1986
Oil on canvas
50×70
Courtesy Zeno X Gallery
© Luc Tuymans 2007

Photo source for Luc Tuymans, *Prisoners of war*, 2001 (cat. 99)
Television still
Courtesy Lux TV

Photo source for Liu Xiaodong, *Three Girls Watching TV*, 2001 (cat. 71)
From Liu Xiaodong's series 'A room in Beijing'
Photo: the artist, courtesy the artist and Timezone 8 Limited

Photo source for Liu Xiaodong, *A Transsexual Getting Down Stairs*, 2001 (cat. 70)
From Liu Xiaodong's series 'Transvestites in Singapore'
Photo: the artist, courtesy the artist and Timezone 8 Limited

Eberhard Havekost
Before the Oscar, B06, 2006
Oil on canvas
Diptych; left: 57×40; right: 35.5×37.5
Private collection. Courtesy Jay Jopling/White Cube (London)

Working drawing for Johannes Kahrs, *La Révolution Permanente*, 2000 (cat. 47)
Painted film still from *Sympathy for the Devil*, 1968
Jean-Luc Godard (director)
Image courtesy the artist and Zeno X Gallery

Working drawing for Johannes Kahrs, *93'09"*, 1997 (cat. 46)
Painted film still from *Taxi Driver*, 1976
Martin Scorsese (director)
Image courtesy the artist and Zeno X Gallery

Peter Doig
The Hitch-Hiker, 1989/90
Oil on sack cloth
152×226
Courtesy Victoria Miro Gallery. © the artist 2007